LEONARDO
AND
THE
MONA LISA
STORY

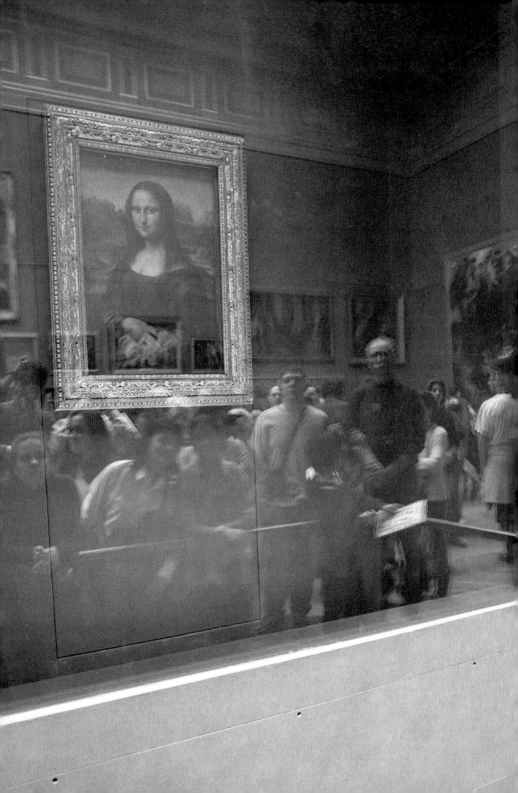

DONALD SASSOON

LEONARDO AND THE MONA LISA STORY

THE HISTORY OF A PAINTING TOLD IN PICTURES

A MADISON PRESS BOOK

Library and Archives Canada Cataloguing in Publication

Sassoon, Donald, 1946-
 Leonardo and the Mona Lisa story : the history of a painting told in pictures /
 Donald Sassoon.

Includes index.

First hardcover edition:
ISBN-13: 978-1-895892-81-9
ISBN-10: 1-895892-81-3

First paperback edition:
ISBN-13: 978-1-895892-82-6
ISBN-10: 1-895892-82-1

 1. Leonardo, da Vinci, 1452–1519. Mona Lisa—History. 2. Leonardo, da
Vinci, 1452–1519. Mona Lisa—History—Pictorial works. I. Leonardo, da
Vinci, 1452–1519 II. Title.

ND623.L5A7 2006 759.5 C2005-907593-7

An Angel Edition for Madison Press Books

Produced by Madison Press Books
1000 Yonge Street—Suite 200
Toronto, Ontario, Canada
M4W 2K2
www.madisonpressbooks.com

Printed in Singapore

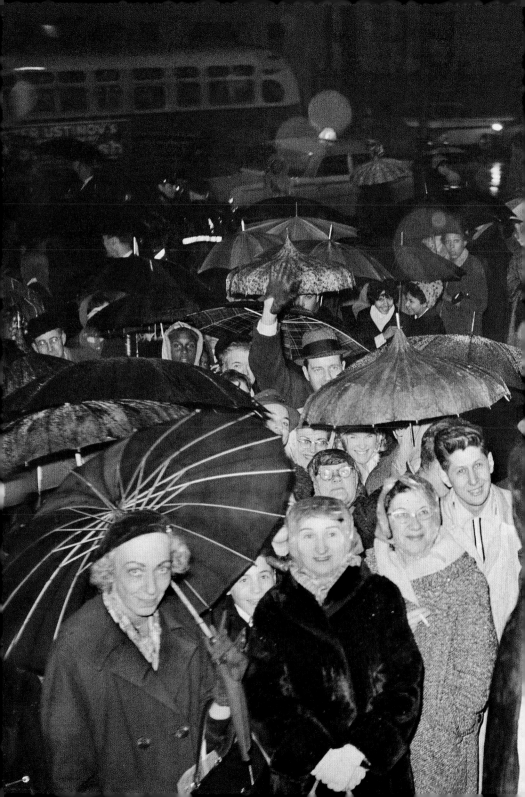

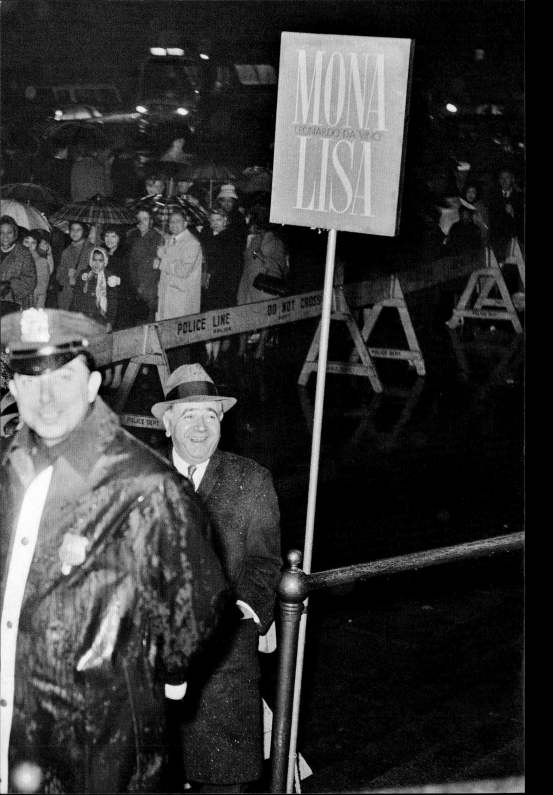

CONTENTS

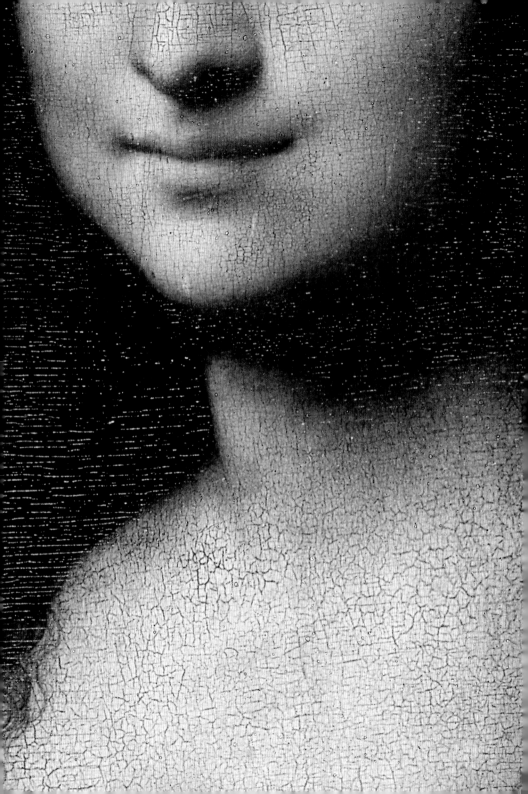

PREFACE

THAT SMILE... WE'VE ALL SEEN IT THOUSANDS OF TIMES. It graces the face of *La Gioconda*, or the *Mona Lisa*, as she is affectionately known—the world's most famous painting, created by Leonardo da Vinci around 1503. From its first viewing, this work of art caused a stir among all who saw it. Was it the peerless technique, the innovative composition? Perhaps the air of mystery about the scene, or the subject's bold but elusive regard? It might well have been that smile. Giorgio Vasari, a sixteenth-century art historian, wrote: "All will acknowledge that the execution of this painting is enough to make the strongest artist tremble with fear.... In this painting of Leonardo there was a smile so enchanting it was more divine than human."

More than the sum of her parts, the *Mona Lisa*, helped along by twists of fate and strange coincidence, has become an icon. And the interest in her shows no sign of waning. In a recent survey that asked people to name the best-known painting in the world, 86 percent of those polled answered the *Mona Lisa*. She is the most viewed masterpiece in the Louvre, attracting over six million visitors a year. There are more than 100,000 Web pages dedicated to her. Books and movies about the painting and her enigmatic creator abound. No work of art has had a more lasting impact on the world around us—art, literature, advertising, the media, and the digital world have all been inspired by the *Mona Lisa*.

Like any historical figure, she has had a life of drama, adventure, even mystery. She has been talked about, written about, parodied, copied, stolen, celebrated, filmed, and toured like a rock star. We do not know for certain who she is, when exactly she was painted, or why she gazes out at us with that inscrutable half-smile. She is entirely familiar, yet eternally mysterious. Here, then, is her story: a biography of a painting, told through pictures.

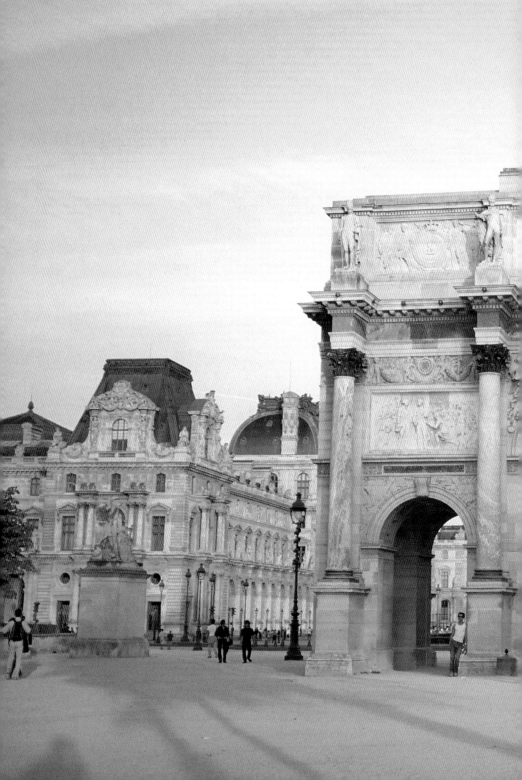

PREVIOUS SPREAD
The Louvre Museum and the Arc de Triomphe du Carrousel from the Jardins des Tuileries

ABOVE
The Louvre seen through the Arc de Triomphe du Carrousel
Every year almost six million people from around the globe visit the Louvre. And while the museum boasts one of the world's most important collections of art and antiquities, most of its visitors come simply to see a single painting—the *Mona Lisa*.

RIGHT
The Cour Napoléon showing the Pyramid and the Louvre

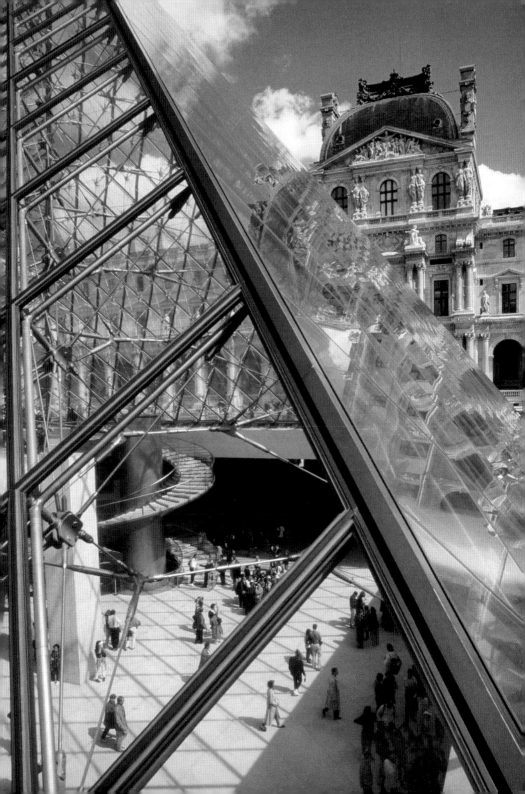

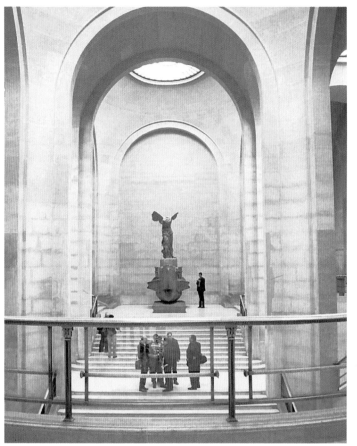

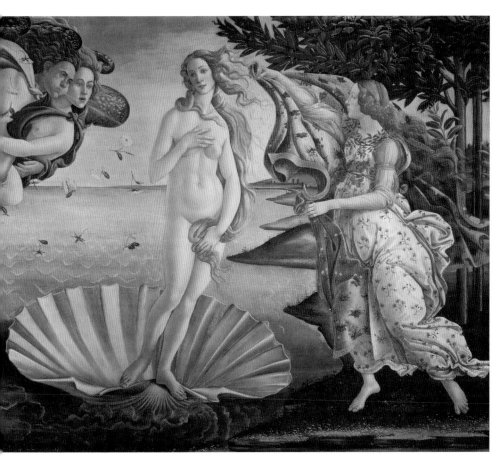

LEFT
Winged Victory of Samothrace
c. 190 BC
The *Mona Lisa* has greater stature than the celebrated sculpture of Winged Victory, also at the Louvre, or Botticelli's much-reproduced and instantly recognizable goddess, a crowd-pleaser at the Uffizi Gallery in Florence.

ABOVE
The Birth of Venus
Sandro Botticelli
c. 1483

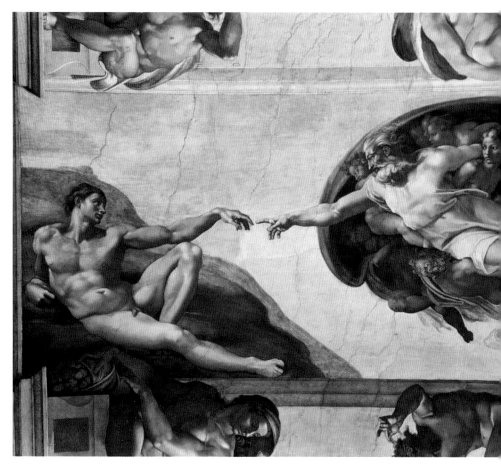

The Creation of Adam, Sistine Chapel
Michelangelo
1509–12
And while the *Mona Lisa* lacks the grandeur of
Michelangelo's frescoes and the vibrancy of
van Gogh's flowers, it still outshines both of these
monumental works.

Sunflowers
Vincent van Gogh
1888

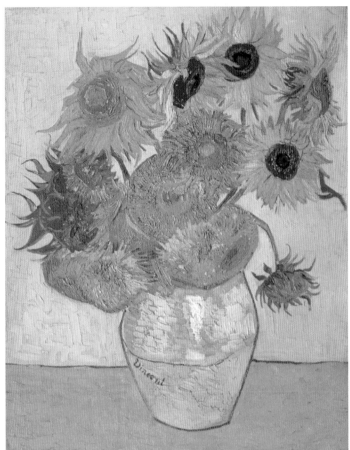

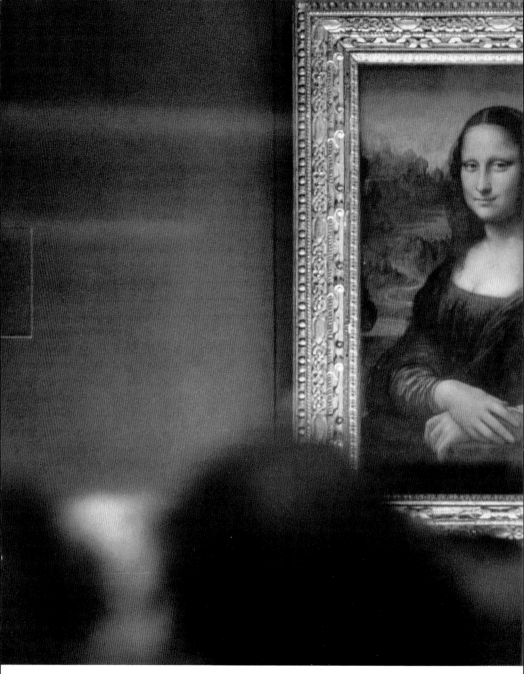

ABOVE
Mona Lisa
Leonardo da Vinci
1503–c.1507

This is what the Louvre's millions of visitors have come to see—the most famous face in the world, instantly recognizable from Asia to South America. Just 30 inches high and 21 inches across, painted in oil on a perilously thin piece of poplar wood, Leonardo da Vinci's *Mona Lisa* has enthralled the world for over 500 years.

1452

1515

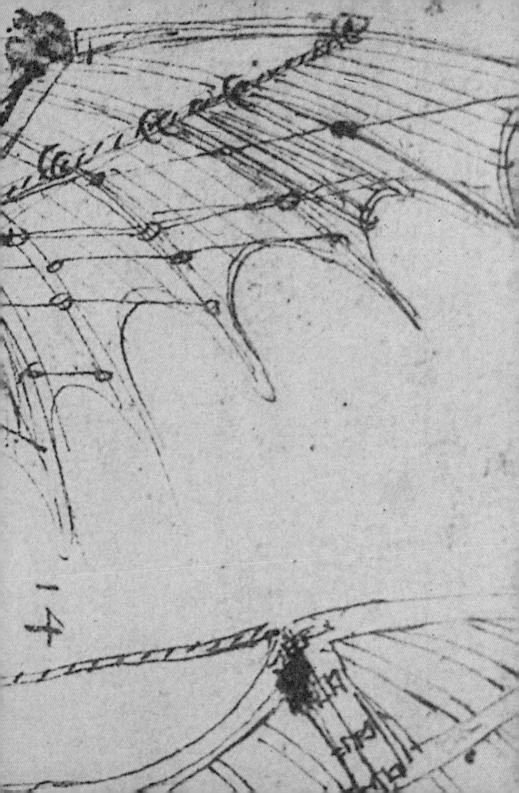

THE PORTRAIT OF LADY LISA hangs in the Louvre, smiling at the tourists. She appears unperturbed by the flashes of cameras, the sighs of recognition, and the jostling of the crowd shifting from foot to foot like a clumsy ballet. Demure, almost innocent, she seems to contemplate the succession of visitors making room for the next horde without signs of weariness. And how could she be weary? After all, the lady is not a "she" but an "it"—a mere object, a few layers of pigmented oil on poplar wood—admittedly the best-known piece of wood in the world. Entombed in a concrete block behind a bulletproof glass barrier, the portrait is protected from vandals in search of their fifteen minutes of fame. Fifteen minutes? Lady Lisa—Madonna Lisa (my lady), shortened to Monna Lisa, established in English incorrectly as Mona Lisa, known in France as la Joconde and in Italy as la Gioconda—has had five hundred years of fame. She has the best-known face in the world. But how did she come to be here?

It began with Leonardo, the artist who painted her. Even in his own time he was considered something of a genius, and he lived among probably the greatest group of artists and thinkers ever to occupy the same territory at the same time—the masters of the Italian High Renaissance. Raphael, Michelangelo, Titian, and their peers were not only artistic giants but also men of enormous intellectual curiosity. They investigated different theories of composition in both perspective and anatomy, and experimented with paints, texture, color, and tone. And they wanted more than harmony and balance in their compositions—they wished to reveal the "motions of the mind" of the frightened warriors and horses in battle, the veiled thoughts of the men and women they portrayed, the psychological drama and intensity of the moment of crisis caught in the painting.

When Leonardo was born, on Saturday, April 15, 1452, the omens were hardly propitious, for his mother, Caterina, an illiterate peasant woman, was not married to his notary father, Piero. Still, his obscure birth was not as great a handicap as it might seem. Illegitimate children were better treated in Italy at the time than elsewhere. Piero, though perhaps not the most caring of fathers, never denied paternity. And the boy was uncommonly handsome and well proportioned. He loved the countryside, the hills, and valleys of his native land. Later, he urged fellow painters to expose themselves to the heat of the sun and experience nature at first hand. As a solitary farm boy he was familiar with animals, and he learned to love them and draw them.

The noted art historian Giorgio Vasari tells us Leonardo was a brilliant pupil, but inconsistent: "He set himself to learn many things, only to abandon them almost immediately." Leonardo referred to himself as an "omo senza lettere"—a man without letters—meaning he was never taught Latin. He did not regard that as a handicap, though. He could learn from experience—a better teacher, he thought, than those who merely "recite the works of others." Although Piero married four times in all and had twelve children, Leonardo was Piero's only child until he reached adulthood—a singular advantage. He was well looked after, growing up with his paternal grandparents and his uncle Francesco, who died childless and left him his estate.

Leonardo's birthplace, Anchiano, a couple of miles from Vinci, was in the middle of the Tuscan countryside, thirty miles from Florence—one day's travel on horseback. And what luck for an aspiring artist to be born in Tuscany in the middle of the fifteenth century. The different city-states of Italy were then supreme in all forms of art and science. The country had the best

engineers, architects, mathematicians, scientists, bankers, accountants, explorers, musicians, painters, sculptors, poets, political scientists, and historians. Perhaps one is born a genius, but without the right environment, stimuli, and upbringing, the talent may remain hidden.

In the mid-1460s Leonardo moved to Florence. Thanks to his father's connections, he was accepted in the *bottega* (shop) of Andrea del Verrocchio as an apprentice. Verrocchio was then only thirty-one, but he was already the head of the most prestigious studio in Florence, patronized by Lorenzo the Magnificent, the Lord of Florence and a great protector of the arts.

The increased demand for new works of art in late-fifteenth-century Italy attracted upwardly mobile young men, the talented children of craftsmen and shopkeepers. Leonardo's fellow students included Domenico Ghirlandaio, Pietro Perugino, and Lorenzo di Credi. Sandro Botticelli was a frequent visitor. Verrocchio taught his pupils to disdain narrow specialization and to try their hand at everything: sculpture, jewelry, suits of armor, decorative works, heraldic devices, bronze objects, tombstones, and Madonna and Child paintings. There were no books in the Verrocchio workshop, no theory, no abstract medieval learning, and the students learned from practice and experimentation, by making mistakes and putting them right. Most of the great artists of the Renaissance whose paintings and sculptures we revere started their career by learning to make jewelry, carve ornaments, and become stonemasons. Brunelleschi, Ghirlandaio, and Donatello, for example, began their career as goldsmiths.

The idea of an individual artist producing a unique work of art had not yet materialized. The work was the product of a workshop, not of an auteur: it was not signed, and it usually had

no title. Leonardo was taught to produce hundreds of drawings and preparatory studies, and he eventually helped Verrocchio in increasingly demanding tasks. We know that he painted the angel and part of the landscape on the left side in one of his master's major achievements, *The Baptism of Christ* (1470–76, now in the Uffizi Gallery in Florence).

In 1477 Leonardo, after ten years as an apprentice, set up his own studio—and he immediately enjoyed some success. He had already started work on his first portrait, that of the young, beautiful, and rich Ginevra de' Benci. It had been commissioned by Bernardo Bembo, the Venetian ambassador to Florence. Ginevra was married and so was Bembo, but he conducted a public platonic relationship with her. Ginevra is portrayed standing by a juniper tree, in Italian *ginepro*—a pun on her name. This painting is recognized as Leonardo's first masterpiece. The unsmiling, almost sultry, Ginevra was followed by a Madonna and Child, the Benois Madonna. Here the Virgin Mary's smile has no mystery: it is the smile of a mother who delights in her child. He also attempted a Saint Jerome, but, like so many of his works, he left this masterpiece unfinished and went on to something else.

In 1481 Leonardo left Florence, in search of a prince, a patron, and a court. He was attracted to Milan, a powerful and rich city, less artistic than Florence but ruled with a rod of iron by Lodovico Sforza (1451–1508), known as *il Moro*. It is not clear why Leonardo left Florence. Perhaps he felt restricted there, where artists were paid for each job in installments, always at the mercy of the authority of the guilds. Paradoxically, if he were attached to a court, with a regular stipend, he would be freer to experiment with his many scientific and artistic interests and be more original. And that was what he did.

Leonardo was so eager to join Lodovico's court that he did not wait to be invited (as was the custom) but wrote offering his services. Of the ten areas he listed in which he claimed to excel, nine were directly concerned with engineering and warfare—the skills that really interested Lodovico. "I can," he boasted, "build bridges and battering rams, secret passages, covered wagons behind which soldiers can hide." He added the tenth and last item of expertise almost as an afterthought: "I can carry out sculptures in marble, bronze, or clay, and also I can do in painting whatever may be done, as well as any other, be he who he may."

But Leonardo never actually built any military machines, or bridges, or buildings. What he left us were thousands of drawings depicting projects he never finished: plans for cities and canals, drawings of staircases and knots, a defensive system of curtains, mortars with explosive cannonballs, various flying machines, a giant crossbow, hydraulic devices, and armored cars. His one great attempt at a major sculpture, known as *il Cavallo*—a gigantic equestrian statue twenty-one feet high, in memory of Francesco Sforza, Lodovico's father—aimed to rival his teacher Verrocchio's *Bartolomeo Colleoni* in Venice, but it was never made. The surviving drawings had not resolved the technical problems involved in holding such a monumental sculpture in the desired position. In technical and scientific matters, he seems to have been more a visionary than a practitioner.

At court, Leonardo entertained everyone with his music. He excelled at the *lira da braccio*, a seven-stringed instrument played with a bow, a precursor of the violin rather than the modern lyre, but he also drew and, above all, he painted—and painted better than any other artist there. Few of his paintings survive, but many of his outstanding masterpieces originated in this period. First

came *Virgin of the Rocks*, of which there are now two versions, one entirely by him at the Louvre, and the other a studio work now at the National Gallery in London. Then he painted a large fresco in the Church of Santa Maria delle Grazie: *The Last Supper*, where, unusually, Judas is sitting among the other disciples instead of facing them, his back to the viewer. The work is brilliant in composition and psychological insight, but, unfortunately, it began to deteriorate almost immediately, as Leonardo mixed his paints so poorly.

Leonardo also painted, in about 1488–90, *Lady with an Ermine*. The ermine was a symbol of Lodovico Sforza, and the Greek word for ermine is *gallé*—two clues that suggest the lady depicted is the young and smiling Cecilia Gallerani, Lodovico's mistress. Mistresses come and go and, ten years later, still in Milan, Leonardo painted another beautiful and slightly brooding woman—"charming and cruel," in the words of one of Leonardo's first biographers, Gabriel Séailles. In the seventeenth century she was erroneously identified as *La Belle Ferronnière*, the mistress of François I, but the sitter was Lucrezia Crivelli, another of Lodovico's favorites.

Leonardo stayed in Milan for almost twenty years, leaving only after the French had defeated Lodovico in December 1499. In these tumultuous times he went at first to Mantua to the court of Isabella d'Este, whose sister Beatrice had married Lodovico. The rich and powerful Isabella, impressed by *Lady with an Ermine*, asked Leonardo to paint her portrait, but all he produced was a half-length drawing. Leonardo was on the move. While he was in Venice, marauding French soldiers vandalized the clay model of his monumental *cavallo*, dealing the final blow to that ill-starred project.

By April 1500 he was back in Florence, where the city was still reeling after a period of fervid religious revival. There was little money and little work. Leonardo had probably started another major work, *The Virgin and Child with Saint Anne*, now in the Louvre, though he had declared he no longer wished to paint. Yet he produced, with his assistants, more Madonna paintings, including two versions of *Madonna of the Yarnwinder*—one of which is now in a private collection while the other, later, version was stolen in August 2003 from the Duke of Buccleuch's castle in Scotland. In 1502 Leonardo joined Cesare Borgia (the famous, or perhaps infamous, son of Pope Alexander VI) in central Italy. While there, he worked as the architect and engineer-in-chief for Borgia's short-lived ambition to rule central Italy. Interestingly, the campaign drew the admiration of Machiavelli, who used Borgia as a prototype for his treatise on statecraft, *The Prince*.

In 1503 Leonardo was back in Florence, without a patron and without money. It is said that he even offered his services to the Turkish Sultan. What Leonardo really wanted to do was to be involved in some major engineering project, perhaps a bridge over the Golden Horn in Constantinople or changing the course of the Arno to reduce the perils of floods (another failed project). Instead, he was engaged to paint the portrait of an unknown and unprepossessing Florentine housewife—not the kind of work likely to make Leonardo famous. The portrait was that of Madonna Lisa, wife of the prosperous merchant Francesco del Giocondo.

In all likelihood it was started in 1503. We do not know when it was finished, but, as with many of his commissions, Leonardo never handed it over to Mrs. Giocondo or to her husband. In a description of the painting written a few years later, Vasari said it was unfinished, so it's possible that Leonardo did

not complete it in the time allowed. What we do know is that Leonardo kept the portrait with him in his subsequent travels between Florence and Milan, which was still under French control. It was with him when he went to Rome, in 1513, to place himself under the patronage of the Florentine Giuliano de' Medici, brother of the new Pope, Leo X. When Giuliano died in March 1516, the aging Leonardo was once again in search of a protector.

Tuscan countryside

Anchiano, a small town in rural Tuscany and birthplace of Leonardo da Vinci, was a humble reflection of Italy in the mid-fifteenth century as the Renaissance center of art, commerce, and science.

1426

[handwritten entry, largely illegible]

1428

[handwritten entry, largely illegible]

1432

[handwritten entry, largely illegible]

1436

[handwritten entry, largely illegible]

1452

[handwritten entry, largely illegible]

LEFT
Act of a notary
c. 1452
This document records Leonardo's birth on April 15, 1452, in the hamlet of Anchiano. He was the illegitimate son of a notary and a peasant woman. Giving also the hour of his birth (the third hour of the night), the document has provided ample clues for those who seek genius in astrological charts.

ABOVE AND BELOW
Town of Vinci
After 1454, when his mother married and his father moved to Florence, Leonardo lived in his grandfather's house, in the nearby town of Vinci. More than five hundred years later, Vinci remains a classic Tuscan town, emerging from a steep hillside.

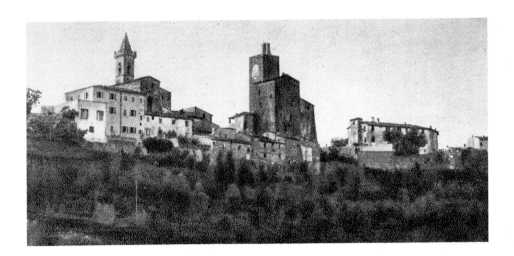

Detail from the *Catena Map* of Florence
1480
For any ambitious young man, Florence, only twenty miles from Vinci, was the place to be. At the height of its glory, the city was wealthy, cosmopolitan, and the home of many important patrons of the arts.

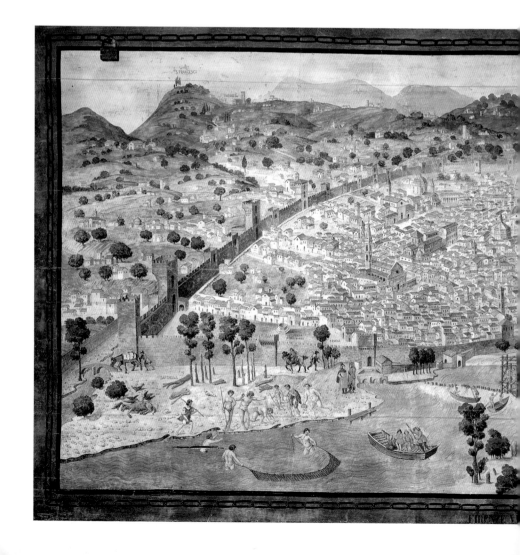

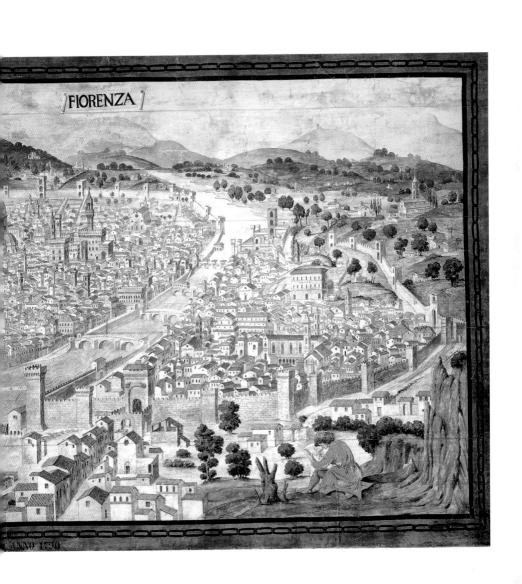

FIORENZA

ANNO 1470

Duomo of the Cathedral of Santa Maria del Fiore
Filippo Brunelleschi
1420–36
The grand dome of the cathedral dominated the
skyline of Florence when Leonardo arrived there in
the mid-1460s.

Drawing of the construction of the Duomo
Filippo Brunelleschi
c. 1430
Brunelleschi's sketch illustrates the great strides made by
artists in the late thirteenth and early fourteenth centuries,
after they mastered perspective and, by understanding
its mathematical base, developed a true-to-life style of
drawing and painting.

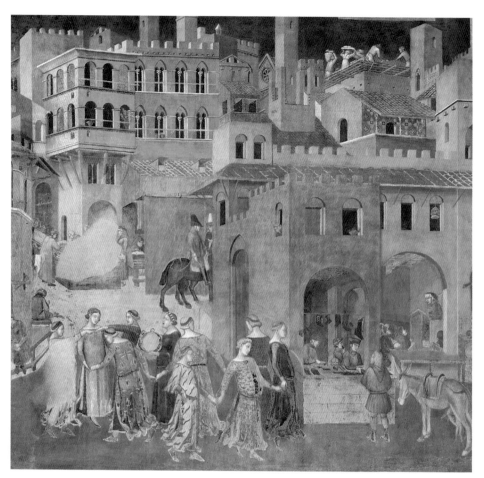

ABOVE

Detail of *Allegory of Good Government:*
Effects of Good Government in the City
Ambrogio Lorenzetti
c. 1338–40

Florence aspired to the Italian ideal of the well-ordered city—one modeled on classical notions of state management, with a strong but just ruler, respected merchants, and productive workers. This ideal is depicted in Lorenzetti's famed allegory.

RIGHT

Lorenzo de' Medici, il Magnifico
16th century

Lorenzo the Magnificent, son of the great banking family and master of Florence, was a patron of the arts who supported many contemporary artists. Ambitious and talented, Leonardo was aware of the competition he faced in gaining the notice of the great Lorenzo.

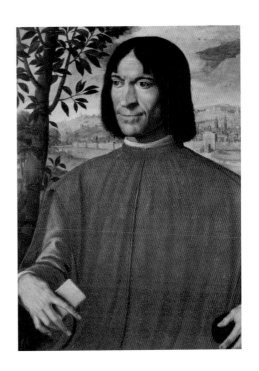

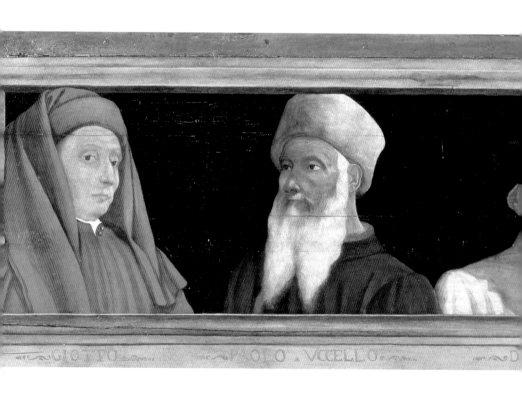

**Cassone with Portraits of Masters
of the Florentine Renaissance
c. 1500–50**
At the time of Leonardo's arrival in Florence, the city
boasted an impressive artistic tradition and had been
the principal center of artistic innovation since the
thirteenth century. Giotto, Uccello, Donatello, Manetti,
and Brunelleschi, depicted here from left to right, were
considered the supreme masters.

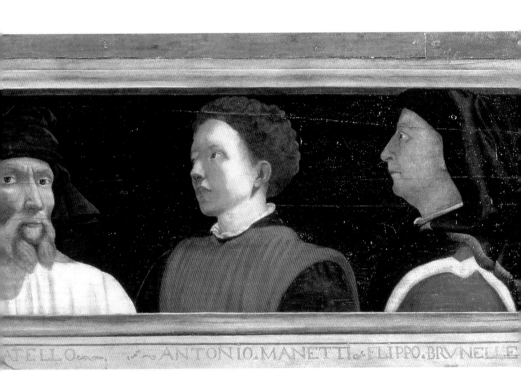

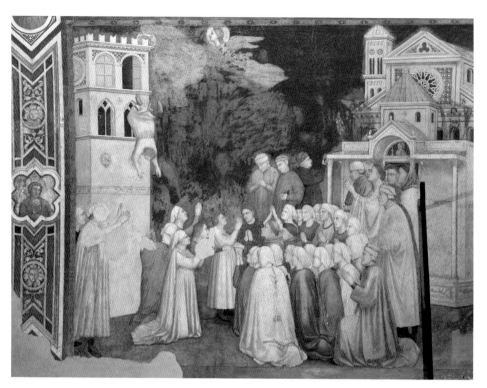

Stories of Saint Francis:
Saint Francis Saves a Falling Child
Giotto di Bondone
c. 1295–1300
Often considered the first of the great Italian Renaissance artists, Giotto led the progression from strictly religious art to more secular decorative works. His frescoes from the life of Saint Francis depicted religious subjects, but his figures are robust, human characters.

David
Donatello
1428–32
Master of line and form, the great Florentine sculptor Donatello used *contrapposto* (counterpoise) to great effect in his *David*. Leonardo later experimented with this technique to give a sense of movement to two-dimensional figures in his paintings.

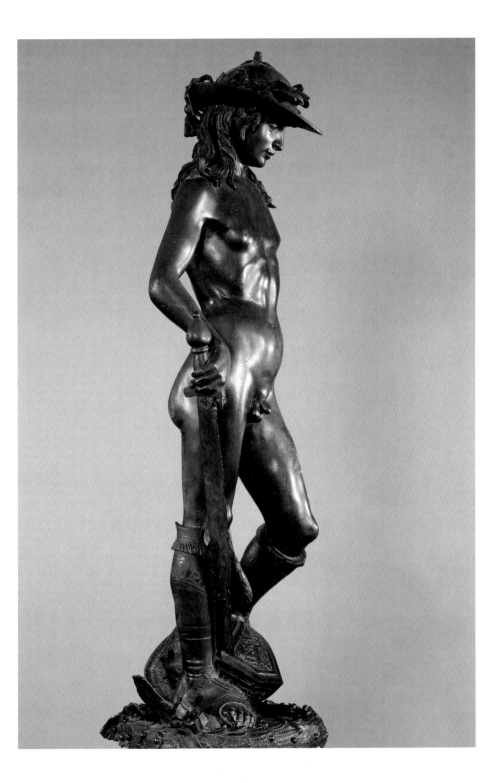

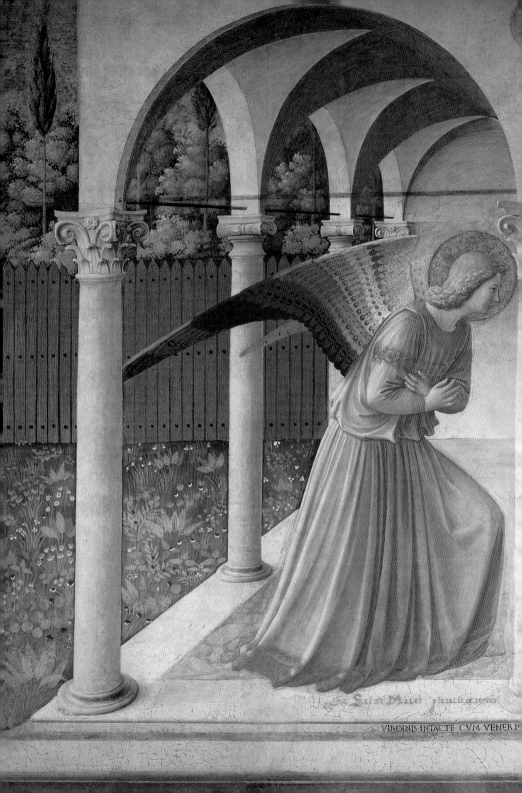

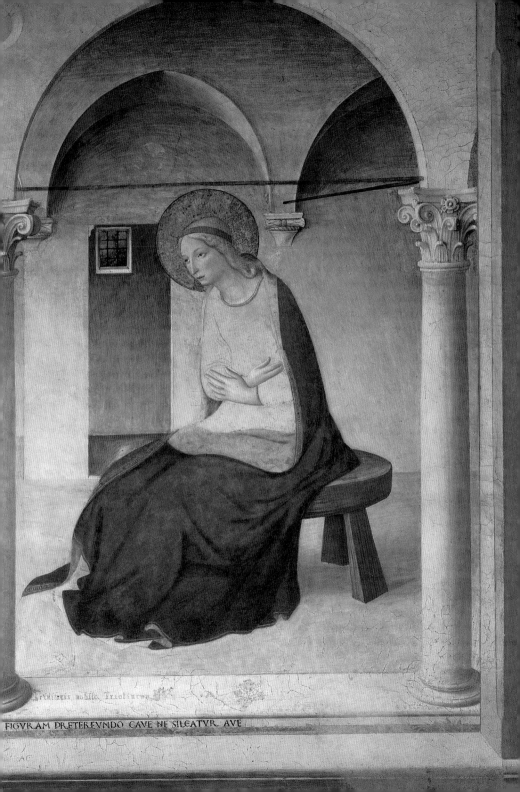

FIGVRAM PRETEREVNDO CAVE NE SILEATVR AVE

The Annunciation
Fra Angelico
c. 1450
The early Renaissance
masters Fra Angelico
and Paolo Uccello made
innovative use of perspective
in their depiction of interior
and exterior spaces, as
Leonardo later would in
his paintings.

The Battle of San Romano
Paolo Uccello
1456

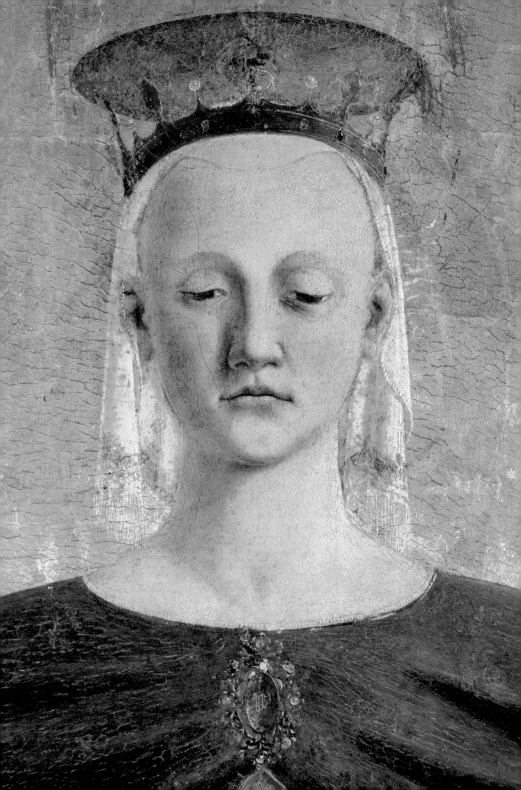

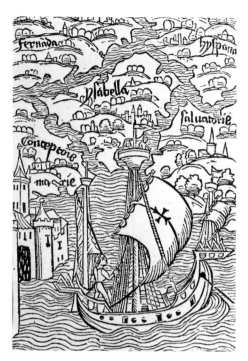

ABOVE

**Columbus on his caravelle near the Islands
of the Savior and Conception**
16th century
Columbus's "discovery" of North America in 1492 literally
opened up new worlds as possible subjects for artists.

RIGHT

**Anatomical study, illustration from _De Humani
Corporis Fabrica_**
Andreas Vesalius
1543
During the Renaissance, both doctors and artists
shared an interest in the human body. As medieval
taboos relaxed, the study of anatomy led to a more
realistic depiction of the body in art.

FOLLOWING SPREAD

**Drawing of the heliocentric universe
after Nicolaus Copernicus**
1530
The astronomer Copernicus contended in his ground-
breaking work _De Revolutionibus_ that the Earth rotated
on its axis once daily and traveled around the sun
once yearly. His successor Galileo continued to expand
knowledge about the Universe itself.

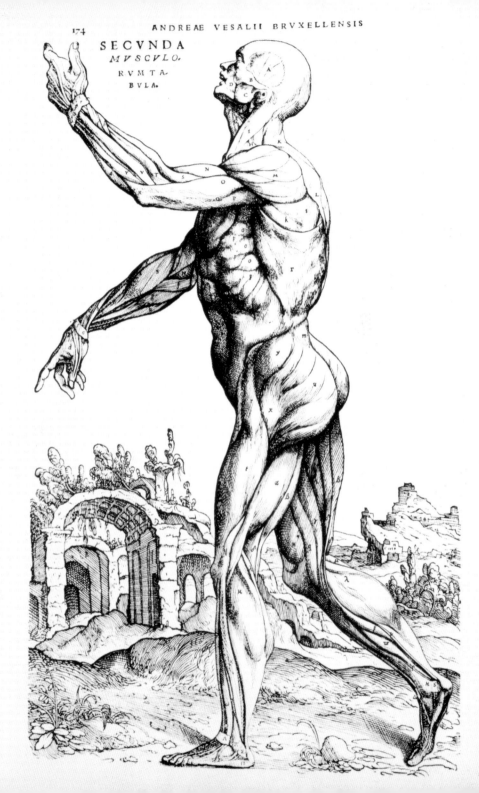

SECVNDA
MVSCVLO.
RVM TA.
BVLA.

Portrait of Andrea del Verrocchio
Lorenzo di Credi
late 15th century
Like all young artists of his time, Leonardo began as an apprentice. His master, Andrea del Verrocchio, who produced works for the Medici, ran a studio where many young painters and sculptors learned their trades.

The Artist's Studio
Giorgio Vasari
c. 1530
Although romanticized, this view of a Renaissance artist's studio gives a sense of the bustling workplace. Verrocchio's studio, like many others, produced goldwork, sculpture, and frescoes as well as paintings, and Leonardo learned by practice. Apprentices ground precious stones for paints, cleaned brushes, primed wood for canvases, and filled in parts of their master's works.

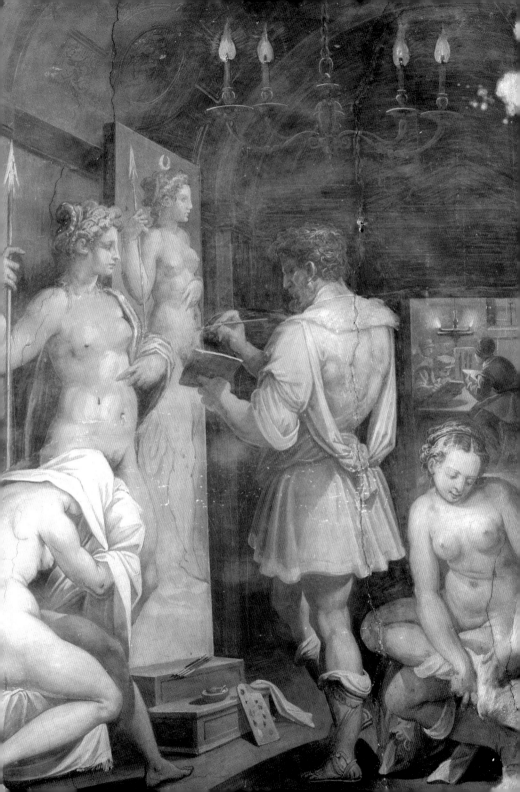

Drawing of the head of a woman
Andrea del Verrocchio
c. 1475
Verrocchio's drawing shows the intricate hairstyles of the period. Nearly thirty years later, Leonardo's sketch for his painting of Leda and the Swan reflects his own preoccupation with complex patterns but clearly owes a debt to his master.

Study for the head of Leda
Leonardo da Vinci
c. 1505–7

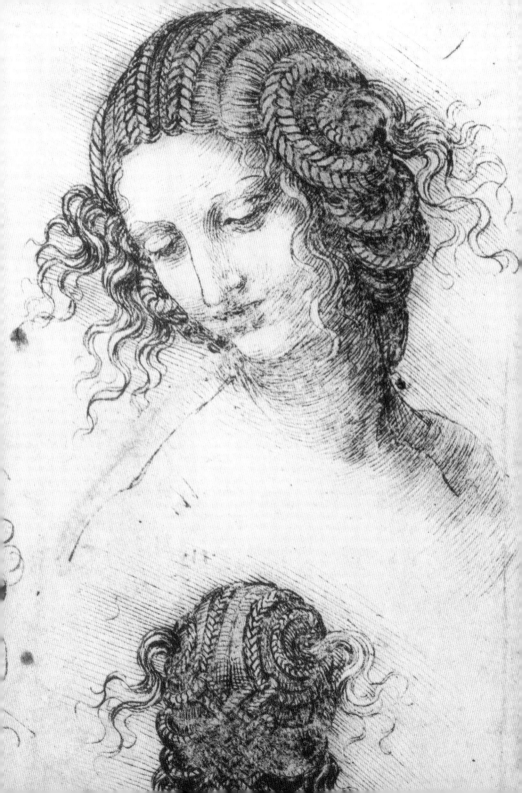

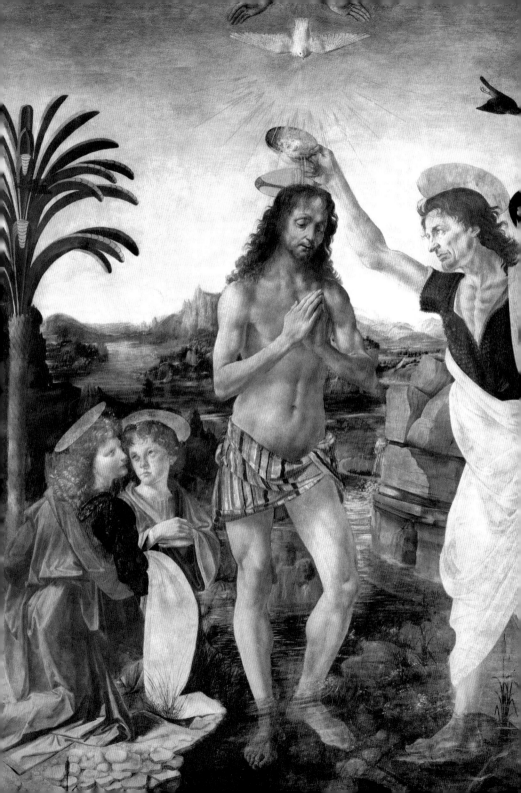

The Baptism of Christ
Andrea del Verrocchio and workshop
1470–76
As apprentices became more skilled, they assisted
their masters with larger works. Leonardo, who soon
developed a reputation as a gifted pupil, began early on
to contribute to paintings produced by the studio. In
one of the first works that clearly illustrates his emerging
genius, Leonardo painted the angel on the left, reworked
Verrocchio's landscape, and revamped the figure of Christ.

...hiacopo coni merc...

...nardo didomenich...

...renço diiacopo chelli...

...lapino. dimichele barbie...

+ lorenço dipuccio dipinto...

+ lorenço dipiero dipintore...

+ LORENÇO DIPIERO ACV...

+ LIONARDO D S PIERO

LVCA DI F VOSI...

lorenzo dandea difio...

+ lorenzo dgiouanni fegu...

lorenzo gmagbo dfangi...

+ lorenzo d rofegg...

lefandro dfidom o delofego...

ọpß	ⅮⅭⅭⅭⅭXXⅢ	₲
vo · rachanck	Ⅾ ⅢⅠⅠXXⅢⅠⅠ	₲
i.g. anbruogo	℞ ⅢⅠⅠXXⅢⅠⅠ	₲
c · p · s̃ · k̃nita	℞ Ⅾ ⅢⅠⅠXXⅢⅠⅠⅠⅠ	₲
ọp	Ⅼ ⲥⲥⲥⲭⅬⅡ	₲
randog̃h	ⅬⅮⲥⲥⲥⲥXⅬⅥⅢⅠⅠ	₲
s̃ A̅ · DIPINTORE	Ⅼ	₲
A̅VINCI · DIPINTORE	Ⅼ	₲
IOᵃ DI LVCA	Ⅼ	₲
	Ⅼ	₲
	Ⅼ	₲
dipintori 1525	Ⅼ	₲
mgnano dip 1525	Ⅼ	₲
Poilera 1525	Ⅼ	₲
no dipintori 1525	Ⅼ	₲

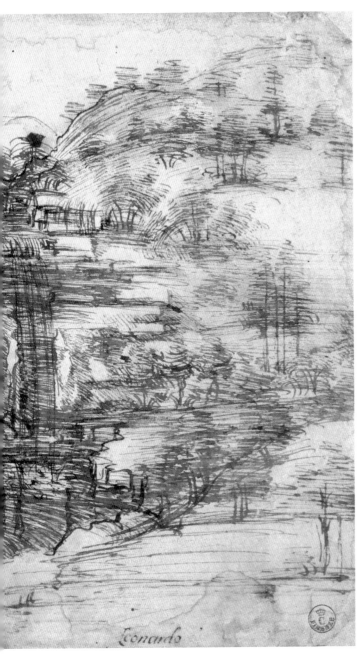

Leonardo

**Registry of the Accademia
di San Luca
c. 1472**
Leonardo was soon ready to
strike out on his own. By
1472 his name appeared in
the registry of the Florentine
painters' guild.

LEFT
**Landscape
Leonardo da Vinci
1473**
This landscape, done when
Leonardo was twenty-one,
is the earliest work we
know of that was exclusively
his own.

Annunciation
Leonardo da Vinci
1472–75
Leonardo created the *Annunciation*, his first major work,
for the Church of San Bartolomeo of Monteoliveto in
Florence. Though this is still an early piece, elements
that would become Leonardo trademarks are evident in
the drapery of the garments worn by the two figures
and especially in the hazy, mysterious landscape.

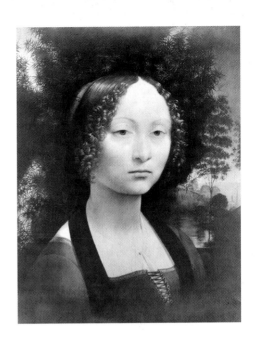

LEFT
Madonna of the Carnation
Leonardo da Vinci
c. 1475
Throughout his career, Leonardo would continue to
develop some of the elements visible in this painting and
the one above—the mountainous background, framing
columns, and elaborate drapery in the *Madonna of the
Carnation*, as well as the intricate, finely detailed hairstyle
seen in *Ginevra de' Benci*, one of his first important
commissions. These details would contribute to the
originality and complexity of his later works.

ABOVE
Ginevra de' Benci
Leonardo da Vinci
c. 1475
As with many portraits of the period, Leonardo's painting
of Ginevra de' Benci includes a clue to her identity. He
painted her sitting in front of a juniper bush—juniper is
ginepro in Italian.

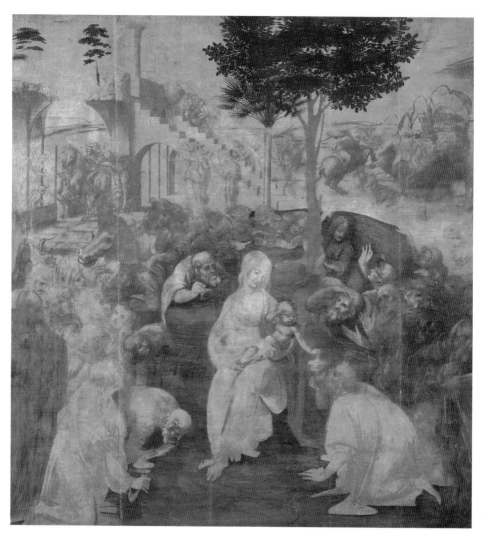

ABOVE

Adoration of the Magi
Leonardo da Vinci
1481–82

During his formative years in Florence another trait of
Leonardo's appeared. In the early 1480s, the monks of
San Donato commissioned a painting of the Adoration
from Leonardo. He left it unfinished—the first of many.

RIGHT

View of Milan

A great artist requires a great patron. Dissatisfied,
perhaps, with Lorenzo de' Medici's patronage of other
artists, Leonardo left Florence in 1481 to join the court
of Lodovico Sforza, *il Moro*, later Duke of Milan.

Drapery study for a kneeling woman
Leonardo da Vinci
c. 1477

RIGHT
Virgin of the Rocks
Leonardo da Vinci
1483–86
This was Leonardo's first work in Milan, intended for an altar in the chapel of the Immacolata in the Church of San Francesco Grande. Renowned for its unusual setting and composition, this work also showcases Leonardo's genius for depicting drapery. It also represents what would become another of Leonardo's lifelong habits: he kept this painting and then did another version for the church.

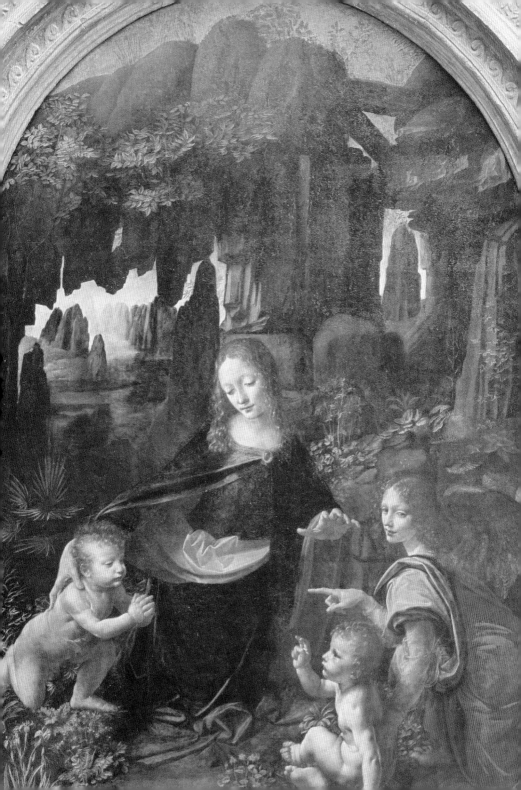

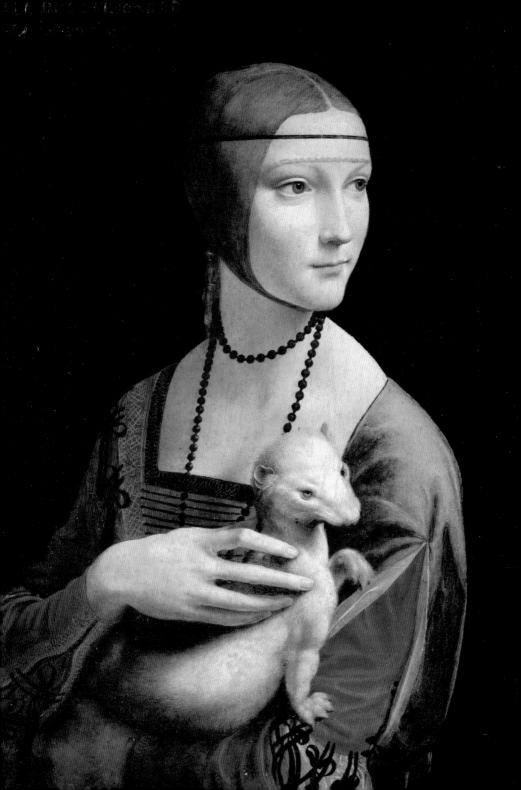

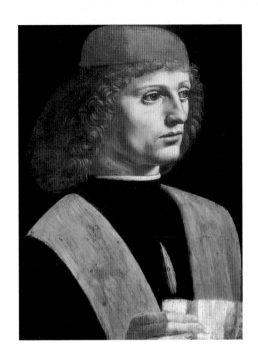

LEFT
Lady with an Ermine
Leonardo da Vinci
1488–90
Lady with an Ermine likely shows Cecilia Gallerani, a mistress of Lodovico Sforza. Critics also believe she was the model for the angel in the second *Virgin of the Rocks*. The ermine she holds represents purity, though this detail also gives a clue to the sitter's identity—the Greek word for ermine is *gallé*.

ABOVE
Portrait of a Musician
Leonardo da Vinci
c. 1485
One of the least documented of Leonardo's works, *Portrait of a Musician* is his only surviving nonreligious painting of a man. Many questions still surround it, including whether it can definitively be attributed to Leonardo. However, the shadowed background, impressive knowledge of the bone structure under the face, and finely modeled fingers and hair point to Leonardo as the artist. When a 1905 cleaning of the painting revealed that the figure was holding sheet music, it seemed an obvious clue that the sitter was a musician. Which one, though, has never been determined.

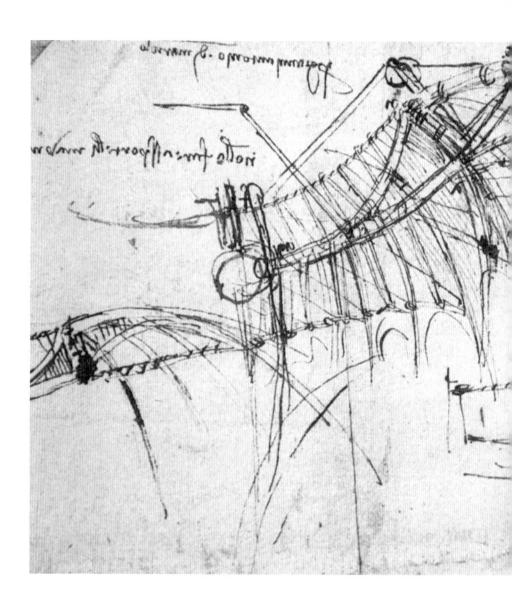

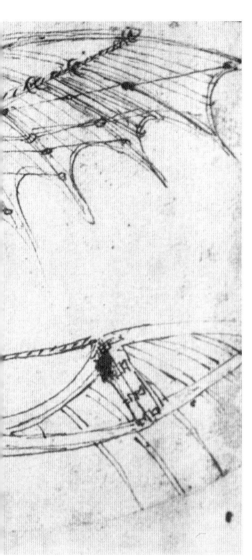

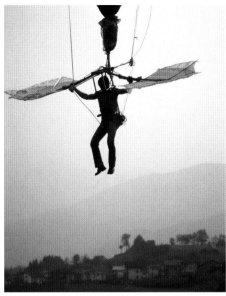

LEFT
Studies of a jointed wing
Leonardo da Vinci
post-1490
Leonardo had sold himself to Sforza more as an engineer and scientist than as an artist. His work in Milan included anatomical studies and numerous technical drawings for various inventions, including plans for flying machines.

ABOVE
Man trying a da Vinci-inspired flying device
Leonardo was fascinated by the idea of flight. His note-books contain many detailed drawings of birds in flight and bird anatomy, and he roughed out numerous flying machines. Since the discovery of Leonardo's notebooks, people have been fascinated by his inventions—some of which have been built and flown. In 1976, this brave man attempted to soar in a machine modelled after one of Leonardo's flying devices.

ABOVE
Drawings of a centralized church
Leonardo da Vinci
c. 1487–89
Plans for a symmetrical church shared a page in one of
Leonardo's notebooks with other rough sketches.

RIGHT
Anatomical sketch
Leonardo da Vinci
1488–89
Leonardo's enthusiasms were catholic and universal.
Nothing escaped his eye. Here he presents a remarkably
detailed, if not always perfectly accurate, study of a
baby in utero.

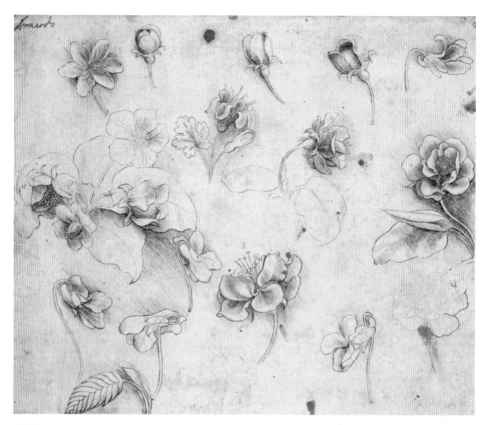

Studies of flowers
Leonardo da Vinci
c. 1490
Leonardo was fascinated by the natural world, but these closely observed flowers might have had another impetus. Court artists had to have many talents, including the ability to capture in the portraits of court ladies every detail of fashion in clothes, hairstyle, and jewelry. Leonardo also served as "party planner" to the court—designing decorative motifs, festivities, masquerades, and triumphal pageants.

La Belle Ferronnière
Leonardo da Vinci
c. 1495
Leonardo's next project for the court was of Lucrezia Crivelli, Lodovico Sforza's new favorite. The name "_la belle ferronnière_" is due to an incorrect identification with the French king François I's mistress.

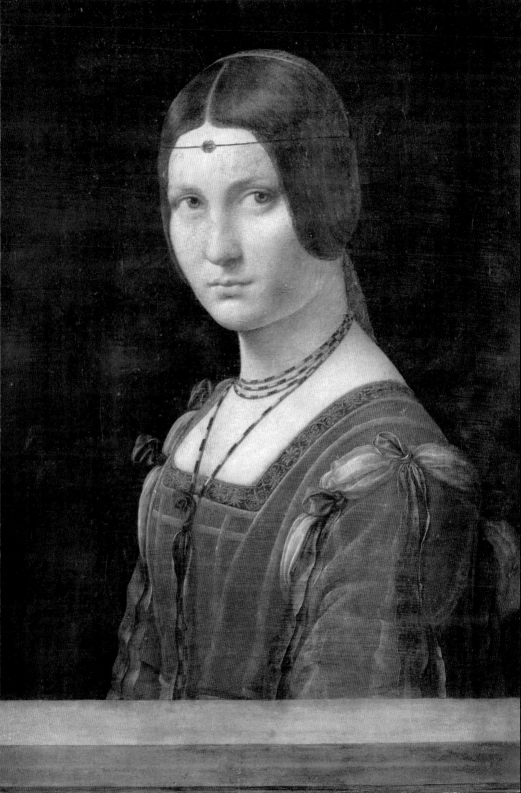

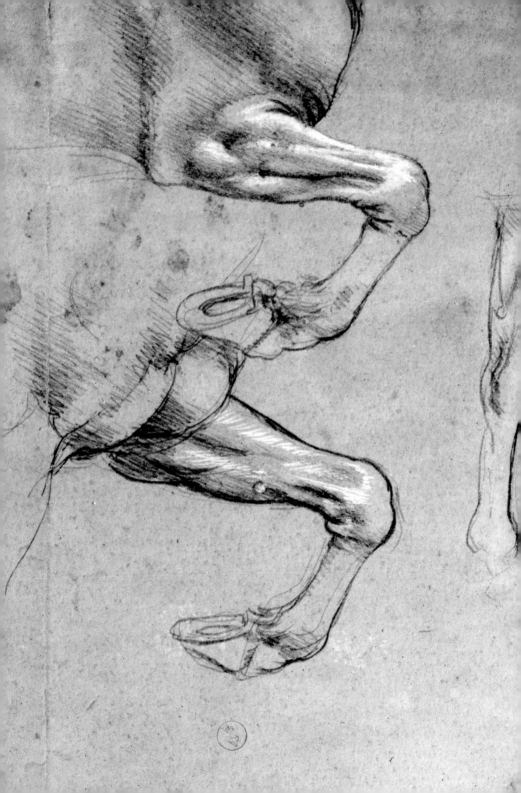

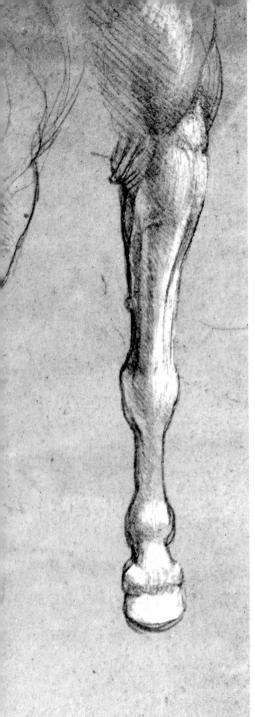

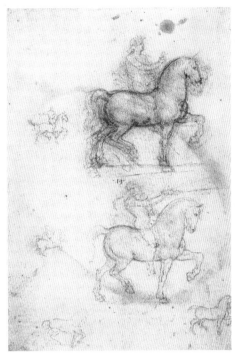

LEFT
Studies of horses' legs
Leonardo da Vinci
c. 1490
In a letter of introduction, Leonardo had loftily informed Sforza, "I can carry out sculpture in marble, bronze, or clay." His major sculptural work for the Milanese was to be a monumental equestrian statue, *Il Cavallo*, of the duke's father.

ABOVE
Study for the Sforza monument
Leonardo da Vinci
c. 1485–90
Leonardo made numerous sketches and studies, and may even have constructed a small version of the statue in clay, but got no further. Indeed, the iron set aside for the monument was eventually put to use to make cannons when the French invaded Italy only a few years after Leonardo began the work.

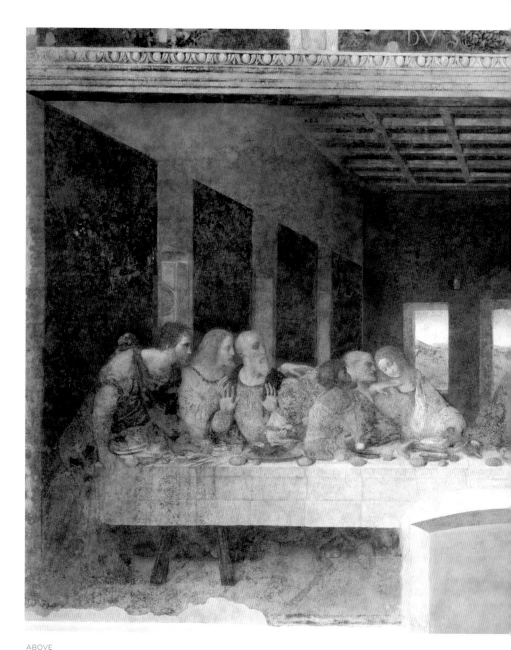

ABOVE
The Last Supper
Leonardo da Vinci
1495–98

Near the end of Leonardo's time in Milan, he was commissioned by the duke to paint a fresco of the Last Supper in the refectory of the Church of Santa Maria delle Grazie, which Sforza had chosen as his family chapel. In this celebrated work, Leonardo captured the drama and gravity of this biblical scene by condensing several moments into one image—we see the shock on the faces of the apostles even as Jesus is announcing his coming betrayal.

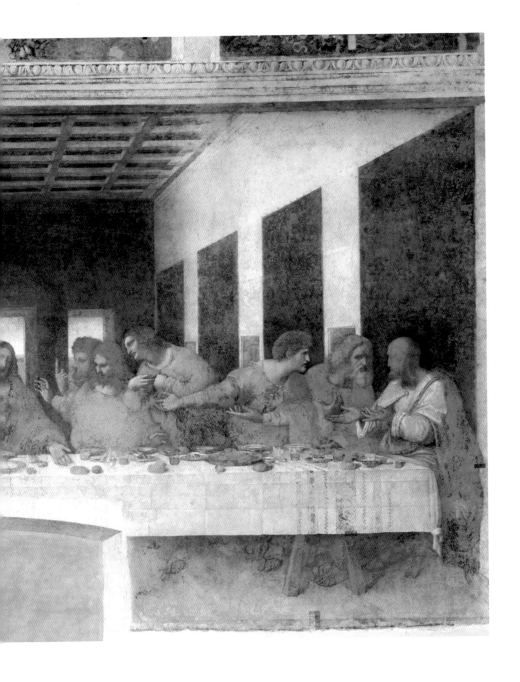

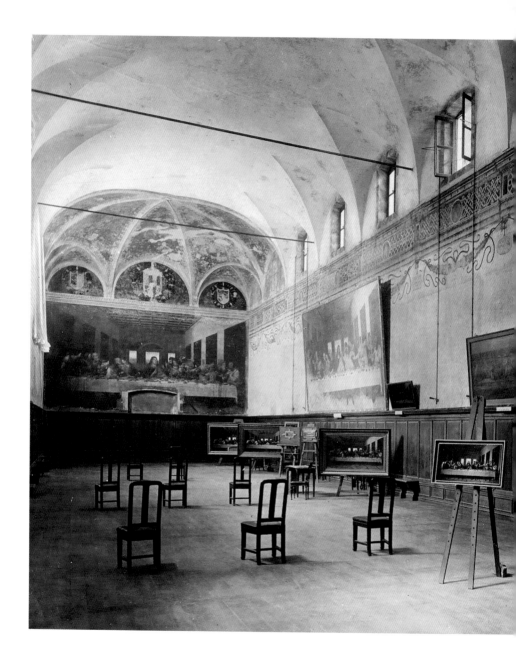

Interior of the Church of Santa Maria delle Grazie
Despite Leonardo's talent, he had difficulty with his materials. The extreme deterioration of the fresco of *The Last Supper*, seen on the far wall, may have occurred in part because the combination of oil and tempera paints used was not suited to plaster. Despite this, the fresco has enthralled viewers for centuries.

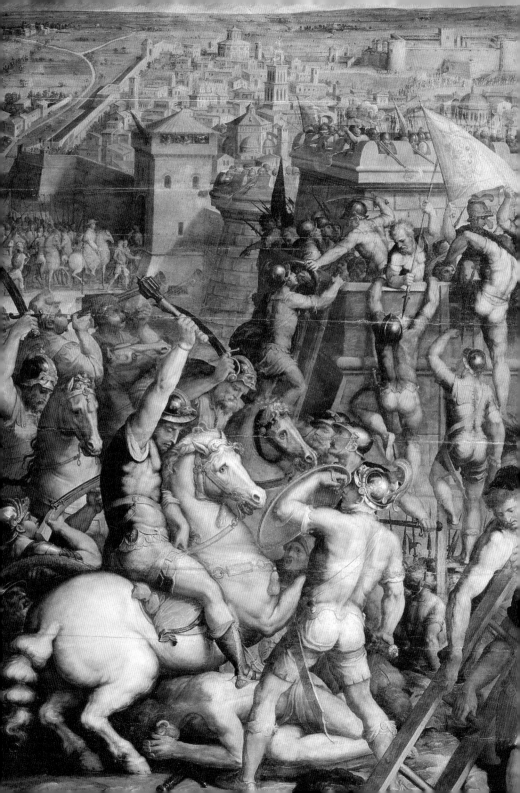

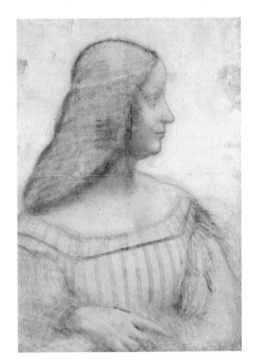

LEFT
The Capture of Milan by the French Army
Giorgio Vasari and assistants
c. 1560
In December 1499 the French defeated Lodovico Sforza
and occupied Milan, depriving Leonardo of a patron.

ABOVE
Isabella d'Este
Leonardo da Vinci
1500
Leonardo left Milan, traveled through Tuscany, and went
on to Venice, stopping for a time at the court of Mantua,
home of the formidable marchioness Isabella d'Este.
Isabella had been angling for a portrait by Leonardo for
some time—she had even had *Lady with an Ermine*
sent to her to judge his skills. This sketch is as far as
Leonardo got with fulfilling Isabella's request.

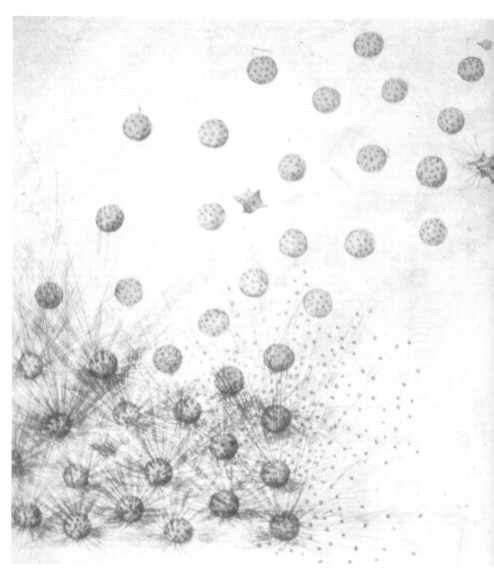

Drawing of exploding cannonballs
Leonardo da Vinci
late 1490s
Still without a patron, Leonardo joined Cesare Borgia,
son of Pope Alexander VI, in his campaigns in central
Italy during the summer of 1502. History doesn't tell us
how useful Leonardo may have been to Borgia, but he
certainly produced many designs for fearsome weapons
and other military machines.

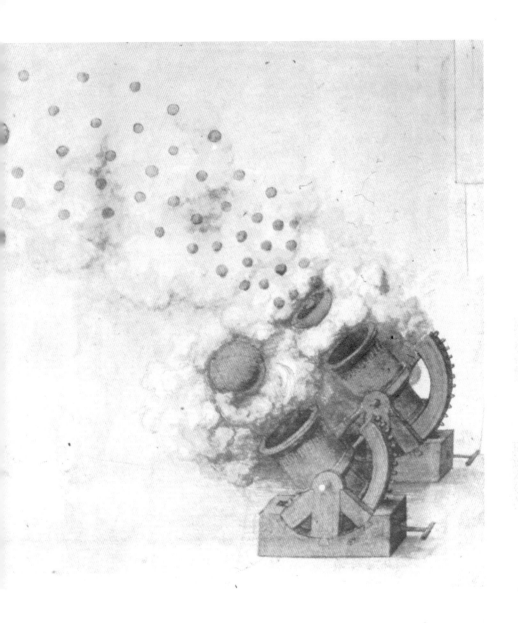

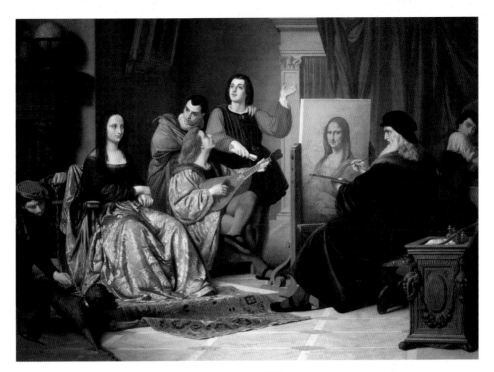

Piazza della Signoria, Florence
Leonardo's stint with Cesare Borgia did not last long.
Weary, perhaps, of battlefields, he returned to Florence
in 1503.

Leonardo Painting the Gioconda
Cesare Maccari
1863
In Florence in 1503, Leonardo started work on the
Mona Lisa. Here, a nineteenth-century artist imagines
the scene as the master paints Madonna Lisa,
most probably Lisa Gherardini, the wife of Francesco
del Giocondo.

Studies of the movement of water
Leonardo da Vinci
c. 1513–14
Among Leonardo's recurring motifs were knots and other
ornate patterns, such as the intricate swirls in these
water studies. By this time Leonardo's reputation as an
artist and inventor was well founded. His interest in
the movement of water may have been spurred initially
by a project from this period, when Florence was at
war with neighboring Pisa from 1503. The powerful
Niccolo Machiavelli had enlisted Leonardo's help in a
scheme to divert the Arno and force Pisa to surrender.

Study for *The Battle of Anghiari*
Leonardo da Vinci
1503–04
Following successes against Pisa, Leonardo took on a
major commission to paint the Florentine victory at the
battle of Anghiari on the walls of the Grand Council
Chambers of the Palazzo Vecchio. Michelangelo was to
produce the companion piece, *The Battle of Cascina*.

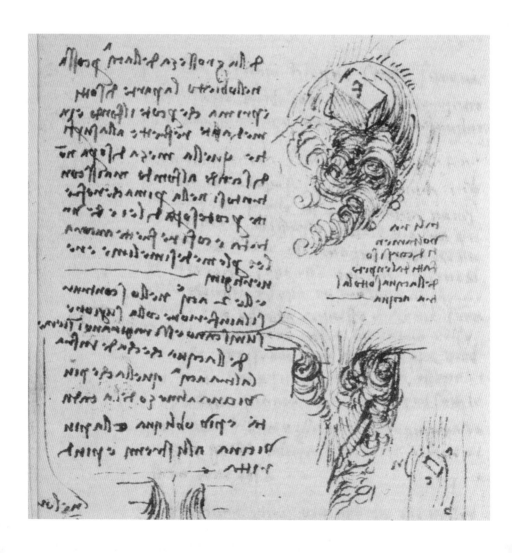

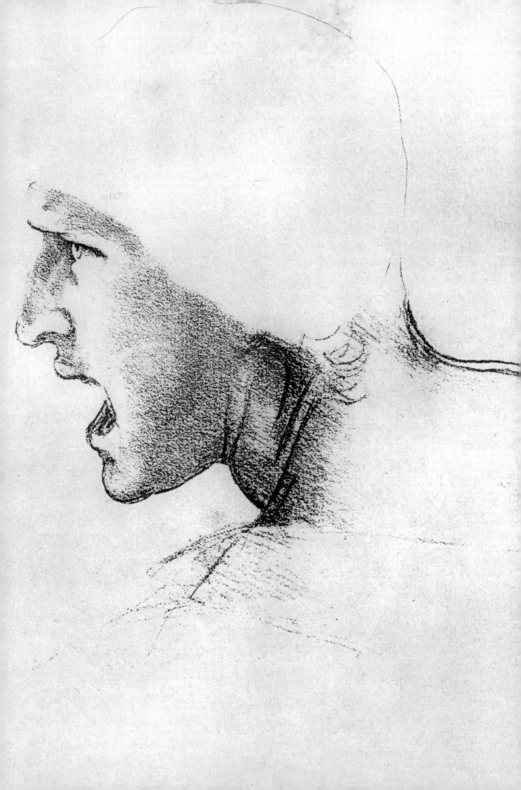

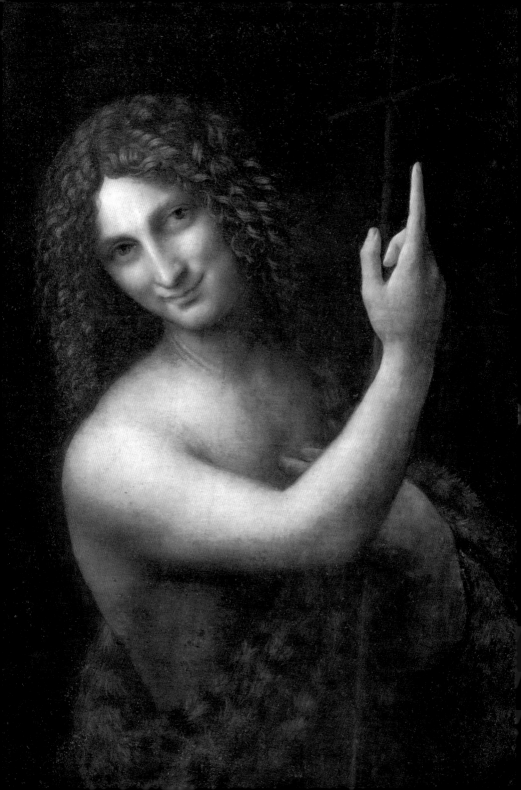

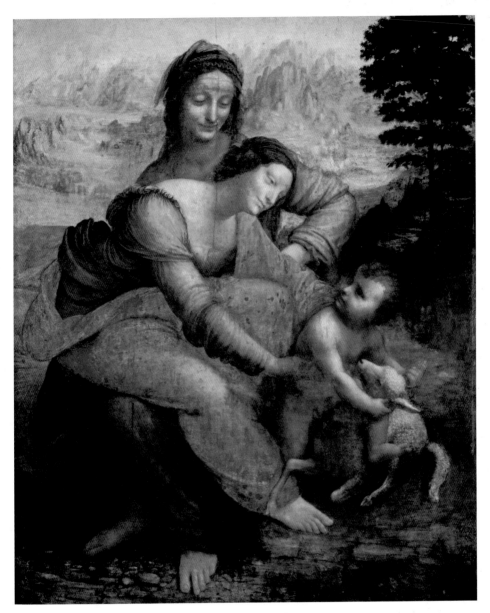

Saint John the Baptist
Leonardo da Vinci
1508–13
Scholars have long commented on the androgyny of
many of Leonardo's subjects. Here Saint John emerges
from a smoky *sfumato* background, smiling and in a
coquettish pose, not at all typical of paintings of the saint.
The same suggestion of androgyny appears in both the
Mona Lisa and *The Last Supper*.

Virgin and Child with Saint Anne
Leonardo da Vinci
1508
Here Leonardo continues his experiments with
movement and with the positioning of figures. The
interaction between each of these three figures creates
a sense of continuity that draws the eye from one
to the other, taking in the complex relationship among
them as well as the whole scene.

View of Rome

After some time spent traveling between Florence and Milan, Leonardo moved to Rome in 1513 at the invitation of Giuliano de' Medici, brother of the newly elected Pope Leo X.

Saint John (Bacchus)
Leonardo da Vinci
c. 1510–15

In Rome, Leonardo explored the theme of John the Baptist for a second time. This painting of the saint, sometimes identified as Bacchus, is also the artist's last known work.

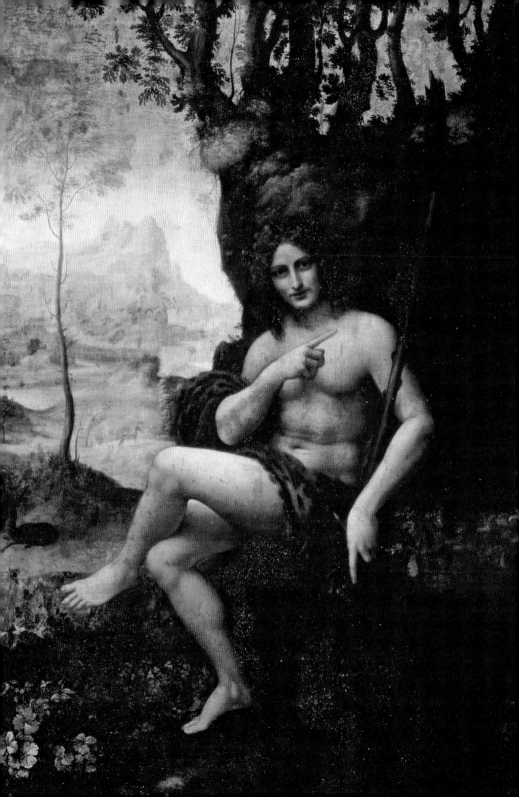

1516

1700

LEONARDO WAS UNABLE TO FIND PATRONS worthy of his rank in the rival city-states of Italy. The competition was overwhelming. In Venice, then the richest and most vibrant city in Europe, Titian ruled supreme, having been appointed in 1516 the official painter to the Venetian republic. In Rome the Pope had found Leonardo unreliable because he did not finish any of the paintings for which he'd been commissioned, and, in any case, the Pope preferred Raphael, who, at the age of thirty, was the rising star. Michelangelo, now forty, was widely regarded, after the feat of the Sistine Chapel, as the supreme artist in Italy, unparalleled in both sculpture and painting. So Leonardo left Italy for France and went to Amboise, to the court of King François I. France—not yet Europe's artistic center—was the best Leonardo could get.

And perhaps Leonardo was the best François could get, for the king had already tried and failed to convince the prolific and active Titian and Michelangelo to come to France. François gave Leonardo an ample annuity and a comfortable manor house, Clos Lucé, linked by a narrow passage to the royal residence, the castle at Amboise. There the now-elderly man basked in the admiration of a powerful king besotted with all things Italian. He had the peace and quiet he needed for the research and writing he most enjoyed. To earn his keep, Leonardo became a court decoration for the greater glory of François, organizing costumes for masquerade parties, drawing whatever took his fancy, and devising mechanical horses and other toys. He had completely lost interest in painting.

But Leonardo had a few of his paintings with him in France, including the *Saint John (Bacchus)*, the *Virgin and Child with Saint Anne*, and the portrait of a "Florentine lady"—the *Mona Lisa*.

The *Mona Lisa* had made an immediate impression on contemporary artists and historians. Giorgio Vasari, in his famous

essays on Renaissance painters, devoted more lines to this one work than to any other and observed: "The execution of this painting is enough to make the strongest artist tremble with fear." Raphael admired it and incorporated many of its innovations into his own works. It was seen as a revolutionary painting in its own time and centuries later the perception of intrigue and mystery would add to its appeal. What characteristics in particular made the *Mona Lisa* so special?

Let's begin with the painting itself. It's much smaller than most people expect, just under 31 by 21 inches, painted in oil on poplar wood. The *Mona Lisa* we see today at the Louvre is not quite the same as that painted by Leonardo. As with other Renaissance paintings, the colors are now not as bright as they were, and the gradual yellowing of the varnish has made the portrait dark, even gloomy. The curators at the Louvre say it's in fine condition, and the surface sports some half-million cracks. No one wants to tamper with any restoration work and risk wiping the smile off the famous face.

The young woman in the painting sits in a chair on a balcony, overlooking a strange, craggy landscape. The arm of her chair is parallel to the picture plane, as is her torso. But she turns to the viewer and looks directly ahead, her dark eyes slightly to the right. Her cheeks are full; her forehead wide and without eyebrows; her lips together, with just a hint of a smile at the left corner. Her left hand clasps the arm of her chair, and the slender fingers of the right hand fall gracefully over the other. She wears a translucent veil over her hair, her dress drapes in simple folds, and a mantle falls from her left shoulder.

The background behind the sitter is reminiscent of that in Leonardo's *Virgin of the Rocks* and *Virgin and Child with Saint*

Anne. In portraits, such completely imaginary landscapes were rare, for the purpose of the landscape was to help identify the sitter. When Renaissance painters included the hands of the sitter, they, too, usually had a similar function: by holding a symbolic object, they provided a further clue to the sitter's identity. Leonardo himself had planted clues in other portraits, as we have seen—in his *Ginevra de' Benci* and his *Lady with an Ermine* as well as the *Portrait of a Musician* he painted in Milan. But Mona Lisa holds nothing in her hands, wears no jewelry, and has but a simple dress. There is nothing in the painting to tell us who she is.

Leonardo left behind thousands of preparatory drawings and detailed notes about all aspects of his life, yet there is not a single preliminary sketch of the *Mona Lisa* and not a mention of it in his notebooks. This uncertainty contributes to the mystery surrounding the *Mona Lisa.* When the sitter is a lady of some importance, identification is simple. Contracts are exchanged and records are kept. Those who commission the painting get it and keep it. Yet despite the uncertainty about the woman portrayed, there has never been doubt that Leonardo painted the portrait.

Vasari identified the woman as Lisa Gherardini. His description was probably written in 1547 and appeared in his huge publication, *The Lives of the Most Eminent Painters, Sculptors, and Architects* (1550). Vasari also tells us that Leonardo started working on the portrait after his return to Florence from Milan in 1500 and that it took him four years to complete.

Who was Lisa Gherardini? The registry of San Giovanni confirms she was born in Florence in 1479. At sixteen she was married to a man nineteen years older and twice widowed: Francesco del Giocondo, a Florentine notable. In 1503 Francesco moved with his family to a new house, and he may have taken this opportunity

to ask a leading artist looking for a commission to portray his young wife.

In our democratic age, some people may find it appealing that the wife of an ordinary merchant and mother of two children has been transformed into a global icon that graces mugs, calendars, T-shirts, and mousepads. Others, however, have hoped for someone more suitable and more aristocratic. Perhaps she was Isabella d'Este, whom Leonardo had already sketched, or Costanza d'Avalos, Duchess of Francavilla, or perhaps the beautiful Isabella Gualanda, or Pacifica Brandano, the mistress of Giuliano de' Medici. But the weight of the evidence—slight as it is—points to Lisa Gherardini. When Vasari wrote his commentary on the painting, both Francesco and Lisa were still alive and he lived quite close to them in Florence, so it's possible he knew them and heard details of the sittings with Leonardo from Lisa herself.

Does the *Mona Lisa* possess intrinsic qualities as a work of art? In Leonardo's lifetime, the painting was regarded as a masterpiece because of the originality of the technique used, the innovative pose adopted by the sitter, and, in Vasari's words, the fact that it was "true to life." Almost immediately, other artists tried to incorporate these characteristics into their own work.

Mona Lisa's translucent veils add depth to the painting. The numerous ripples of the garments, the rivulets of drapery falling from her shoulders, and the spiral folds of the mantle across the left breast highlight the close spatial relationship between the sitter and the sinuous landscape in a way that was very unusual. The barely perceptible columns at either side of the figure frame the portrait, making it a picture within a picture. The background is asymmetrical, the right side being a little higher than the left. Behind the balcony on which Mona Lisa is sitting are rocks, lakes,

and streams, but no trees or plants. The sole human structure is on the right-hand side: a bridge. The landscape is constructed vertically, the depth being obtained by scanning it from top to bottom, like a Chinese painting where the base is foregrounded.

Conventional Renaissance portraits usually represented the sitter in profile. Here, though, the figure presents a three-quarter view while the face looks directly at the viewer. Other artists painted women with downcast eyes. Mona Lisa looks back, challenging the insolence of the male gaze. It's as though Leonardo had called to her: Lisa turns her face completely until she looks right at him. Her upper body remains halfway through the movement—a position known as *contrapposto*. In this way, Leonardo "captured" the moment. Already in *The Last Supper* he had attempted to freeze a particular moment of a narrative—the reaction of the disciples to Jesus's announcement that one of them will betray him. This technique almost fuses two chronologically distinct moments into one. We "see" the reaction, but we deduce from it the dramatic preceding moment.

The representation of movement in art had previously been employed in sculpture. Michelangelo used it to great effect in his *David*. But Leonardo wanted to show he could represent movement in a two-dimensional form. The solution was not to use a static pose but a single moment in sequence—much like a photograph of an object in movement. Because the visage of the sitter faces a point different from that facing the torso, the entire body seems to be in movement. Mona Lisa is now a person in motion, and her figure appears to have the volume of a third dimension.

Leonardo had experimented with the contrapposto previously, notably in the portrait of Cecilia Gallerani, *Lady with an Ermine*, where not only the sitter is in movement but also the furry animal.

But Cecilia looks away from us and the background is dark, and he found he didn't achieve the full effect he wanted.

The technique Leonardo used in the *Mona Lisa* to achieve volume required many layers of paint. This factor alone helps to explain the length of time he took to paint the portrait—he was forced to wait between layers for the paint to dry. The *sfumato* (literally "smoky") technique Leonardo pioneered here consisted in building up layers of paint from dark to light, letting the previous one come through in order to achieve, through a play of shadows and lights, the optical illusion of a relief. Leonardo's contemporaries were impressed by the sfumato. It appeared to solve the problem all artists encountered of losing a sense of depth in their paintings as they moved from one color, or one gradation of light, into another. Most notably, Leonardo applied his sfumato to the corners of the Mona Lisa's eyes and mouth, the main identification points of her facial expression. The blurred effect produced an uncertain look. It is not quite clear whether she is sad or happy, whether she is smiling or not, or what kind of smile she has. This tone of mystery would add considerably to the charm of the picture in the nineteenth century, when paintings came to be regarded as harboring an essence that had to be interpreted.

The smile of the Mona Lisa is, in some ways, reminiscent of other smiles painted by Leonardo, such as that of Saint Anne and the Virgin Mary, of the Madonna on the Rocks, and of two other figures in paintings now at the Louvre, Bacchus and Saint John. But it is also very different, as it's far more subtle and complex. Vasari explained it all quite practically by saying that Leonardo had Lisa "constantly entertained by singers, musicians, and jesters so that she would be merry and not look melancholic, as portraits often do." The idea that there was something enigmatic

about the smile came much later. For Vasari, the smile was "so enchanting that it was more divine than human." Finally, in this painting, Leonardo perfected the use of the pyramid composition, where the sitter's hands provide the base, with her head at the apex. This structure gives the painting a monumental appearance. The painting might be small, yet Mona Lisa seems to tower over the mountainous landscape behind her. He also used very fine brushes in painting this portrait, and, even under a microscope, no brushstrokes are evident on the originally very smooth surface.

The *Mona Lisa* should be seen as the culmination of Leonardo's many fine portraits. It had taken twenty-five years, since painting Ginevra de' Benci, for Leonardo to perfect the pose and to blend it with an appropriate landscape. Mona Lisa is elegant, though she wears a simple dress. She is nonchalant without being arrogant. The uncertainty of her smile is reflected in the uncertain feelings of the viewer toward the painting. Barely perceptible, the smile forever intrigues.

Leonardo's own talented contemporaries were certainly impressed by this painting. Raphael may have seen only a preliminary drawing of the *Mona Lisa*, yet he was enraptured by it. Immediately he made a drawing, *Young Woman in a Loggia*, which uses exactly the same contrapposto pose as that of the *Mona Lisa*. Satisfied with the effect, he repeated it again and again in his portrait of Maddalena Doni, in *Lady with a Unicorn*, in *La Muta*, in *La Donna Velata*, and in his magnificent portrait of Baldassare Castiglione, which now hangs in the Louvre not far from the *Mona Lisa*. He also experimented with Leonardo's pyramid composition in his paintings.

After Leonardo died in 1519, the *Mona Lisa* found its way into the collection of the French king. We don't know if François

bought it directly from Leonardo or from his chosen heir, but only that he paid a considerable sum for it. Now part of the Royal Collection, the *Mona Lisa* was on display for visiting artists, writers, and tastemakers.

In the centuries before the invention of photography and of the means of reproducing color, the only way an artist could become well known was through the production of copies. These replicas also provided younger artists with examples from which to learn the techniques of the established classics. Without constant copying, there could be no artistic development. Every imitation was regarded as a tribute to the artist and was highly valued in other collections.

We know that Leonardo was widely admired in the sixteenth and seventeenth centuries because of the number of copies that were made of his works—including almost sixty of the *Mona Lisa* alone. Rembrandt was struck by copies he saw of *The Last Supper* and made his own sketch of it. In Lombardy, where Leonardo had many followers, imitators abounded at this time. Some of this group also wrote enthusiastically about his work, contributing to the expansion of his fame. Some of Leonardo's pictures, including the *Mona Lisa*, were copied on canvas between 1594–1600 when Henry IV restored the Appartement des Bains in the royal household of Fontainebleau where they were hung.

Some of the copies from the sixteenth and seventeenth centuries were likely commissioned by ladies who asked to be painted in the *Mona Lisa* style. The racy esthetic at Fontainebleau even inspired a series of nude or partly clothed Giocondas, with the figures posed in the classic contrapposto position, along with the now traditional folded hands. What all this copying suggests is that the term *Joconde* or *Gioconda* had come to stand for any

female portrait using a pose vaguely similar to that of Leonardo's famous original. A handwritten note in the inventory of one Jean-Baptiste de Champaigne (1681) stated the presence of "une Joconde daprés Leonard Davency." The inventory made on December 30, 1701, of the estate of Marie Boncot, wife of Jacques Benoist, counselor at the Cour des monnaies, contained an entry stating, simply, "une Joconde."

Paradoxically, though, as copies proliferated—some commissioned by the French Crown—the *Mona Lisa* itself was falling from favor. In 1625 Louis XIII was even prepared to accept a two-for-one swap with Charles I of England, a sophisticated patron of the arts. Charles I had sent the Duke of Buckingham to France to accompany Louis's sister Henrietta Maria back to England to be his bride, but he also proposed a deal in paintings on the side. The French would give Charles the *Mona Lisa* and receive in return both *Erasmus* by Holbein and a Holy Family by Titian. Louis was tempted to accept, but his courtiers intervened. The *Mona Lisa* was, they claimed, one of Leonardo's best pictures. It should not leave France. Louis accepted their advice and gave Leonardo's *Saint John* to the deeply disappointed duke. After Charles's execution and the sale of his collection, the banker Everhard Jabach brought *Saint John* back to France and sold it to Louis XIV for the same sum he had paid: 140 pounds. It, too, is now in the Louvre, near the *Mona Lisa*.

Though mentioned by Rascas de Bagarris (1567–1620) in his list of "les plus rares peintures de Fontainebleau" (1608–10), by Cassiano dal Pozzo in his diary (1625), and by Pierre Dan, the Father Superior of the monastery of Fontainebleau, in his 1642 inventory of the "Treasures and Marvels of the Royal Household of Fontainebleau," when Roger de Piles classified paintings in

ABOVE
Map of the Loire Valley, France
Leaving the turmoil of Italy behind, Leonardo traveled to
Amboise in the Loire Valley after accepting an invitation
from the French king, François I, to be his "First Painter,
Engineer and Architect."

RIGHT
The Seigneurial Life: The Promenade
late 15th century
The French court, while perhaps not yet as sophisticated
as the Italian courts, was becoming increasingly literate,
cosmopolitan, and appreciative of art and music.

FOLLOWING SPREAD
The School of Athens
Raphael
1510–11
Leonardo had not been the king's first choice for court
artist. Yet younger Italian painters, including Raphael
and Michelangelo, considered him a great genius.
Raphael likely cast Leonardo as Socrates, the principal
figure in his *School of Athens* (at center left with his finger
raised), where he took pride of place among the artists
of the day, including Michelangelo and Bramante.

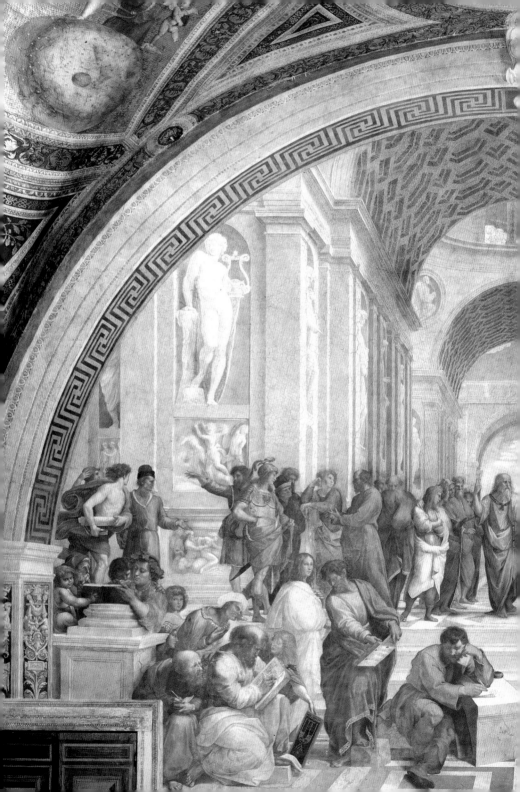

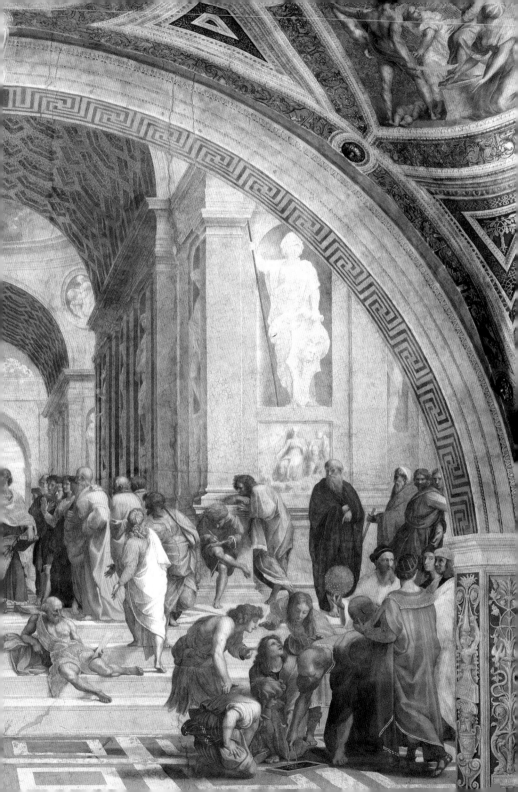

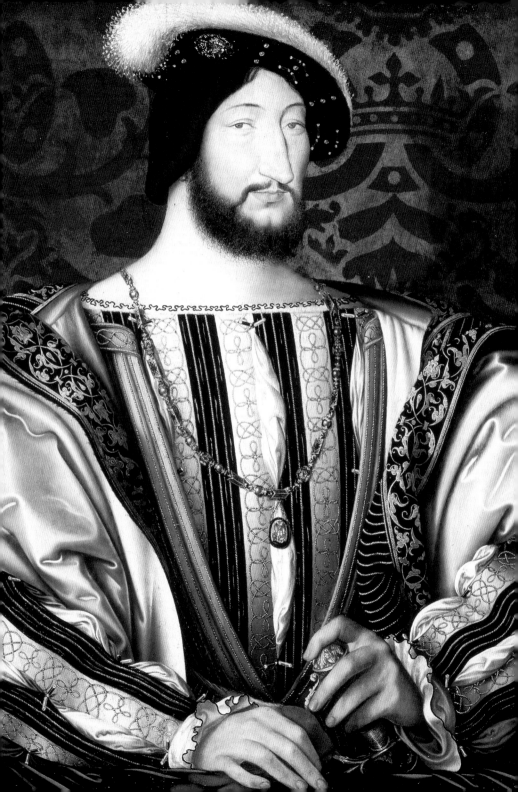

LEFT
François I
Jean Clouet
1525–30
The wealth, power, and personality of France's first true Renaissance king is evident in this masterly portrait. François and his court lived sumptuously, both at the principal royal residence at Fontainebleau and at a number of castles throughout the realm, including Amboise.

ABOVE
Clos Lucé
Leonardo was given this manor house near Amboise and a handsome stipend in exchange for relatively light duties.

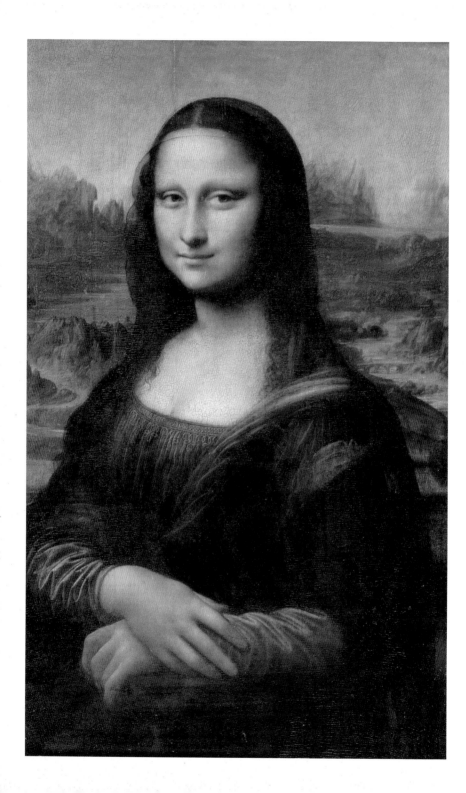

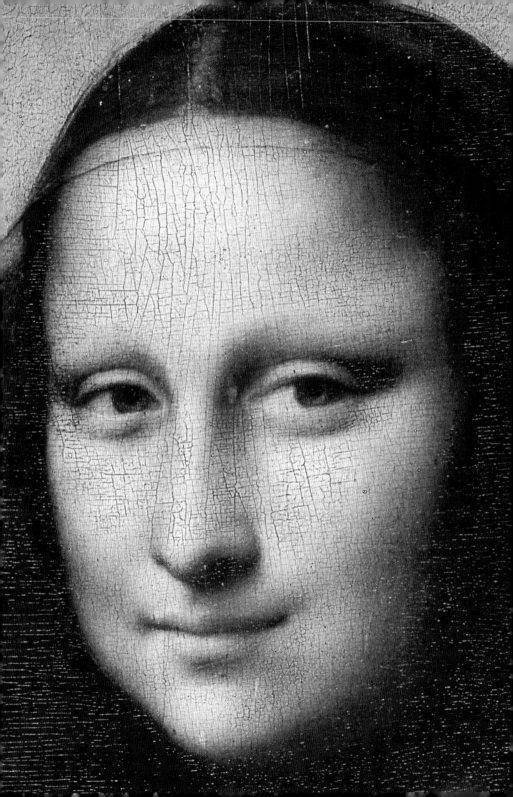

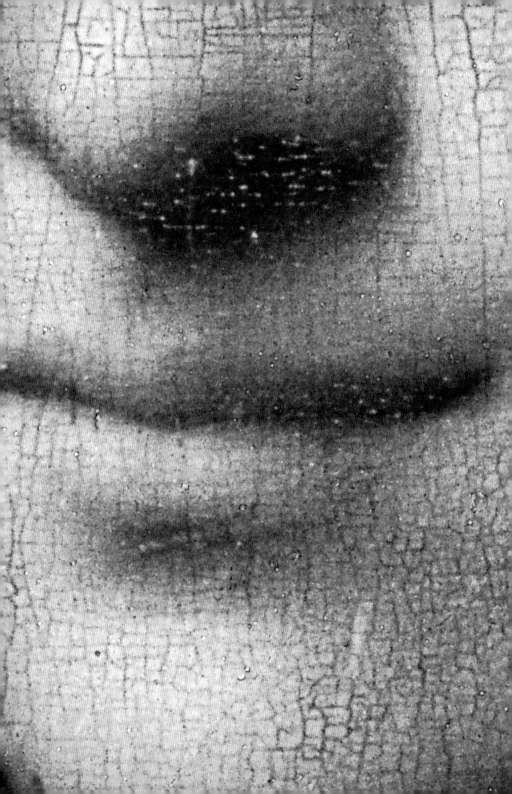

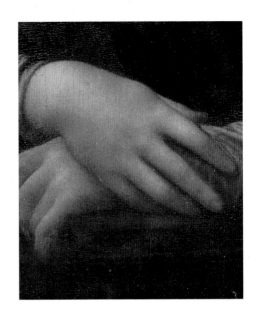

Mona Lisa
Leonardo da Vinci
1503–c.1507
By the time Leonardo arrived in France, his painting days were behind him. But he had a female companion with him—the *Mona Lisa*.

LEFT
***Mona Lisa*, detail of mouth**
Leonardo da Vinci
1503–c.1507
We do not know why Leonardo decided to keep the *Mona Lisa* with him. He may have felt that the painting, which incorporates all his innovations in style, was his masterpiece. The *sfumato* technique—the building up of many layers of paint to create a soft and rounded look—gave the face a fleeting, mobile quality, particularly around the mouth.

ABOVE
***Mona Lisa,* detail of hands**
Leonardo da Vinci
1503–c.1507
The painting was also remarkable because portraits of this time usually didn't show the subject's hands. When they did, the sitter often held a symbolic object. Mona Lisa's hands are empty. But they are essential to the composition of the painting, where they form the basis of a pyramid, with her head at the apex.

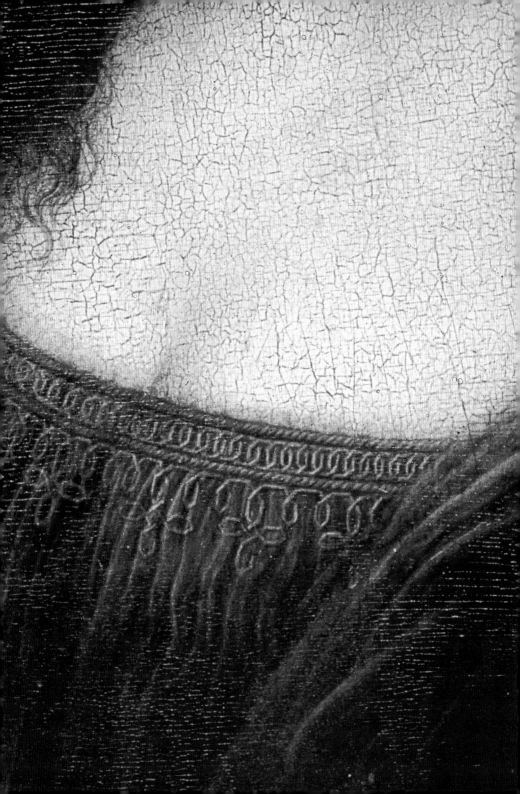

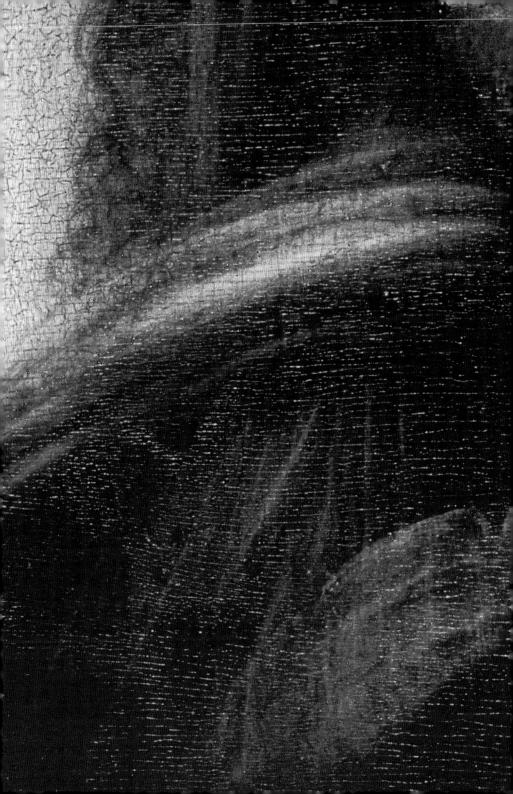

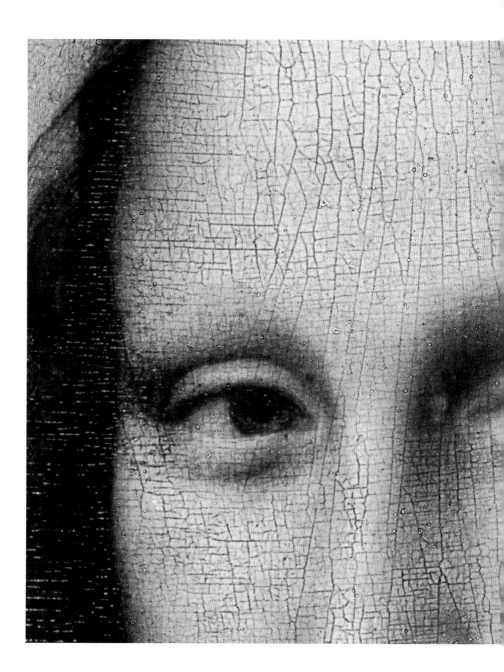

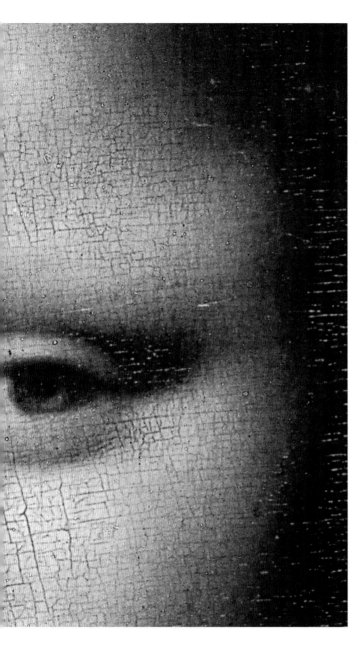

PREVIOUS SPREAD
***Mona Lisa,* detail of mantle**
Leonardo da Vinci
1503–c.1507
Leonardo's mastery in depicting intricate folds and drapery is evident in the many pleats and tucks of Mona Lisa's garments.

LEFT
***Mona Lisa*, detail of eyes**
Leonardo da Vinci
1503–c.1507
Leonardo had once stated that the gaze of a female subject in a painting should never meet that of the viewer but should, instead, be cast modestly downward. Obviously rules—including his own—were made to be broken. The result is Mona Lisa's direct gaze, which almost, but not quite, crosses the viewer's and has captivated admirers for centuries.

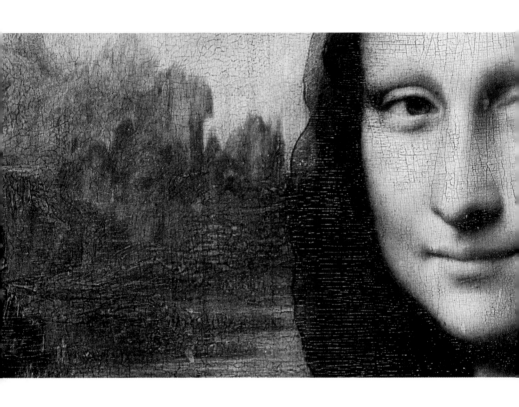

Mona Lisa, detail of left and right background
Leonardo da Vinci
1503–c.1507
Most portraits of the period include a harmonious, realistic background, often connected to the life and world of the sitter. The *Mona Lisa*, with its asymmetrical, dreamy landscape, once again departs from tradition.

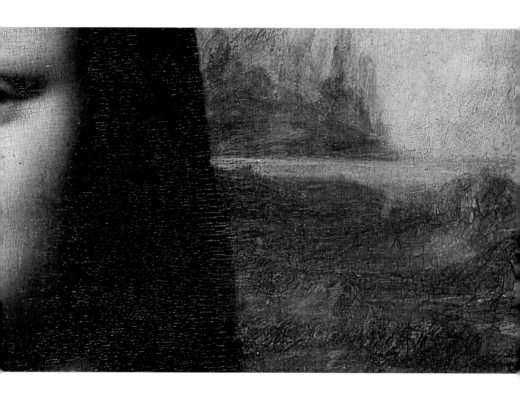

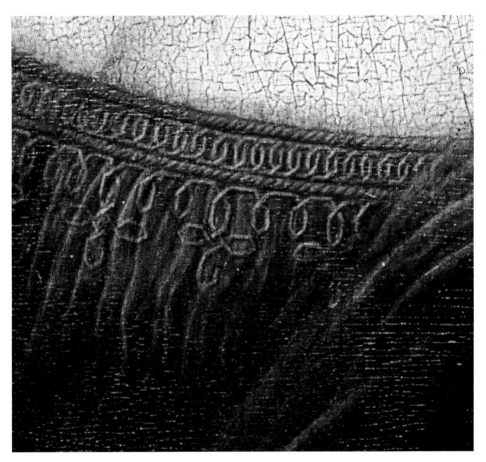

Mona Lisa, detail of dress
Leonardo da Vinci
1503–c.1507

Do the intricate knots bordering Mona Lisa's bodice contain some clue to her identity? Because the painting holds no discernible hints about the sitter—no Latin text or motto, no symbolic object—viewers have long read much, perhaps too much, into every detail.

Drawing of knots
Leonardo da Vinci
c. 1487

Knots and other puzzle-like drawings fascinated Leonardo. Sketches of knots such as these abound in his notebooks and can also be found in *Lady with an Ermine*.

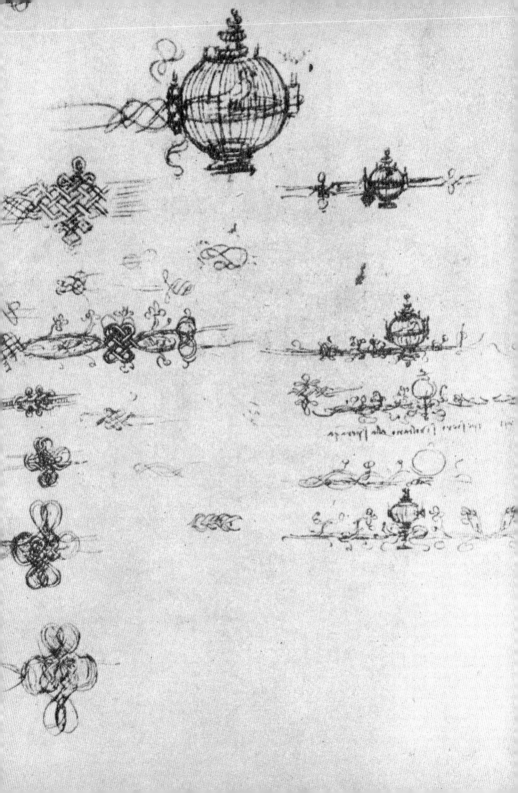

LEFT
Saint Jerome
Leonardo da Vinci
1483
In Renaissance portraits, the background usually
contains clues about the subjects and their world.
In Leonardo's *Saint Jerome,* the background bears
a striking resemblance to the rocky landscape that
appears in the upper right corner of the *Mona Lisa*.

ABOVE
***Mona Lisa*, detail of background**
Leonardo da Vinci
1503–c.1507

ABOVE
Mona Lisa, **detail of background**
Leonardo da Vinci
1503–c.1507
What was the inspiration for the landscape behind Mona
Lisa? Was it based on a real location? In the delightful
work *Old Man with a Young Boy*, painted a decade earlier,
Domenico Ghirlandaio used a wandering river similar to
the one found in Leonardo's masterpiece.

RIGHT
Old Man with a Young Boy
Domenico Ghirlandaio
c. 1490

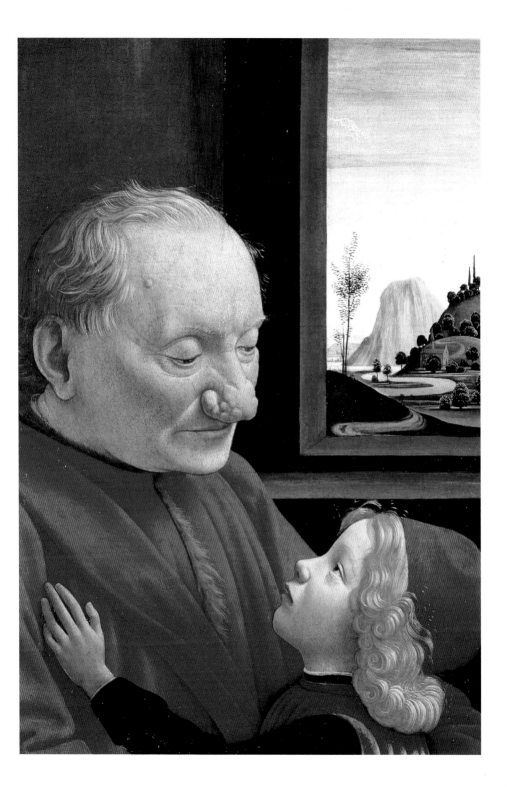

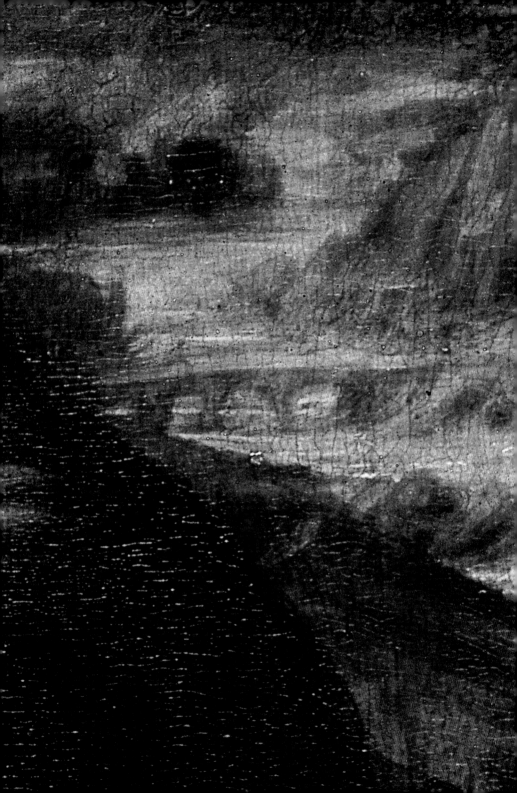

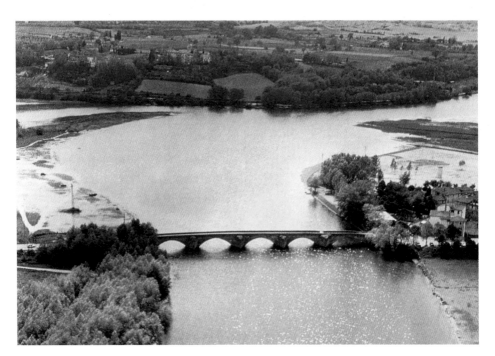

Mona Lisa, detail of background
Leonardo da Vinci
1503–c.1507
Perhaps Leonardo presented the landscape in the *Mona Lisa* as a romanticized view of the Tuscan countryside. Near the town of Arezzo stands the Buriano Bridge, which crosses the Arno. Built in 1277, its multiple spans bear a remarkable resemblance to the bridge depicted in Leonardo's famous painting.

The Buriano Bridge

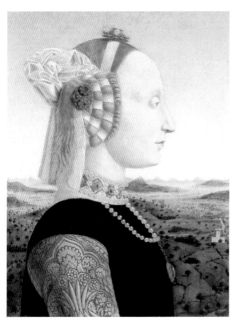

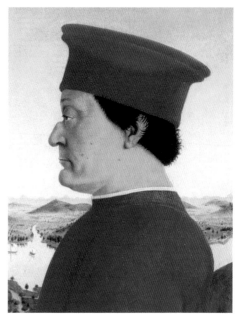

ABOVE
Battista Sforza (wife of Federico,
Duke of Montefeltro)
Piero della Francesca
1465–66

ABOVE
Federico da Montefeltro
Piero della Francesca
1465–66

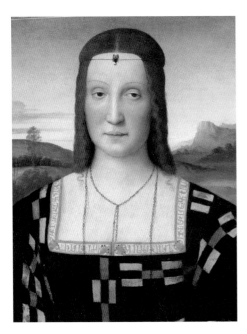

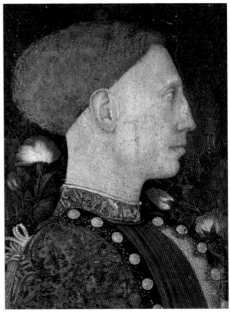

Portrait of Elisabetta Gonzaga
Raphael
1502–03

Lionello d'Este, Duke of Ferrara
Pisanello
1441

Portraiture before Leonardo's innovations had been static and posed. Most sitters were presented in profile or directly facing the viewer. Even masterly portrayals such as these were not able to convey the subject as a three-dimensional person, as the *Mona Lisa* does.

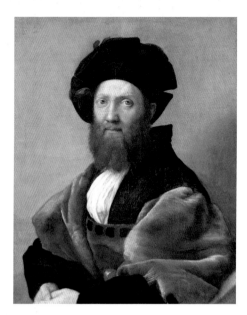

ABOVE
Baldassare Castiglione
Raphael
1514–16
Leonardo's peers loved the *Mona Lisa*, and its influence
on their art was noticeable almost immediately. Raphael,
who had seen an early version of the painting, borrowed
the contrapposto pose for many of his paintings, including
this portrait of Baldassare Castiglione and of the veiled
woman at right.

RIGHT
The Veiled Woman
Raphael
1514–16

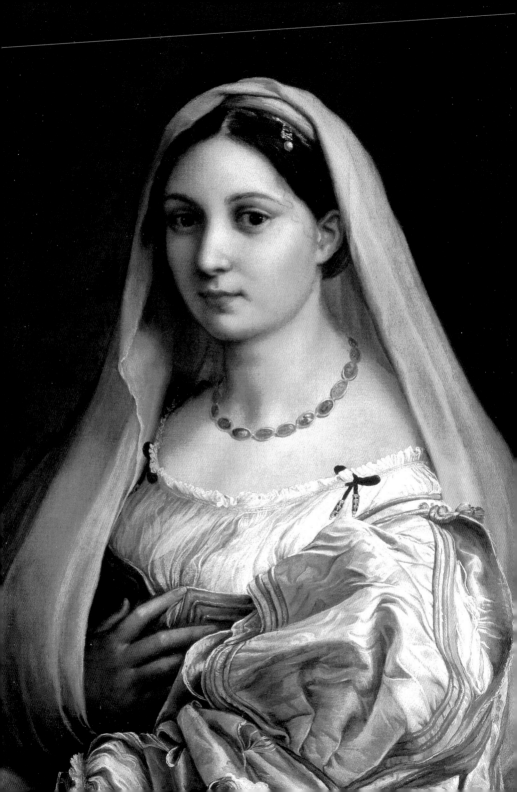

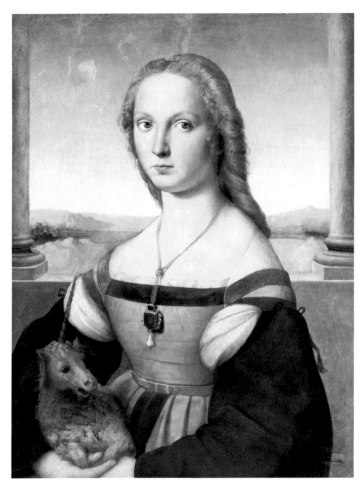

ABOVE
Lady with a Unicorn
Raphael
1505
In a double tribute to the master, Raphael here borrows both the *Mona Lisa*'s pose and the background details of Leonardo's painting.

RIGHT
Isabella d'Este
Titian
1536
Observers curious about Mona Lisa's true identity speculated she might be Isabella d'Este, whom Leonardo had sketched previously while spending time in her court at Mantua.

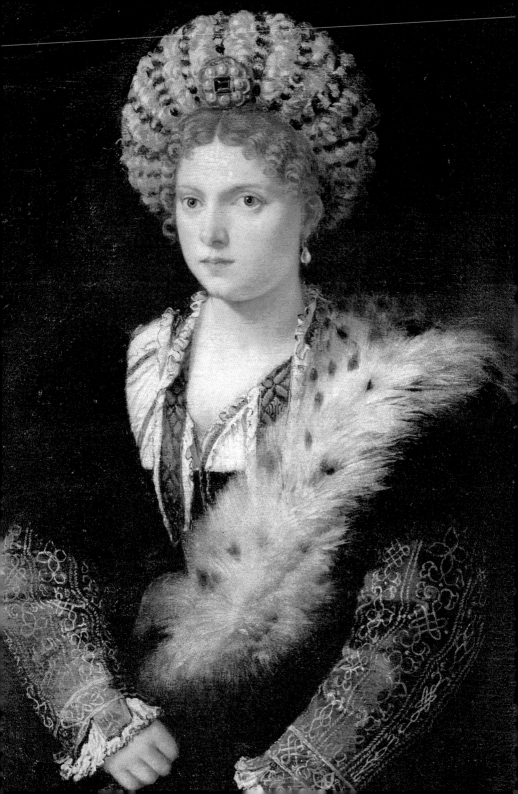

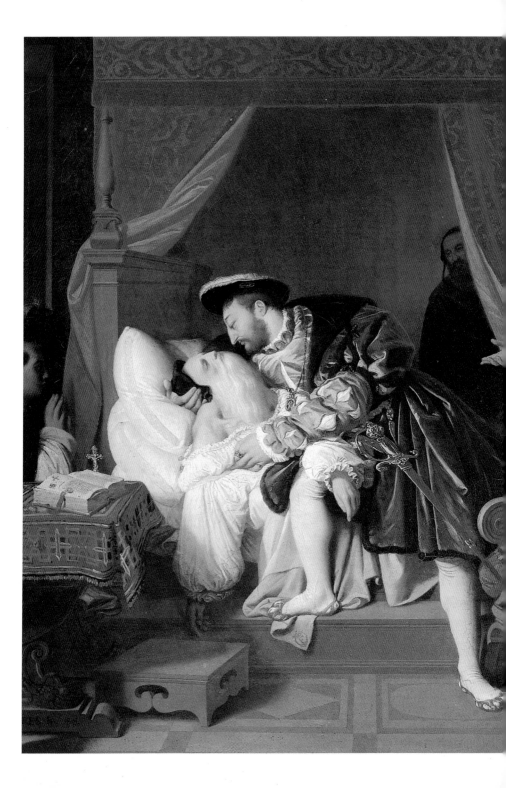

The Death of Leonardo in the Arms of King François I
Jean-Auguste-Dominique Ingres
1818

Leonardo died on May 2, 1519, a few weeks after his sixty-seventh birthday. Legend has it that François I, on learning that his resident genius was dying, rushed to Leonardo's bedside. The old painter struggled to sit up, apologized to the king for any shortcomings, and expired in his arms. Well, it *should* have happened that way, but evidently the king was not at Amboise at the time.

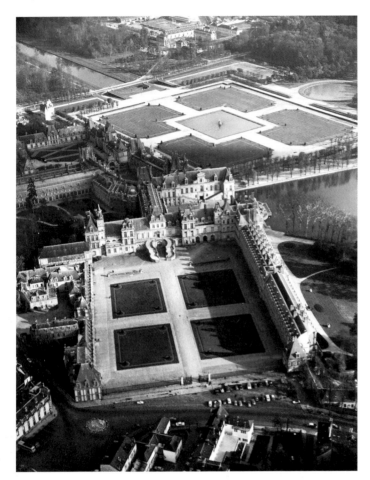

Palace of Fontainebleau
What happened to the *Mona Lisa* immediately after
Leonardo's death is still unclear today. Perhaps the
portrait remained in France and was sold to the king.
Perhaps it was taken to Italy by Leonardo's assistant,
Salai. When Salai died suddenly a few years later, his
sister sold off his estate, putting the works he owned on
the open market. Perhaps that is how François I gained
possession of the *Mona Lisa*. After acquiring the work,
the king found the perfect place for it in the Appartement
des Bains at Fontainebleau.

Monna Vanna, **after Leonardo da Vinci**
c. 1513
Mona Lisa inspired many "Gioconda-style" nudes,
especially once it had been hung in François's
bathhouse gallery.

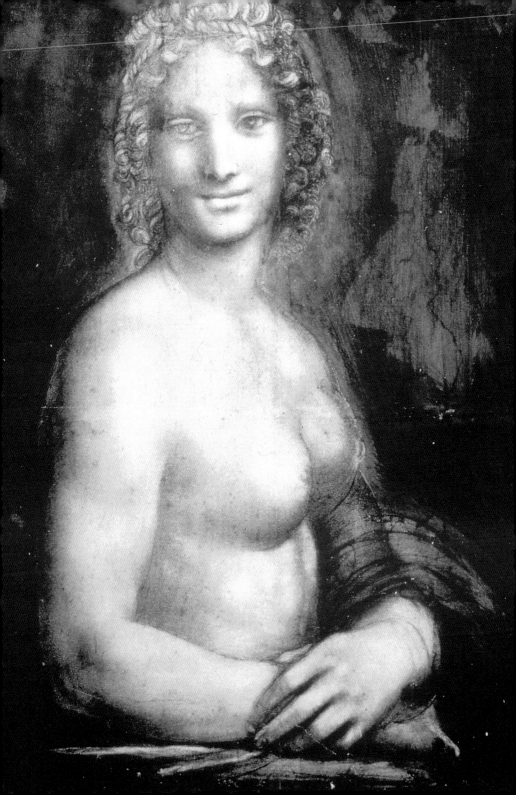

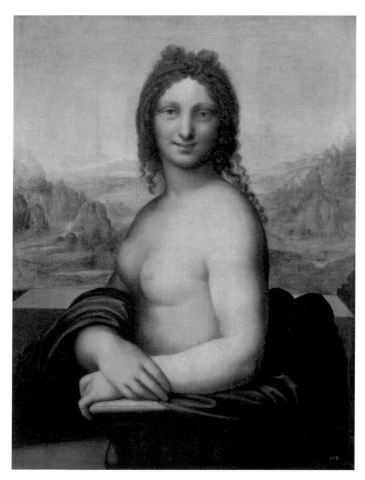

ABOVE
Nude Lady
late 16th century

RIGHT
Portrait of a Woman after the Mona Lisa
Jean Ducayer
17th century
The vogue for nude and clothed variations of the
Mona Lisa continued into the painting's second
century. Ducayer's homage appropriated Mona Lisa's
facial expression.

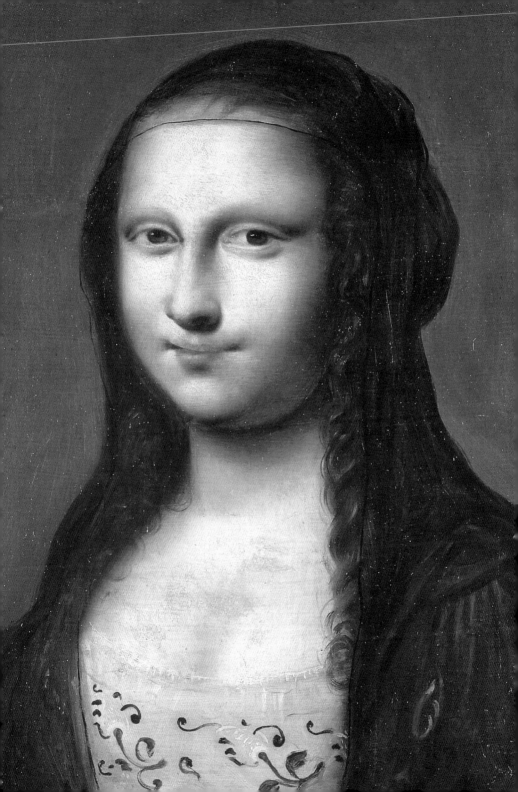

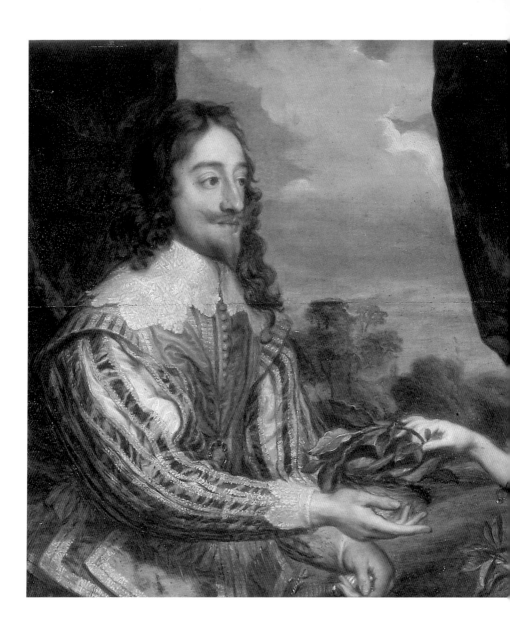

Charles I and Henrietta Maria with a Laurel Wreath
Gonzales Cocques
17th century
The *Mona Lisa*, now part of the Royal Collection, was
passed down from François I to subsequent kings of
France. Louis XIII considered swapping the painting for
two works in the collection of Charles I of England during
the marriage negotiations for his sister Henrietta Maria in
1625. Thankfully for France, the king's courtiers talked
him out of the trade, in which Louis would have received
Holbein's *Erasmus* and a Holy Family by Titian in
exchange for the *Mona Lisa*.

ABOVE
Erasmus
Holbein
1523

1701

1910

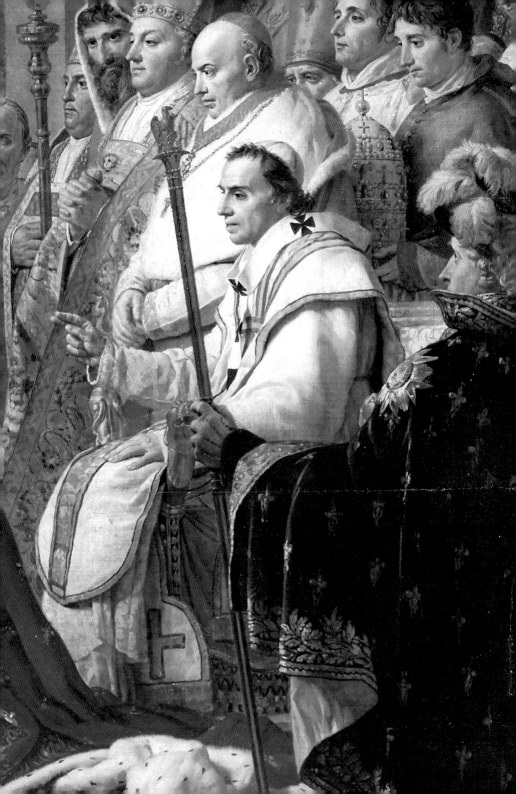

FROM NAPOLEON TO THE FEMMES FATALES

APPRECIATION FOR THE MONA LISA did not thrive in the decadent, Rococo esthetic of the eighteenth century. When the 110 "best" items of the Royal Collection were exhibited to a highly select group at the Luxembourg in Paris on October 14, 1750, the *Mona Lisa* was not among them. In 1695 she had been moved to Louis XIV's extravagant palace at Versailles; by 1760, the painting had been relegated to the office of the Directeur des Bâtiments (the keeper of the royal buildings). At the end of the century, however, the French Revolution suddenly changed everything in France—including views about the *Mona Lisa*. The next one hundred and twenty years of her history saw an incredible rise in her popularity, spurred perhaps by the succession of famous men—from an emperor to a generation of artists and poets—who fell for her.

The French monarchy was abolished, violently, in 1792—along with the Royal Collection. What had once been reserved for the privileged few became the common property of the citizens of France. A section of the ancient palace of the Louvre in Paris was slated to become the new public museum. The revolutionary government appointed a commission to choose the paintings to be moved from Versailles to the museum; by its eighteenth meeting, on July 13, 1797, it had made the final selection. The *Mona Lisa* was included on the list. Ironically, Jean-Honoré Fragonard (1732–1806), Louis XVI's celebrated court artist—a painter of historical subjects and slightly erotic, lightheaded themes—was entrusted with the task of overseeing the transportation of the Versailles collection to Paris.

General Napoleon Bonaparte, capitalizing on his popularity and control of the army, staged a coup and became de facto dictator of France in 1799. Following his rise to power, the diminutive

"First Consul for Life" seems to have become enraptured by the *Mona Lisa*. In 1800 he had the portrait removed from the Louvre and placed in his bedroom in the Tuileries Palace. There it remained for four years, until he had himself crowned emperor and the painting went back to the Louvre. No king, emperor, or head of state dared to remove it for his own use ever again. The *Mona Lisa* now belonged to the people of France. From this moment on, its history is inextricably linked to that of the Louvre.

Over the course of the nineteenth century, both the *Mona Lisa* and her creator experienced a profound change in reputation and popularity. In the seventeenth and eighteenth centuries, the Italian Renaissance did not have the prestige it acquired in the following two centuries. In the early 1800s, the prolific Michelangelo, Titian, and Raphael were far more highly regarded than Leonardo. Horace Vernet's famous painting *Raphael at the Vatican* (1832) tells all. It shows Raphael in the act of drawing, surrounded by friends and admirers. In the foreground, on the left, lurks Michelangelo. On a platform, Pope Julius II is busy examining future projects. Leonardo is also there, but on the distant right-hand side, looking wistfully at the busy scene around him. In 1831, John Scarlett Davis had painted *The Salon Carré and the Grande Galerie of the Louvre*, but the *Mona Lisa* was not among the paintings on the walls.

Only around the middle of the century did the *Mona Lisa* start attracting more attention. Giuseppe Castiglione included it in his *View of the Salon Carré in the Louvre Museum* in 1861, though it was partially hidden by the turbans of two Moorish visitors. By the end of the century, however, Leonardo had overtaken his rivals and become the archetypal Renaissance genius. What contributed to this elevation?

Leonardo came to be regarded as not only a major painter but also a great scientist. The claim is exaggerated, of course, as Leonardo was far more the visionary and doodler than the practical inventor, and his contribution to the development of technology and science is marginal. None of the great breakthroughs in hydraulics or aviation owes anything to his insights. Yet the popular image of Leonardo as a major scientist has remained alive to the present day: models of his various machines have been built based on his drawings and are displayed in a few museums, such as his last residence at Clos Lucé. He also became a cult figure. His drawings were not widely available, his grandiose works were unrealized, his notes were scattered everywhere, and his paintings were unfinished or severely damaged because of his inappropriate preparation of the paints. But none of that mattered. What fascinated his admirers was the idea of an inquisitive scientific and artistic mind at work, never satisfied, steadily searching for the new: the nineteenth-century idea of true genius.

The cult of Leonardo as the paragon of progressive and modern thinking was part of a wider secular nineteenth-century political and ideological project. Leonardo was regarded as someone who had left behind all religious dogmas. He was not afraid to dissect corpses to gain an understanding of human anatomy; he did not paint halos on his religious figures—thus, as one writer put it, "uncrowning the Middle Ages." Unlike Raphael and Michelangelo, he was never the servant of popes.

France claimed Leonardo as its own, as Léonard de Vinci, and the Louvre gradually assembled the most important collection of his paintings in the world. Great prominence was given to his final years in the country, his "true home," where his genius had finally been recognized. The scene of his death was often represented in

paintings, most notably by Jean-Auguste-Dominique Ingres in *The Death of Leonardo in the Arms of King François I* (1818), later engraved by Claude-Marie-François Dien.

In 1800 the most famous of Leonardo's paintings was not the *Mona Lisa* but *The Last Supper*, its fame spreading rapidly after it was engraved by Raphael Morghen and produced in an edition of five hundred. The spread of tourism among the moneyed classes further enhanced its reputation. Charles Dickens stopped by the famous fresco in November 1844. "In the old refectory of the dilapidated Convent of Santa Maria delle Grazie," he wrote, "is the work of art perhaps better known than any other in the world: *The Last Supper*, by Leonardo da Vinci." Another visitor, Goethe, declared it "a real keystone in the vault of one's notion of art." Neither one mentioned the *Mona Lisa*.

If the *Mona Lisa* was to become well known among the general public, the painting would have to be available in large quantities of reasonably priced prints. True, the portrait was copied seventy-one times between 1851 and 1880, but copying merely increased a painting's reputation among the more affluent members of society. Prints would enable a painting to become more widely known, for they were far cheaper than copies. *Mona Lisa*'s sfumato was difficult to engrave, and early examples in the 1820s and 1830s were of poor quality. Then the great Italian engraver Luigi Calamatta (1801–1869) produced a fine engraving in Paris in 1857, which was immediately popular.

Once again, artists began to use Leonardo as the subject for their paintings. In 1863 Cesare Maccari provided a full pictorial representation of Leonardo painting the *Gioconda*. In these images, Leonardo is almost always represented as he appears in a famous red-chalk drawing found in the 1840s—a highly stylized

self-portrait (or so it is alleged) of a wise old man, strong and manly, with full beard, bushy eyebrows, and noble features. The advent of photography would also increase the visibility of the painting and change the way it, and art in general, was viewed. All this exposure seems to have demystified the portrait somewhat. It was around this time that a Parisian illustrator anticipated a later trend by producing the first defacing of the *Mona Lisa*—showing her smoking a pipe.

For others, her mystery only increased. The *Mona Lisa* was becoming the subject of a literary cult. This transition from visual to literary was the work of French writers fascinated by mysterious, seductive women such as Medea, the Sphinx, or Salome. As Leonardo's fame became more established, the literary representation of the portrait of Lisa Gherardini acquired a new meaning. Romantic writers, for whom science was a kind of magic, redefined Leonardo the scientist as the painter of the Eternal Feminine. This transition reflected one of their own central preoccupations—the representation of women. Only a magician could have painted a magical woman's magical smile. Only a universal genius could have painted the Universal Woman.

Early descriptions by these writers tell of a charming visage, serene and proud, and of a timeless and voluptuous smile. The femme fatale was born—and it was *Mona Lisa*. The chief maker of *Mona Lisa* as a mysterious woman with a strange smile was the prominent poet, novelist, and art critic Théophile Gautier. His novels and poems are packed with images of disquieting, threatening, and exotic women. He saw such women everywhere, in *The Young Woman with a Carnation* by Jean-Hippolyte Flandrin, in El Greco's *Lady in Ermine*, in Ingres's portrait of Madame Devauçay. But he reserved his most purple prose for *La Joconde*:

"The sphinx of beauty who smiles so mysteriously in Leonardo da Vinci's painting, and who seems to pose a yet unresolved riddle to the admiring centuries. Who has not contemplated for hours this head bathed in half-tints, enveloped in translucent veils…? Her gaze intimating unknown pleasures, her gaze so divinely ironic. We feel perturbed in her presence by her aura of superiority." What was irresistible and exhilarating, however, was the smile, "wise, deep, velvety, full of promises…the sinuous, serpentine mouth, turned up at the corners in a violet penumbra, mocks the viewer with such sweetness, grace and superiority that we feel timid, like schoolboys in the presence of a duchess."

A trend was launched. Gautier's words were regularly repeated and embellished. The utterly unknown wife of Francesco del Giocondo, the real Lisa, disappeared under the weight of male fantasies. In her place an elaborate structure of images could be erected which no historical research could ever demolish. An indeterminate portrait became the terrain for infinite variations on the same theme. "Whoever looked at her for an instant cannot forget her," George Sand observed, and she became the icon by which other aloof, mysterious beauties could be described. The Goncourt brothers, in their celebrated *Journal*, described a salon beauty in these words: "She is all instinct and no rules, and wears, like an enchanted mask, the smile full of night of the Gioconda." Arsène Houssaye, in his memoirs, described the enigmatic smile of the Princess Belgiojoso as "a pure masterpiece of unsatiated Gioconda."

Were there other candidates for the role of the femme fatale? As we have seen, Gautier had also lusted after portraits by Ingres and Flandrin, but these paintings were too contemporary. The El Greco he mentioned was not in the accessible Louvre. Rubens's

ladies were too fat, Cranach's too thin. Farther south there was a profusion of beauties, but how could the demure Virgin Marys and Mary Magdalenes and all the saintly Catherines and Cecilias and Annes depicted by Raphael and the other Italian masters be transmuted into mocking and sexy femmes fatales? It may be amusing to stroll through the Louvre scouting for possible candidates, pausing by Titian's *Jeune femme à sa toilette*, or Raphael's *Jeanne d'Aragon*, or Veronese's *La Contessa Nani*. Taste may differ, but, clearly, *Mona Lisa* did not have many competitors for the role.

The purple prose used by Théophile Gautier found an echo in Britain. Walter Pater, the foremost British exponent of the principles of art for art's sake, took the tip from Gautier and made Mona Lisa famous in countries outside France. In his 1869 essay on Leonardo he described Mona Lisa in words that were so often reprinted they brought him fame too:

> She is older than the rocks among which she sits; like the vampire, she has been dead many times, and learned the secrets of the grave; and has been a diver in deep seas, and keeps their fallen day about her; and trafficked for strange webs with Eastern merchants: and, as Leda, was the mother of Helen of Troy, and, as Saint Anne, the mother of Mary; and all this has been to her but as the sound of lyres and flutes, and lives only in the delicacy with which it has moulded the changing lineaments, and tinged the eyelids and hands.

The success of Pater's text was due to the beauty of the prose and to the literary and visual associations it conjured: a "strange

presence," the weight of the past ("a thousand years"), "fantastic reveries and exquisite passions," beautiful Greek goddesses, the "animalism of Greece," the "lust of Rome," medieval mysticism, paganism, the Borgias, vampirism and ghosts ("she has been dead many times"), the Orient (trafficking with "Eastern merchants"), Leda and Helen of Troy. All the usual suspects were there.

Mona Lisa had entered the collective unconscious, and her enigmatic smile became part of the numerous cultural references in literary texts written on both sides of the Atlantic. Readers recognized her presence in works by Oscar Wilde, Marcel Proust, Henry James, the Italian poet Gabriele D'Annunzio, and the Russian novelist Dmitri Merezhkovsky. Among the cultural elite, the celebrated beauty was dangerously close to becoming a cliché.

Finally, both the painter and the portrait were subjected to that peculiarly twentieth-century phenomenon—psychoanalysis. Sigmund Freud examined the enigma of Leonardo and his many cryptic notebooks. He expanded on the centuries-old suggestion of the artist's homosexuality, seeing it as the result of Leonardo's early separation from his mother. And he pointed to Leonardo's androgynous figures and his compulsive scientific research—a sublimation, Freud contended, of the painter's sexual feelings.

Both Leonardo and his masterpiece, the *Mona Lisa,* had entered the twentieth century.

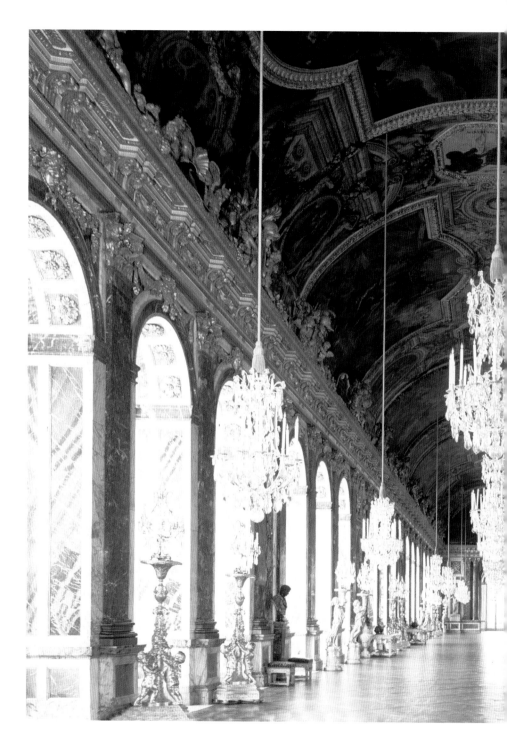

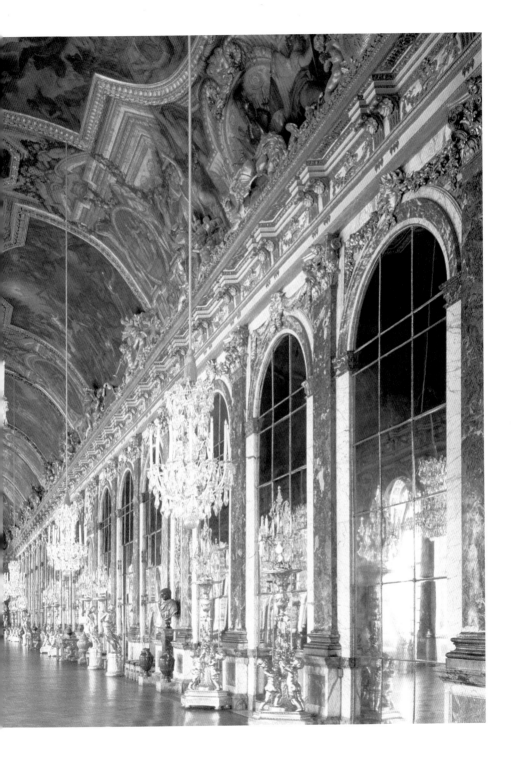

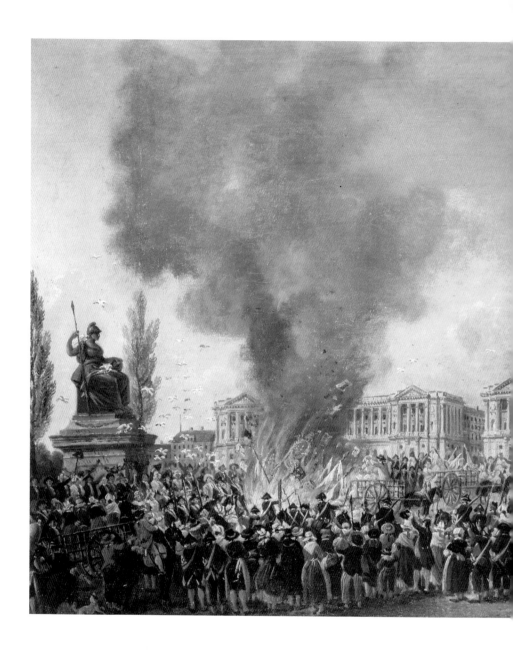

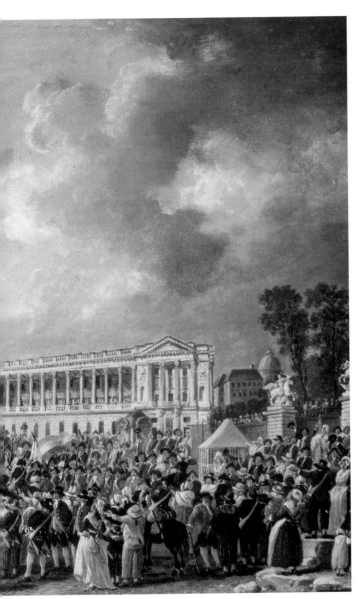

PREVIOUS SPREAD

The Hall of Mirrors, Versailles

Louis XIV's spectacular palace at Versailles, a work of art in its own right, was filled with beautiful objects—including the *Mona Lisa*, which had been moved there in 1695.

LEFT

Celebration of Unity, Destruction of Royal Emblems, August 10, 1793 **Pierre-Antoine Demachy 18th century**

To Arms, Citizens! The French Revolution was a seminal moment in the history of Europe and in the life of the *Mona Lisa*. With the abolition of the monarchy, artworks included in the Royal Collection became the property of the people of France.

FOLLOWING SPREAD

The Grande Galerie at the Louvre in the Course of Restoration, 1798-99 **Hubert Robert late 18th century**

The revolutionary government decided to convert the Louvre, the former royal palace, into one of Europe's first art museums. It opened to the public in 1793. Four years later, when the Royal Collection became the new national collection of art, the *Mona Lisa* was among the Louvre's new treasures.

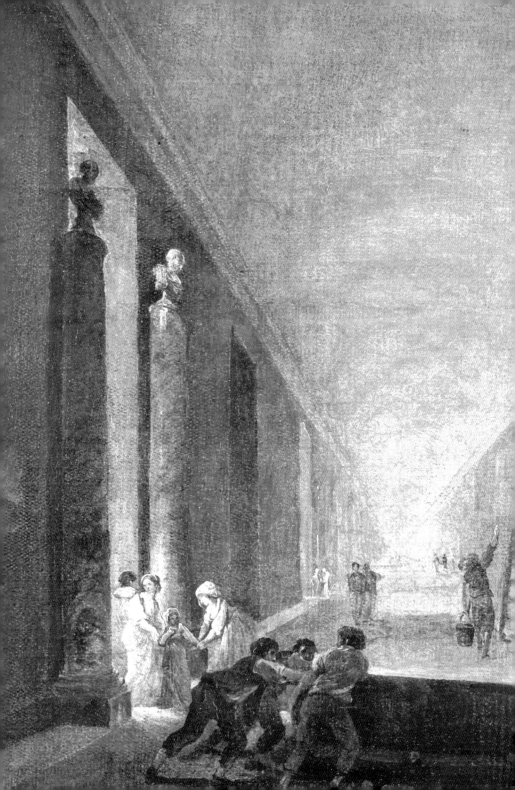

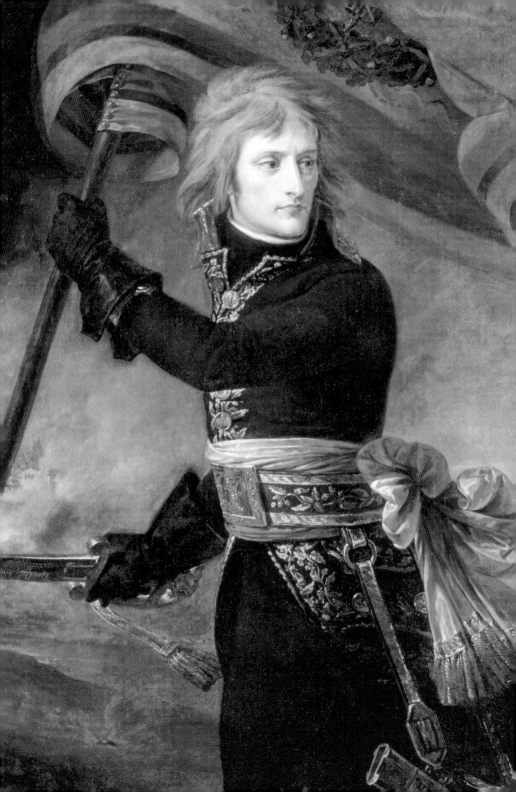

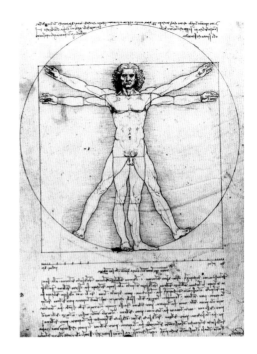

General Napoleon Bonaparte at the Bridge
of Arcola, November 17, 1796
Antoine-Jean Gros
1796
In 1796 the French Revolutionary Army, led by
Bonaparte, invaded northern Italy—the first of many
conquests. By 1799 Bonaparte had taken control
of France, initially as first consul and then, in 1804,
as emperor.

Vetruvian Man
Leonardo da Vinci
1490
After the French invasion of Italy, many works of art
and other cultural treasures were discovered, including
Leonardo's scientific manuscripts. These eclectic,
far-ranging works revealed a forgotten aspect of the
great Italian master. This famous drawing showing the
proportions of the human body was inspired by the
writings of the Roman architect Vetruvius, who lived in
the first century B.C.

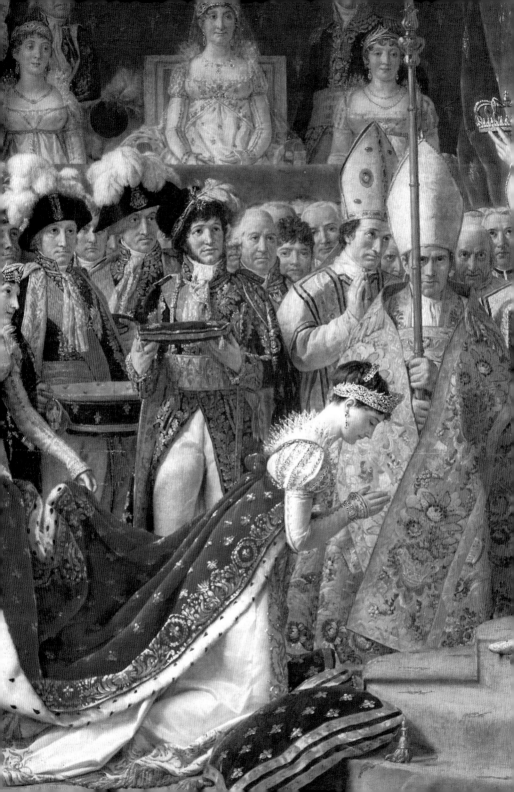

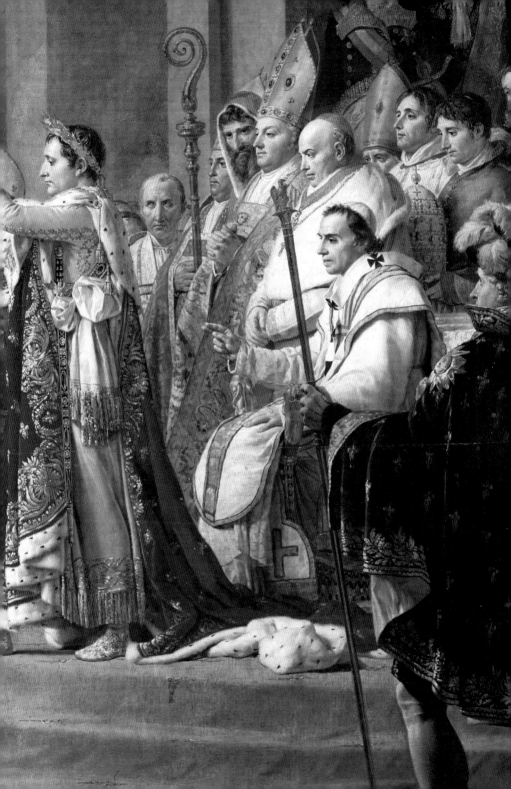

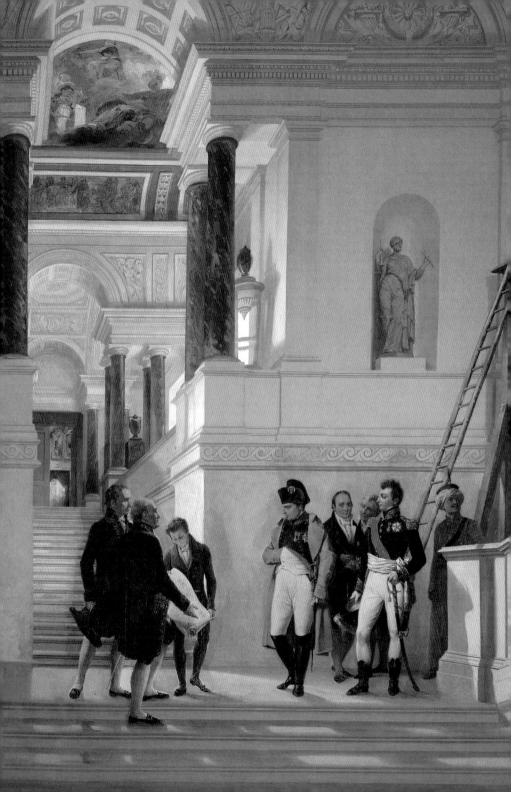

PREVIOUS SPREAD
Coronation of Napoleon I
Jacques-Louis David
1806–07
In this great work of art, Napoleon's destiny is clearly in his own hands as he crowns his wife, Josephine, while the Pope bears silent witness from the sidelines. As Napoleon's armies continued to sweep through Europe, they returned to France laden with treasures appropriated from churches, museums, and other cultural sites. Most of these works of art were deposited in the national museum at the Louvre—at the time called the Musée Napoléon—laying the foundation for what would become one of the world's most important public art collections.

LEFT
Napoleon I Visits the Louvre, Accompanied by Architects Percier-Bassant and Fontaine
Louis-Charles-Auguste Couder
1833
Architects Charles Percier-Bassant and Pierre-François-Léonard Fontaine were commissioned to further renovate the Louvre and to connect it to the neighboring Tuileries Palace. Napoleon took a certain interest in the new museum, just as he had in the *Mona Lisa*. When Napoleon was still first consul, he had had the *Mona Lisa* hung in his bedroom at the Tuileries. After his crowning he had it returned to the Louvre.

RIGHT

The Gallery of the Louvre
Samuel F. B. Morse
1831–33

Throughout the early part of the nineteenth century the Louvre prospered as a world-class museum and, increasingly, as a tourist destination. Samuel Morse's painting of the Salon Carré illustrates the nineteenth-century style of museum display. Although the *Mona Lisa* was on view (bottom row, sixth from right), it was not yet the focus of any particular attention.

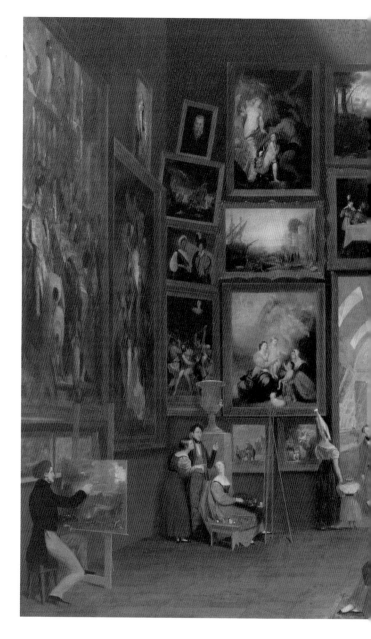

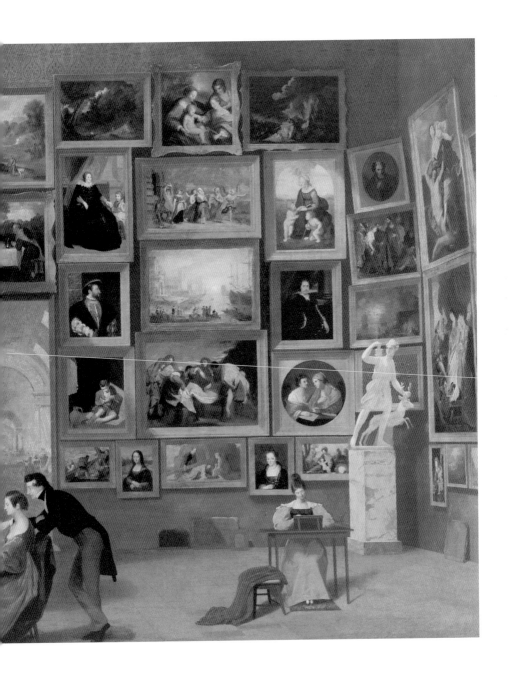

Four o'clock at the Salon
François Biard
1847
The Louvre had long been
the site of the Salon de Paris,
an annual showcase at which
celebrated artists were given
pride of place. For aspiring
artists in particular, exhibition
at the juried Salon was
essential for success. The
event drew enormous crowds
to the museum, especially
from among the increasingly
affluent bourgeoisie in
Paris—which meant a far
wider audience for the
Mona Lisa.

Louvre Museum
By the mid-nineteenth century, the Louvre was establishing itself as one of the world's most important museums—in large part because of its unrivaled collection of works by Leonardo da Vinci.

Tourists on Vesuvius
c. 1840
The nineteenth century also saw Italy become a popular destination on the Grand Tour, a cultural holiday where British and Northern European travelers crossed Europe to drink in the sites and the history and to enjoy a few adventures.

View of a park
Louis-François Cassas
19th century
Visitors often journeyed to Italy to seek out antiquities, finding in the shattered pillars and ruined statuary the glory that once was Rome.

Travelers at the Ponte Vecchio in Florence
The Renaissance, after two centuries of neglect, was
"rediscovered" by these cultural travelers. Italy also
attracted Romantic poets, artists, and critics who
idealized its antiquities, art, and culture. Art lovers read
Vasari's *Lives of the Most Eminent Painters, Sculptors,
and Architects*, which hailed Florence's artists as
the greatest of all the masters. Leonardo, both as artist
and as scientist, was celebrated as the epitome of
the Renaissance man—and his works as the ultimate
expression of genius.

Engraving of the *Mona Lisa*
Antoine-François Dezarrois
19th century

Capitalizing on the renewed interest in Italian art, engravers created reproductions of the most famous works of art. When Luigi Calamatta succeeded in the difficult task of engraving the *Mona Lisa* in 1857, his template allowed other engravers to follow suit. Soon, easily reproduced versions of the portrait, like the one shown here, helped spread the *Mona Lisa's* fame throughout Europe.

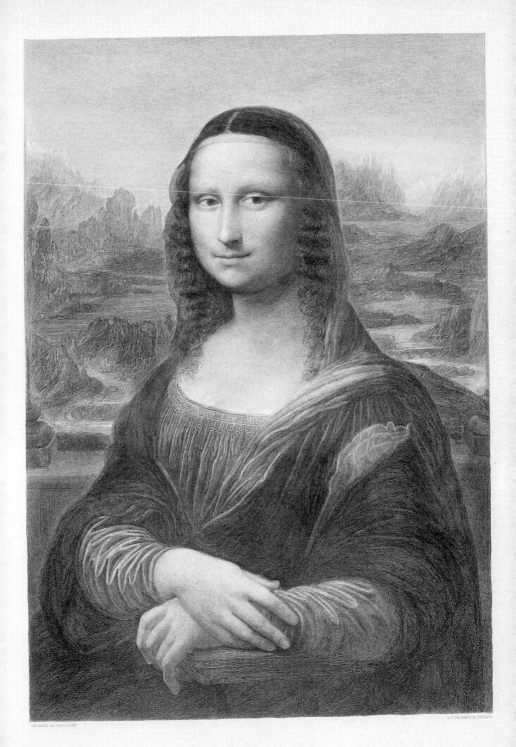

LÉONARD DE VINCI PINX. A.P. DESARROIS SCULPS.

LA JOCONDE

Poster for the opera *La Gioconda*
Prina
1876
Easily reproduced images, together with the renewed
interest in the Renaissance, exposed more and more
people to the *Mona Lisa*. Although Amilcare Ponchielli's
1876 opera *La Gioconda* was about a female ballad
singer and not about the *Mona Lisa*, the poster for the
first performance bore a certain resemblance to the lady.

Mona Lisa with a Pipe
Eugène Bataille (Sapeck)
1887
It was inevitable that the *Mona Lisa*'s growing fame would
also make it the butt of jokes. The illustrator Eugène
Bataille created this send-up as a joke on the *fumistes*
(the smokers)—a group of bohemian pranksters to
which he belonged. His spoof inaugurated what would
become a separate school of art—defacings and
parodies of the *Mona Lisa*.

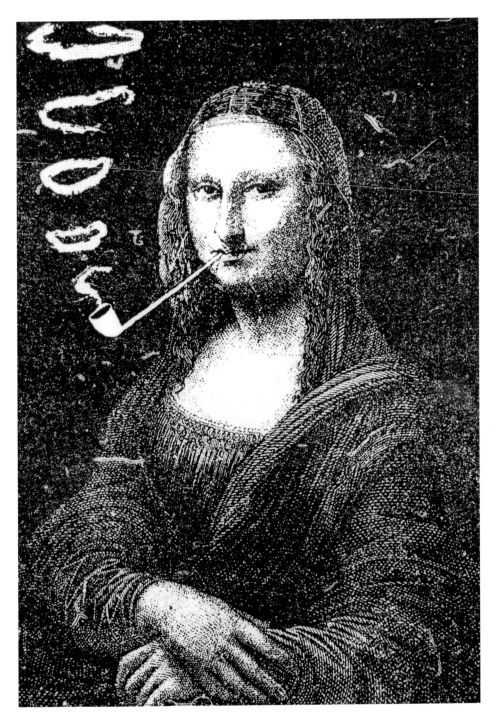

"The Climax."* Illustration for Oscar Wilde's *Salome
Aubrey Beardsley
19th century

Already popularized in a number of media, the *Mona
Lisa* was about to step into the realm of the "femme
fatale." Nineteenth-century artists were transfixed by this
idealized perception of woman as haughty, powerful,
compelling, and, above all, mysterious. The idea of an
alluring but dangerous beauty had its origins in age-old
myths and in stories of archetypal figures such as
Salome and Helen of Troy.

***Helen on the Walls of Troy, with Two Figures
at Her Feet***
Gustave Moreau
19th century

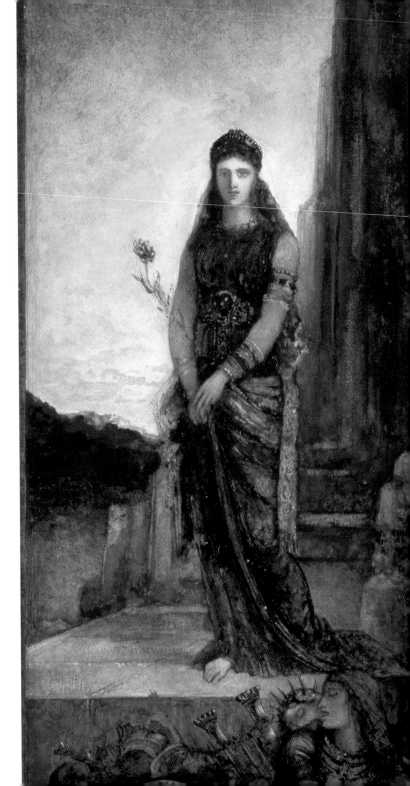

Théophile Gautier
19th century
Foremost among French art critics was Théophile
Gautier — wit, lover, intellectual, and man about town.
Obsessed by seductive women, he popularized the idea
of the femme fatale and developed a particular reverence
for the *Mona Lisa*. His influential writings about the
portrait were essential in establishing her cult status as
the quintessential femme fatale.

Nude with a fan
Théophile Gautier
19th century

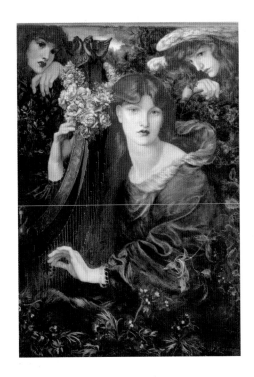

Game of Madness
Pierre-Louis Pierson
c. 1863–66
Those eyes, that smile—the *Mona Lisa* was seen by the
European intelligentsia of the mid-nineteenth century as
the femme fatale par excellence. The self-consciously
dramatic Countess of Castiglione—mistress of Napoleon
III and one of the ephemeral celebrities of Paris in the
late 1850s—was certainly vying for the title.

ABOVE
La Ghirlandata
Dante Gabriel Rossetti
1873
The *Mona Lisa* spoke to artists—Rossetti among
them—who were obsessed by the ideal of the femme
fatale and who found inspiration for their beautiful but
troubled subjects in Leonardo's painting.

FOLLOWING SPREAD
La Ghirlandata, detail
Dante Gabriel Rossetti
1873

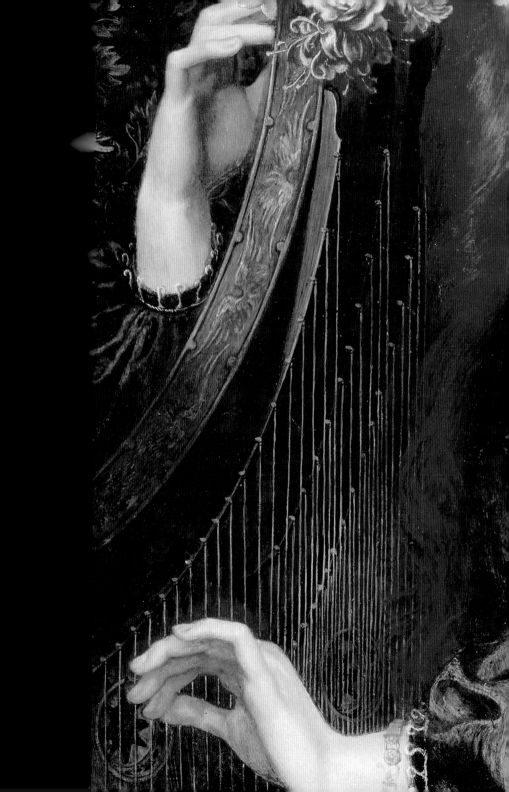

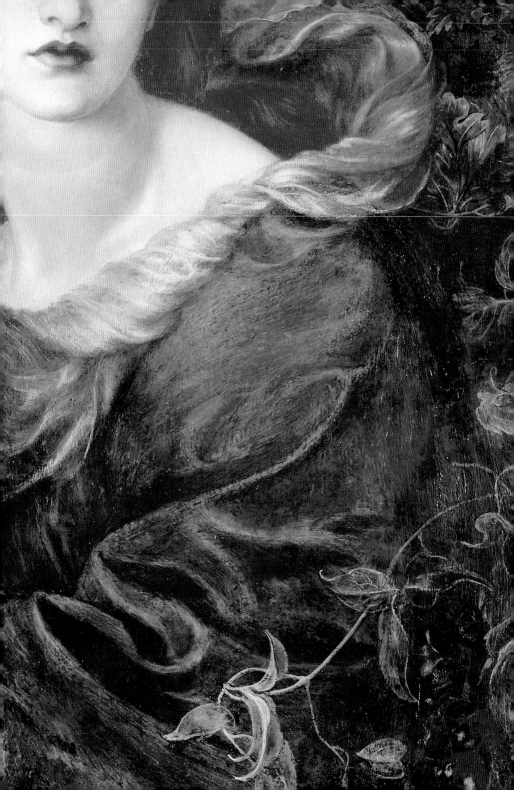

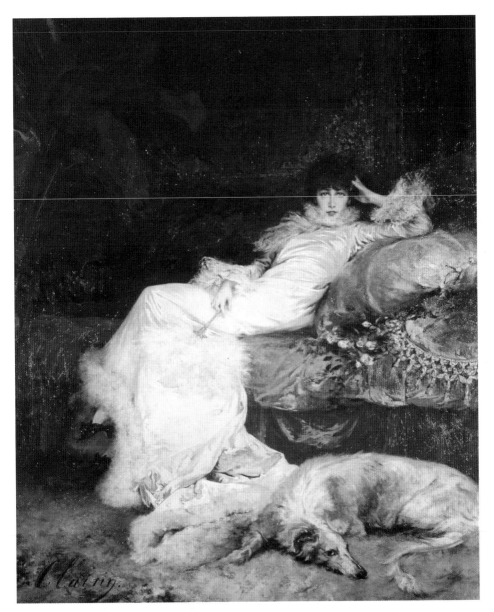

Oscar Wilde
c. 1894
Following the works of Gautier and Walter Pater, other
writers, including the notorious Oscar Wilde, referred to
the *Mona Lisa* as a touchstone of mysterious feminine
beauty. When Wilde dubbed the great actress Sarah
Bernhardt "the Divine Sarah," he was drawing on the
same idea of sublime femininity that the *Mona Lisa*
had come to represent.

ABOVE
Sarah Bernhardt
Georges Clairin
1876
The most celebrated actress of her age, Sarah
Bernhardt combined a remarkable intelligence and
artistic sensibility with a powerful sexual allure.

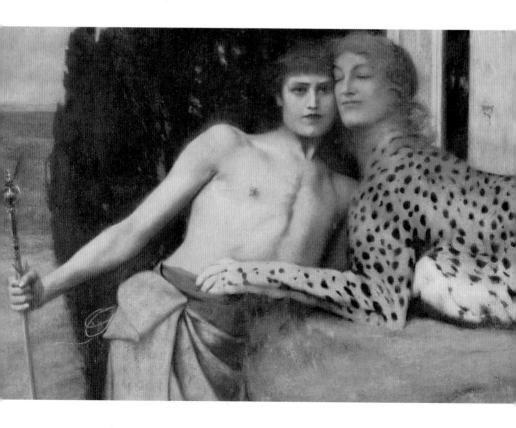

BELOW
Sphinx (of the Caresses)
Fernand Khnopff
1896
The *Mona Lisa* had come to be the definition of the
femme fatale. Her strange allure had been linked to a
long line of rapacious beauties, and she had inspired
writers, artists, and poets. Her enigmatic smile even
drew comparisons to the sphinx.

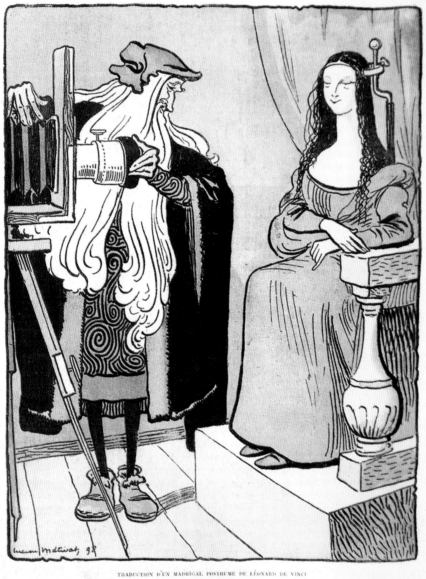

TRADUCTION D'UN MADRIGAL POSTHUME DE LÉONARD DE VINCI

Le roi François Premier — est bien gentil pour moi — mais j'aimerais bigrement mieux — o Mona Lisa, — être mort dans vos bras — que dans les siens.

Dessin de L. Métivet.

Cartoon
Lucien Métivet
1898
By the late nineteenth century the *Mona Lisa* had found
a place in the world of popular culture. Her notoriety
allowed her to be simultaneously a work of great allure
and the subject of spoofs like this one about the growing
popularity of photography.

ABOVE
Sigmund Freud
1910
In 1910 Sigmund Freud published *Leonardo and a
Memory of His Childhood*—his "psychobiography" of the
painter. Freud asserted that Leonardo was homosexual,
noting also that the woman who posed for the *Mona
Lisa*, with her strange half-smile, must have reawakened
the artist's repressed memory of his mother's smile.
Having been psychoanalyzed posthumously by the great
Freud, Leonardo and his most famous creation had
definitely entered the twentieth century.

1911

(Point de vue : 2ᵃ — Réduction 1/7)

1913

25.1.09

378.69

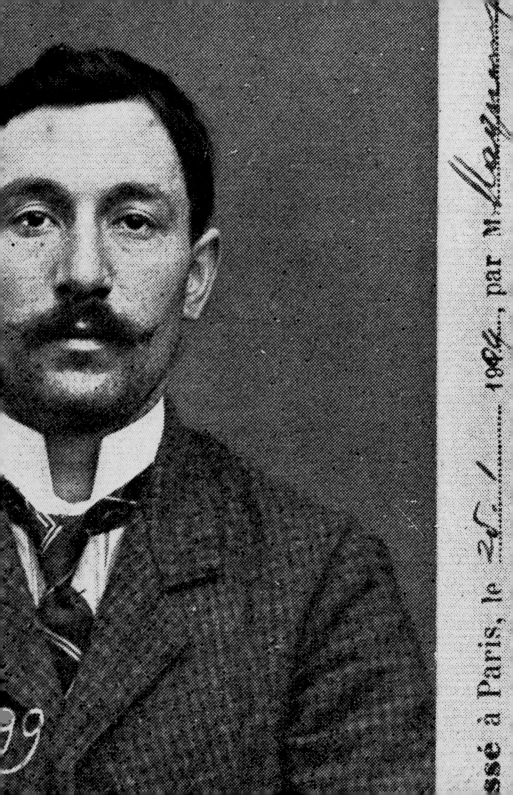

ssé à Paris, le 2 *t.l.* 18*84.*, par M. *Hagnere*

THEFT OF THE CENTURY

BY THE BEGINNING OF THE TWENTIETH CENTURY, the *Mona Lisa* had been widely copied, engraved, used in fiction, and lionized as the Quintessential Woman. And while its creator was revered as the Universal Man the painting itself was not yet an object of mass consumption. But that was about to change.

In the closing decades of the nineteenth century, new technologies and changing social conditions had begun to open the world of high culture to the masses through cheaper books, increasing literacy, and, in particular, mass-circulation newspapers. By 1914 the four largest French dailies sold 4.5 million copies every day. In Britain, the *Daily Mail* churned out over a million copies. What appealed to this eager new readership were human-interest stories, the feats of adventurers and explorers, events surrounding royalty and celebrities, wars (especially colonial wars)—and crimes. How could they resist the story of a sensational art heist at a famous museum?

Early on the morning of August 21, 1911, Vincenzo Peruggia, a thirty-year-old Italian painter-decorator who had been working at the Louvre, removed the *Mona Lisa* from its frame, hid it under his coat, and took it away. It was Monday, and the museum was closed for the day.

The theft was staggering in its simplicity, and the press pounced on every detail of the story. What a scandal for the Louvre! What a shock for the people of France! The French government immediately sacked the director, along with the head of security, and disciplined the guards. But the outcry did not stop there. Nor did the press coverage.

The *Petit Parisien*—now claiming to be the largest-circulation daily in the world, with 1.4 million copies sold—came out on August 23 with a banner headline over a large picture of the stolen

painting: "*La Joconde a disparu du Musée du Louvre.*" The story made clear that this was no ordinary Renaissance masterpiece but the unusual portrait of a mysterious woman, painted by a genius. It was not just a theft. It was tantamount to abduction, almost a rape.

The newspapers dealt with the story according to the unwritten rules of traditional journalistic and popular narratives: they mourned the loss and hyped the painting. Then they speculated: Was the mysterious thief a possessive art lover, a deluded fanatic in love with the great *Mona Lisa*? Or was he, perhaps, a reclusive, eccentric millionaire?

For nearly three weeks, this tantalizing story was played out on the front pages of the newspapers—usually alongside an image of the *Joconde*. The *Petit Parisien* mentioned the enigmatic smile in virtually every issue. Parisians displayed a sense of personal grief. In larger numbers than ever before, they flocked to the Louvre to contemplate the empty space and inspect the hooks that had held the *Joconde*. Outside, peddlers did a roaring trade selling postcards and reproductions of the suddenly famous *Mona Lisa*.

Popular culture then took up the theme and exploited the theft to the full. The Louvre security was lampooned in songs, cabarets, and variety shows. Satirical postcards appeared almost immediately. One depicted the *Mona Lisa*, smiling broadly, under the caption: "Now happy to be on the loose—after four centuries." Cabaret songs satirizing the event, with new lyrics and old tunes, added to the cultural frenzy.

The months passed by. Everyone assumed that the painting would never be recovered. Raphael's *Baldassare Castiglione* took the place of the *Joconde* in the Renaissance gallery. In March 1912,

the Louvre acquired Camille Corot's *Woman with a Pearl*, the best-known modern homage to Leonardo's *Mona Lisa*. With its strikingly similar pose, the painting may have brought some consolation to the museum's visitors.

By 1913, the *Mona Lisa* was no longer listed in the Louvre's catalog. Who could know that the priceless painting now resided in a box in a cubbyhole near the stove in Peruggia's lodging. Then, on November 29, 1913, Alfredo Geri, an antique dealer in Florence, received a letter signed by a person using the name "Leonardo." It claimed to want to "return" the painting to Italy in exchange for 500,000 lire to cover "expenses." Encouraged by the curator of the Uffizi Gallery, Giovanni Poggi, Geri wrote back, expressing interest in the painting. "Leonardo"—Vincenzo Peruggia—set out from Paris by train, carrying the *Mona Lisa* in a box, and checked into a modest Florentine hotel. Geri and Poggi examined the painting and found the correct Louvre inventory number on the back. At the Uffizi, with a photograph of the original in hand, they examined the *craquelures*—the cracks in the paint, estimated now at some 500,000—which provide the unique "fingerprint" of old paintings. Satisfied they had the real thing, Geri and Poggi convinced Peruggia to return to the hotel to wait for his reward. And then they called the police.

The press everywhere went wild. In France, headlines blared that the national treasure had miraculously been found. In Italy, nationalists hailed "their" *Mona Lisa* and demanded that the painting stay at "home." The *Illustrated London News* of December 20, 1913, included a special supplement with several pages of photographs. The Italian government ignored the nationalist calls and agreed to return the portrait to the Louvre. But it requested that the *Mona Lisa* go on tour first—to be exhibited in Florence, then

in Rome in the presence of the royal family, and finally in Milan. This time the painting traveled in style, in a specially constructed padded box, with a guard of honor. And, inevitably, there were more songs, more postcards, more cartoons, more headlines.

On January 4, 1914, the *Mona Lisa* was back in the Louvre. Long lines of Parisians filed past to catch a glimpse of "their" painting. Then came the trial. To the disappointment of the popular press, Vincenzo Peruggia turned out to be a classic loser, not the kind of sophisticated international art thief celebrated in popular novels. The judge treated him leniently, imposing only a twelve-month sentence.

The French street-song industry returned to the *Mona Lisa* with customary speed. More funny postcards appeared: *Mona Lisa* arriving in Paris at the station and demanding to be taken to the Louvre; *Mona Lisa* beaming, holding a baby, a handsome Italian in the background (the mystery explained!). Popular culture, with its irreverent treatment of an art masterpiece, had spawned a new industry: the systematic ridiculing of High Art through postcards. Today, it is almost impossible to find a shop selling art postcards without its own stock of *Mona Lisa* send-ups. *Mona Lisa* was becoming kitsch.

The theft transformed the *Mona Lisa* from a passive object into a real being, one endowed with emotions and feelings. The "it" had become a "she." The exposure, even notoriety, resulting from the theft gave the painting instant recognition among all classes of society in Europe. But the *Mona Lisa* was not yet a household name on the other continents. To complete her transformation into a global icon, she would have to travel to distant countries and to saturate entirely new forms of popular culture.

And that, of course, is exactly what she did.

**Frédéric Laguillermie preparing an engraving
of the *Mona Lisa***
early 20th century
Before the mid-twentieth century, museum regulations
and security were far less strict. The *Mona Lisa* was
not roped off and had no special alarm system. The
priceless masterpiece was not even behind glass, and
nothing prevented visitors to the Louvre, including
copyists like this man, from approaching the painting.

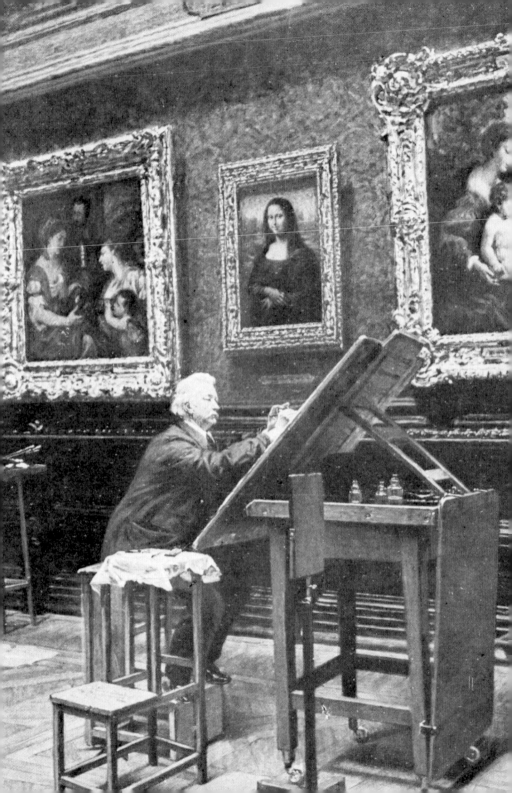

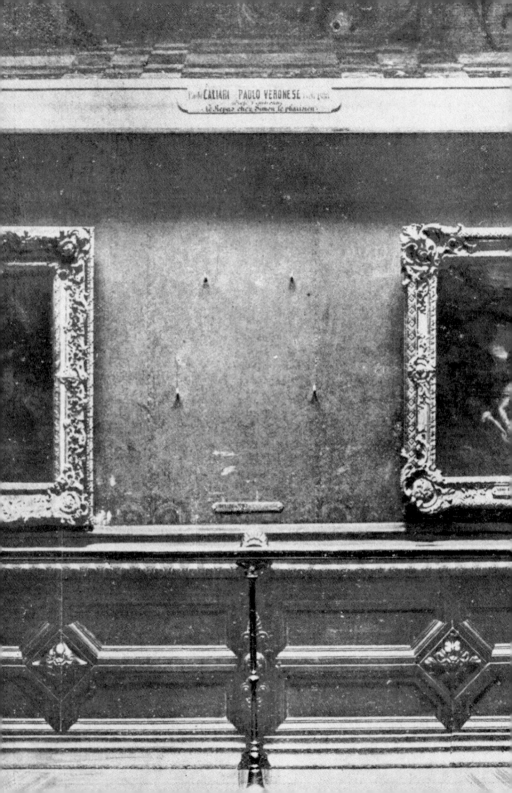

LEFT
Mona Lisa missing from the wall of the Salon Carré
August 1911
When security guards conducted their regular check of
the Louvre on the morning of August 21, 1911, they
discovered the unimaginable—an empty space where
the *Mona Lisa* had been.

ABOVE
Open door, Louvre
August 1911
The next thing they found was an open door leading to
a courtyard known as the Cour Visconti. The thief had
forced the door with a crowbar.

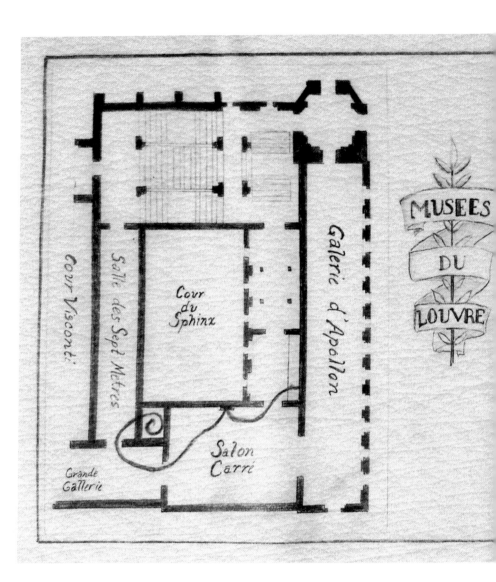

Cour Visconti

Salle des Sept Mètres

Cour du Sphinx

Galerie d'Apollon

MUSÉES DU LOUVRE

Salon Carré

Grande Gallerie

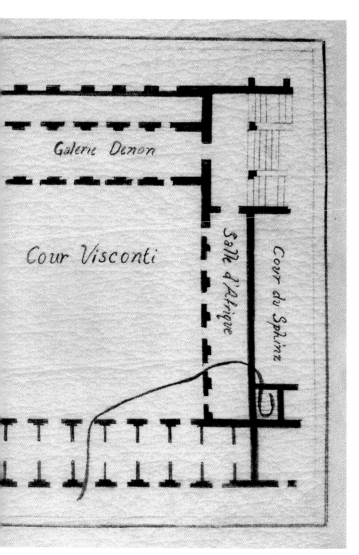

Map of the thief's route, Louvre
August 1911
Authorities soon realized that the thief had hidden in a closet before closing time the previous day. Early the next morning, he grabbed the *Mona Lisa*, ran down a flight of stairs, crossed the Cour Visconti, and headed out into the street.

Galerie Denon

Cour Visconti

Salle d'Afrique

Cour du Sphinx

ABOVE
Cartoon
Georges Léonnec
September 1911
Before the theft, people knew of the *Mona Lisa*, but
her disappearance cemented her fame overnight.
Immediately all kinds of popular materials, including
cartoons such as these, poked gentle fun at the
theft and its aftermath.

RIGHT
Mona Lisa **Cartoon**
c. 1911

Front page of *La Domenica del Corriere*
September 10, 1911
The theft enthralled the popular press and illustrated weekly supplements, including the Milan-based *La Domenica del Corriere* and many others in Europe, Britain, and North America, devoted pages to the story. They featured photographs of the crime scene or imaginative reconstructions of the robbery, which were often disproved by subsequent events.

Cover page of *Excelsior*
August 23, 1911

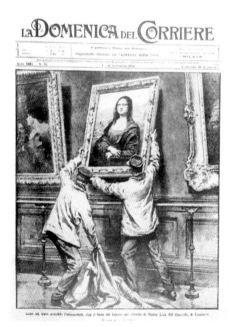

·EXCELSIOR·

Journal Illustré Quotidien

Informations · Littérature · Sciences · Arts · Sports · Théâtres · Élégances

LE LOUVRE A PERDU LA "JOCONDE"

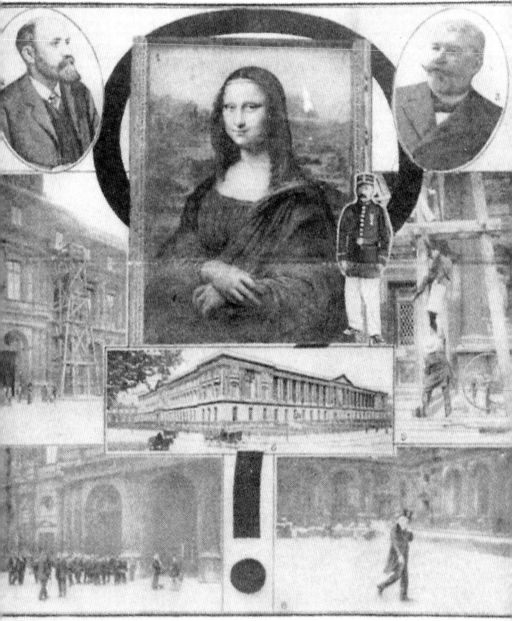

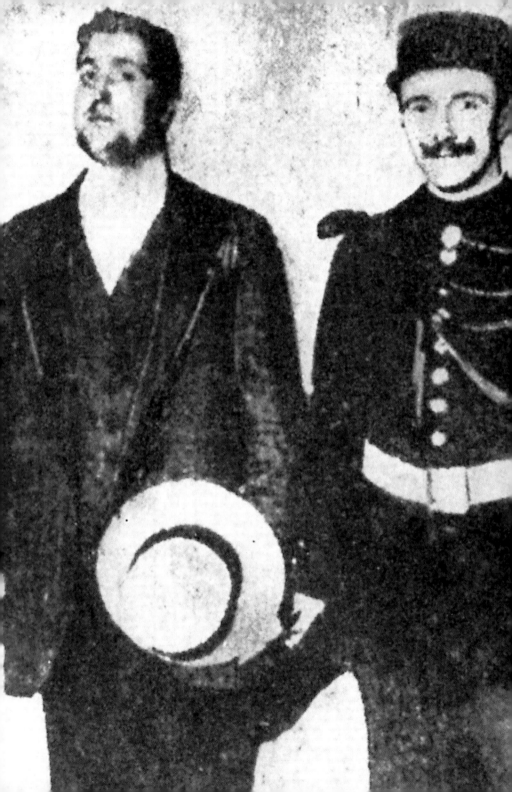

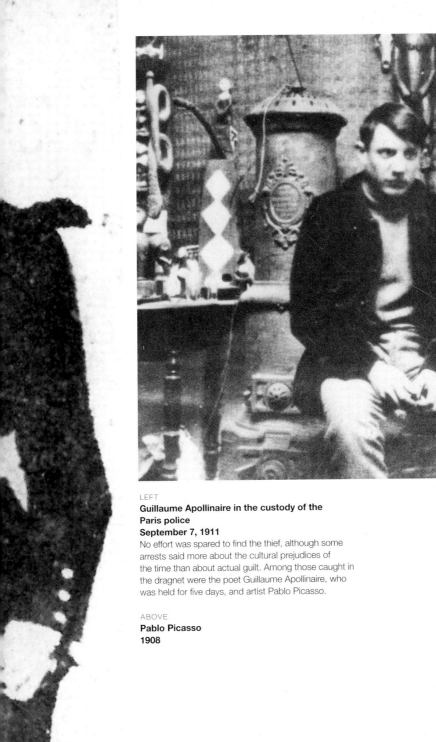

LEFT
Guillaume Apollinaire in the custody of the
Paris police
September 7, 1911
No effort was spared to find the thief, although some
arrests said more about the cultural prejudices of
the time than about actual guilt. Among those caught in
the dragnet were the poet Guillaume Apollinaire, who
was held for five days, and artist Pablo Picasso.

ABOVE
Pablo Picasso
1908

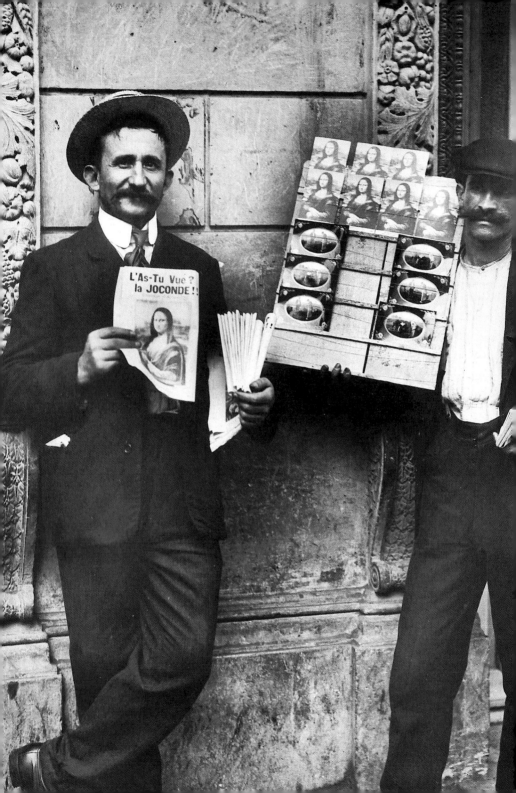

La "JOCONDE" en vadrouille

CHANSON d'ACTUALITÉ

Sur l'air de "*Auprès de ma Blonde*"

LA JOCONDE, de Léonard de Vinci

Paroles d'Antonin LOUIS

LEFT
Paris street singer
1911
The papers weren't the only ones having fun with the theft of the *Mona Lisa*. Street singers and comic songs were a big part of Parisian popular culture, and it didn't take long for them to capitalize on the missing masterpiece. Here a street singer hawks copies of the satiric ditty "Have you seen the Joconde?"

ABOVE
Sheet music for "La 'Joconde' en vadrouille"
c. 1911
Sung to the tune of the French folksong "Auprès de ma blonde," "La Joconde en vadrouille" ("Mona Lisa on a Spree") also enjoyed steady sales in the weeks following the theft.

FOLLOWING SPREAD
Lenten parade featuring the *Mona Lisa*
1912
It was the *Mona Lisa*'s absence, perhaps, that solidified for the French the feeling that the painting was theirs. A float that showed her taking off in an airplane for parts unknown was the centerpiece of the annual Lenten parade in Paris in 1912.

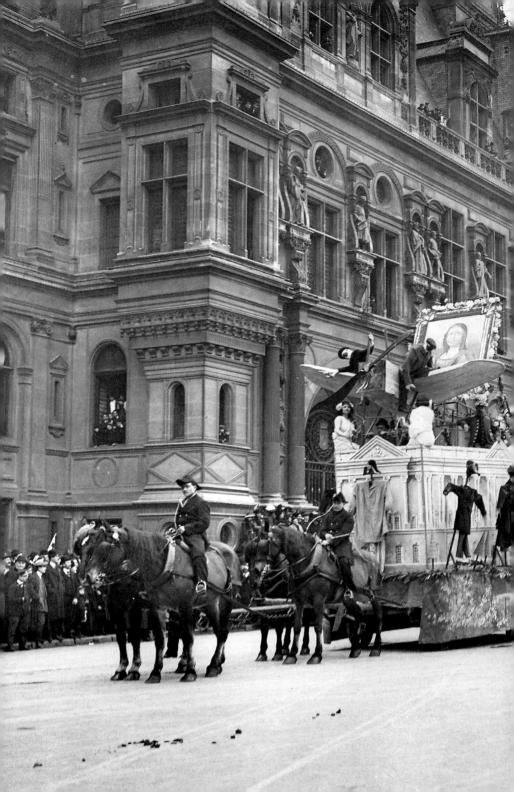

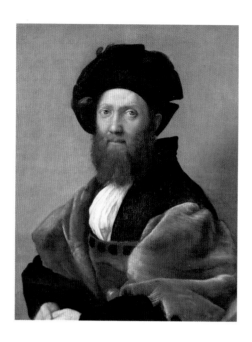

ABOVE
Baldassare Castiglione
Raphael
1514–15
By 1912 it seemed that the *Mona Lisa* might never
be recovered, and Louvre officials decided to hang
something in her place. Raphael's *Baldassare
Castiglione*—a work heavily influenced by Leonardo's
painting—was exhibited until 1913, when the Louvre
purchased Corot's *Woman with a Pearl*. In this
triumph of early Impressionism, the sitter is almost
as mysterious as Mona herself.

RIGHT
Woman with a Pearl
Jean-Baptiste-Camille Corot
c. 1869

ABOVE
Alfredo Geri
c. 1913
On November 29, 1913, Alfredo Geri, a respected antique dealer in Florence, received a letter from someone claiming to have the Louvre's missing painting. Geri contacted Giovanni Poggi, the curator of the Uffizi Gallery in Florence, and the two men encouraged the letter writer to come to Florence with the portrait.

LEFT
View of Florence

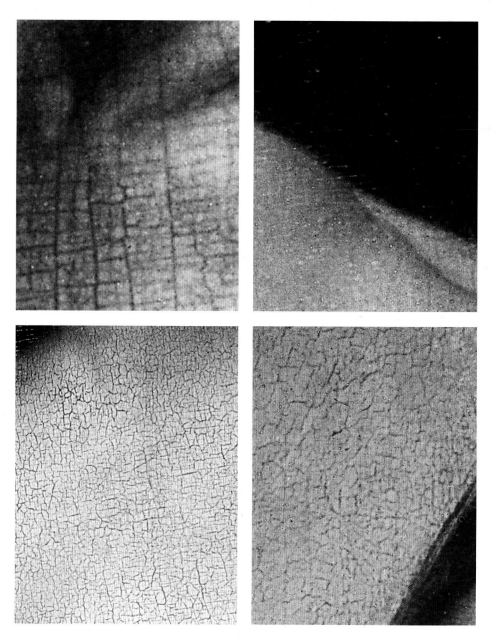

ABOVE, AND RIGHT
Mona Lisa, details showing the *craquelures*
Leonardo da Vinci
1503–c.1507

On December 12, Geri and Poggi visited "Leonardo Vincenzo" at his hotel. Poggi inspected the painting and found the Louvre catalog number and the official museum seals on its back. Both men advised "Leonardo" to bring the painting to the Uffizi. There they performed further tests and confirmed, by a close examination of the *craquelures*, the tiny cracks in the varnish that are unique to a painting, that the portrait was, indeed, the *Mona Lisa*.

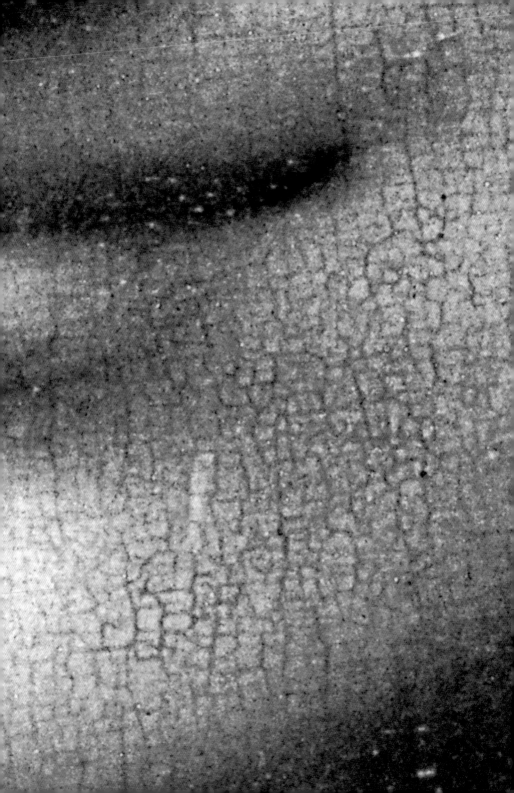

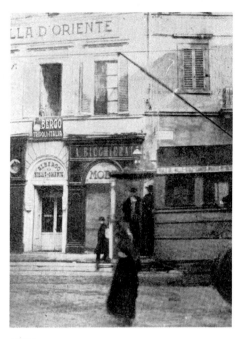

Vo\u00f9te

Enverg. 1ᵐ _6_

Buste 0ᵐ _87.8_

Tête } largʳ

zygʳˢ

Oreille dr.

(Point de vue : 2ᵃ — Réduction 1/7)

Notes

ABOVE
The Tripoli Hotel
c. 1913
Police arrested Vincenzo Peruggia at this modest hotel
in Florence.

RIGHT
Police photograph of Vincenzo Peruggia
1913

Médius g. _11.0_

Auricre g. _8.5_

Coudée g. _431_

Coul^r de l'iris g

aur^{le} _c war cl_

péri^e _ard_

partés

Barbe _chɣa u_

Teint P^{on} _m_ Sce _m_

Main dr.

Main g.

25.1.09

378.699

Dressé à Paris, le _21_ 1904 par M. _Mazgazaudy_

Main droite

ABOVE
**Cubbyhole in the apartment of Vincenzo Peruggia
1913**
Unbelievably, Peruggia had kept the *Mona Lisa* for
two years in a crowded cubbyhole near the stove in his
small Paris apartment, not far from the Louvre.

RIGHT
**Apartment of Vincenzo Peruggia
1913**

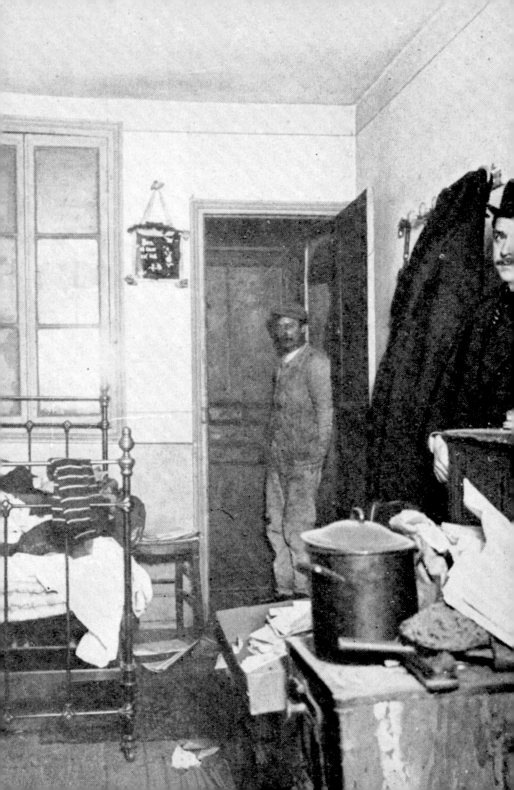

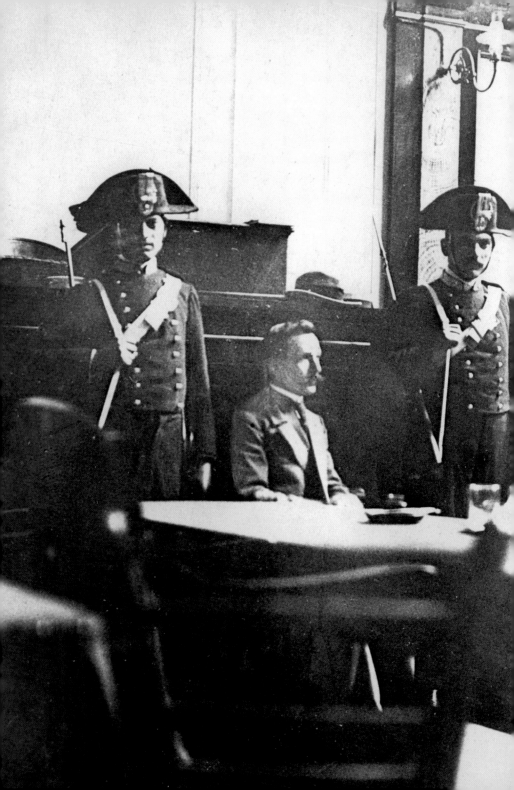

Vincenzo Peruggia in court
1913
An Italian national, Peruggia—shown here flanked by two *carabinieri* in cocked hats—claimed he had liberated the *Mona Lisa* from France and had planned to return the portrait to Italy. The court didn't buy the story but was still relatively lenient. The prosecutor had wanted Peruggia jailed for three years; he got twelve and a half months—and some fleeting fame.

Italian police guarding the *Mona Lisa* at the Uffizi Gallery, Florence
1913
After Peruggia's trial, Italian and French authorities worked out an agreement. The *Mona Lisa* would return to its adopted home, but not before making a grand tour of some of the galleries of Italy. The tour marked the first time the portrait was back in Italy in almost four hundred years.

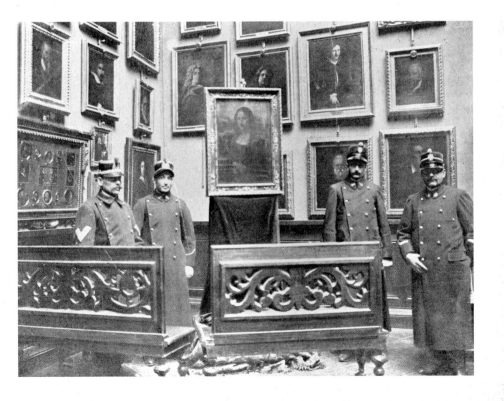

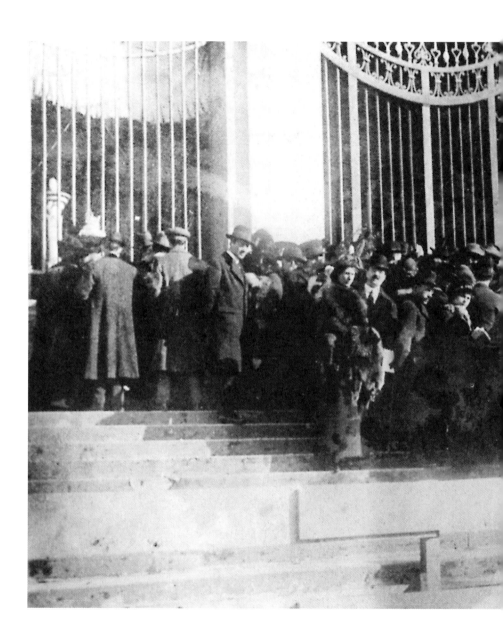

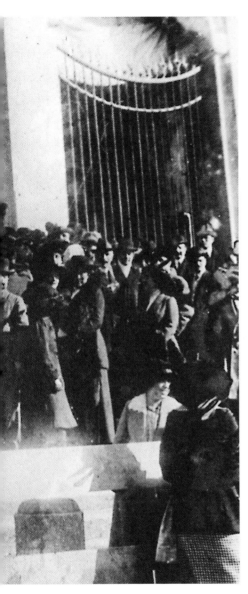

LEFT
**Crowds outside the Villa Borghese, Rome
December 1913**
After Florence, the *Mona Lisa* visited Rome, where
the Italian royal family paid court to her as though
she were a visiting monarch. But it was the ordinary
people, lined up in multitudes, who benefited most from
the visit. This tour signaled the start of what we know
today as the traveling mega exhibit.

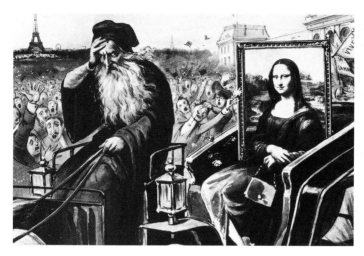

ABOVE
Postcard
Yves Polli
1913
After the festivities in Rome, it was on to Milan and
the Brera museum. This humorous postcard shows the
Mona Lisa being driven through the cheering crowds
in a coach by a harried-looking Leonardo.

RIGHT
The Piazza del Duomo, Milan

View of Paris
The news of the *Mona Lisa*'s return to France electrified
Paris. Enormous crowds gathered at the Gare de Lyon
to witness her arrival by train.

**Postcard commemorating the return
of the *Mona Lisa***
1913

**Inspection of the *Mona Lisa* at the
École des Beaux Arts, Paris
January 1914**
Before the portrait's return to the Louvre, it had one more
guest appearance to make—at the École des Beaux
Arts. After the experts checked on its condition, the
painting was displayed for three days at the art school.

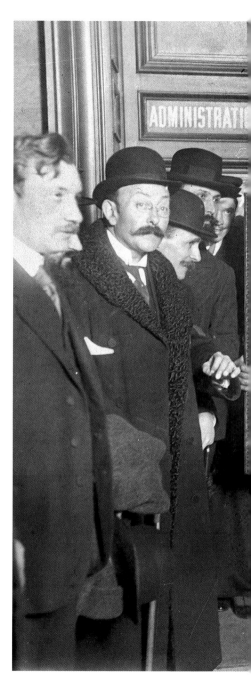

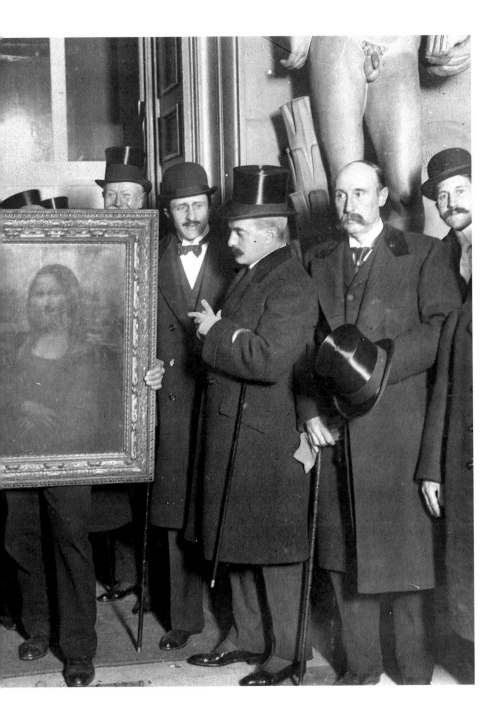

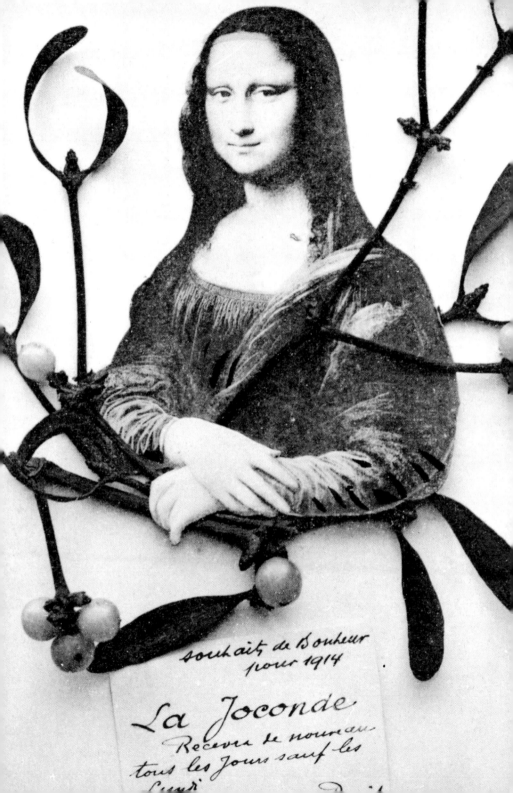

souhaits de Bouheur
pour 1914

La Joconde

Recevez de nouveau
tous les jours sauf les

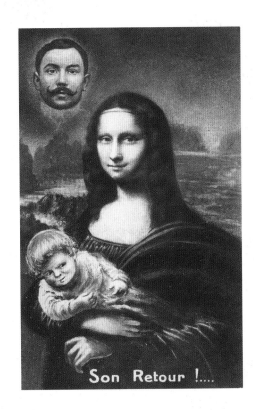

Son Retour !....

New Year's postcard featuring the *Mona Lisa*
1913
The return of the painting triggered another flood of
popular kitsch. This New Year's card reassured
museum-goers that the *Mona Lisa* would again be
receiving visitors—except on Mondays, of course.

Postcard from the return of *La Joconde*
c. 1913
In case anyone wondered what Mona Lisa had been
up to while she'd been away, the artist of this postcard
had the answer!

2006

CHAPTER 5

GLOBAL ICON

AFTER THE EXCITEMENT OF THE THEFT, the *Mona Lisa*'s celebrity was kept alive by clever parodies among the avant-garde and by ever-expanding representation in popular culture. In literature, writers in several countries began to allude to the painting in their works, and the "Mona Lisa smile" quickly became a symbol of enigmatic behavior. D.H. Lawrence mentioned it in his short story "The Lovely Lady" (1933), Lawrence Durrell in *Justine* (1957), and Mary McCarthy in *The Group* (1963). In the memoir, *Words* (1964), Jean-Paul Sartre used it to describe his grandmother's voluptuous smile.

The *Mona Lisa* moved into lyrics and was featured in Cole Porter's 1934 song "You're the Top":

> You're the Nile;
> You're the Tower of Pisa;
> You're the smile
> on the Mona Lisa...

An even greater hit was "Mona Lisa," which Nat "King" Cole made famous in 1950, when it topped the US charts:

> Mona Lisa, Mona Lisa, men have named you.
> You're so like the lady with the mystic smile.
> ...
> Do you smile to tempt a lover, Mona Lisa?
> Or is this your way to hide a broken heart?

And, in 1966, the *Mona Lisa* caught Bob Dylan's attention:

Inside the museums, Infinity goes up on trial
Voices echo, this is what salvation must be like after a while
But Mona Lisa musta had the highway blues
You can tell by the way she smiles.

Mona Lisa, the woman, found a new audience in comic strips such as *Li'l Abner* and *Mandrake*, and in cyberpunk sci-fi such as William Gibson's cult *Mona Lisa Overdrive* (1988). In fiction, the theft story was lavishly used, inspiring a number of stories around the theme "Who *really* stole the *Mona Lisa?*" Meanwhile, copies of the painting previously regarded as mere replicas were now touted by their owners as the genuine *Mona Lisa*.

As the painting's fame spread, it was inevitable that the icon would attract the iconoclasts and be debunked. The main pioneer was Marcel Duchamp, who claimed that art could be made out of anything at all, including a urinal. In 1919 he produced the most famous send-up of all: he took a postcard of the *Mona Lisa* and drew on her face a mustache and a goatee. He compounded the sacrilege by calling it L.H.O.O.Q.—letters which, if spelled out in French, sound like *elle a chaud au cul* ("she's got a hot ass"). Duchamp had started a trend, and artists on both sides of the Atlantic joined in the fun. Fernand Léger illustrated the household popularity of the *Mona Lisa* in his *La Joconde aux Clefs* (1930), where the figure is reproduced alongside keys and other ordinary objects. "The Joconde, for me," he said, "is an object like any other."

During the Second World War, when the French government hid the cultural treasures of the Louvre in a succession of manor houses, the *Mona Lisa* was moved first to the Château at Amboise, then to the abbey of Loc-Dieu, and finally to the Ingres museum

in Montauban. Along with a few other paintings, it received special treatment: only places with central heating would do. Despite the inevitable exaggerations in the press ("Central heating installed for the *Mona Lisa*"), the temperature had to be kept stable for this masterpiece. Mona Lisa's smile was even used by the BBC World Service as a coded message to the French Resistance: "The Joconde keeps her smile."

After the *Mona Lisa*'s return to the Louvre in 1947, artists the world over continued to parody the famous lady. Pop artist Robert Rauschenberg weighed in with *Untitled* in 1952, the first of a large number of works he produced that featured the *Mona Lisa*. In 1960 it was Magritte's turn. His *La Joconde* does not represent the famous Joconde; we all know how it looks, so what we get is a typical Magritte sky with clouds enclosed in a shape, flanked by two pleated curtains, and, at the base, a ball marked by a provocative slit.

Even vandalism is a tribute of sorts to the power and fame of an icon. On December 30, 1956, a half-crazed painter named Ugo Ungaza Villegas threw a stone at the *Mona Lisa*—slightly damaging the pigment near the subject's left elbow—and obtained his fifteen minutes of fame in the process. The incident made it into almost every newspaper in the world, and each article recounted, once again, the now-famous *Mona Lisa* story and its three canonical "mysteries": Why is the smile enigmatic? Who was the model? Is the Louvre's *Mona Lisa* authentic?

Two decades after the war, politics intervened again to send the *Mona Lisa* on the road—first to the United States, then to Japan and Russia, where Leonardo's tiny masterpiece was viewed by millions of people who otherwise would never have seen it except in reproduction. In the process the portrait became not just a

French national treasure but a global icon as well. And it started with the Kennedys.

In 1961, US President John Kennedy and his wife, Jacqueline, visited Paris, guests of President Charles de Gaulle. The purpose of the trip was to improve Franco-American relations, then in one of their regular frosty periods. The First Lady's mastery of French culture and language charmed the usually reserved de Gaulle, along with thousands of screaming Parisians, and the visit was an enormous success. In this new climate of warmth between the two countries, someone suggested that the *Mona Lisa* should be exhibited in the United States. The curators at the Louvre were appalled and cited the risk: the 500-year-old piece of wood might crack at the slightest change in temperature. But the French government was not about to be deterred in its symbolic gesture of goodwill. The *Mona Lisa* was going to America.

The preparations took months. The painting had to travel by ship, like a queen. It was taken to Le Havre with a motorcycle escort. After the captain of the luxury liner SS *France* welcomed the *Mona Lisa* aboard, it was installed in a first-class cabin within a specially constructed waterproof box that could float—in case the ship sank. The press lovingly reported every detail. Finally, on December 14, 1962, the *Mona Lisa* embarked on its first voyage outside Europe.

On January 8, 1963, it was welcomed to the United States at a glitzy party at Washington's National Gallery. Photographers had a field day juxtaposing Jacqueline Kennedy's radiant smile with Lisa's. The dinner at the French Embassy featured *Poires Mona Lisa*, a dessert created for the occasion. The painting was exhibited in Washington and then at New York's Metropolitan Museum of Art. *The New Yorker* calculated that each of the 1.6

million visitors took an average of four seconds to contemplate the portrait. That timing might seem a little rushed, but, as with pilgrims viewing a holy relic, it was sufficient to make people feel sanctified by the experience. The exhibition, its political aims aside, contributed further to the metamorphosis of the *Mona Lisa* into a world icon—like Niagara Falls, the Eiffel Tower, the Grand Canyon, the Great Wall of China, and the Pyramids. It was something one just *had* to see.

A decade later, and despite the same strong opposition from the Louvre's curators, the *Mona Lisa* went on tour again—this time to Japan, the new economic giant of the seventies. The painting traveled by plane and, once more, the trip got huge exposure in the press. During the *Mona Lisa*'s first week on display in Tokyo, more than 18,000 people daily came to view the famous work of art. From Tokyo, the portrait traveled to Moscow for an exhibition arranged by the French government in a spirit of détente with the Russians. This tour, unlike the American one in 1963, involved massive merchandising: *Mona Lisa* dolls, posters, and cards were sold in large quantities, and the enigmatic smile was commented on everywhere.

The Louvre curators had reluctantly agreed to let the painting leave the museum, on condition that it be transported in a special box and exhibited behind protective glass. Once the *Mona Lisa* was back in France, they could hardly deny it the same treatment at home. The portrait was repositioned in the Louvre in a bullet-proof box—the only artwork to be so protected against vandals and crazies. Signposts were also installed throughout the museum, directing visitors to the *Mona Lisa*.

Mass tourism is a recent phenomenon: the wide-bodied jets that can carry over four hundred passengers on a single flight

were brought into service only in 1970. By the 1990s, travel and tourism had become one of the most important industries in the world, as workers won the right to paid holiday time, currencies freed up, and relative travel costs plummeted. "Cultural tourism" benefited the great art-rich capitals of Europe: Rome, London, Venice, Florence, and, of course, Paris.

Most tourists seldom spend more than a few intense and exhausting days in one city. In Paris, a first-timer feels duty-bound to visit the Louvre, along with six million other tourists every year—and a quick look at the *Mona Lisa* is mandatory. After that, for many, the Louvre is "done."

The advent of art posters also helped spread the *Mona Lisa*'s international fame. With vast numbers of posters readily available, everyone could now have Leonardo's masterpiece in their bedroom—just as Napoleon had. Artists everywhere celebrated this new popular cliché. Andy Warhol had already begun his visual commentary on mass production and celebrities, including his series on Marilyn Monroe, Elvis Presley, and Campbell's Soup Cans. In 1963, right after *Mona Lisa*'s American tour, he followed with his *Thirty Are Better Than One*—until the 1980s, his only multiple use of a painting. As ever, he was percipient: *Mona Lisa* was no longer just high culture but had become a cultural icon; it was not just a precious object protected in a museum but a media projection as well. The artists who played with the image were not debunking it but using it to advertise themselves—and, in the process, consolidating its position as the most famous painting in the world.

Mona Lisa was shown with a giant apple hiding most of her face (*Magritta Lisa* by Terry Pastor); in bed with Leonardo (*Leo and Mona* by Graham Dean); as a gorilla (*The Mona Gorilla* by

Rick Meyerowitz); and as an extraterrestrial hero like Steven Spielberg's E.T.—called, appropriately, *Mona Futura*.

Interestingly, advertising has reaped the greatest benefits from these artistic derivations. As production became global and local identities became subsumed in a wider culture, advertisers needed to use instantly recognizable universal symbols—and the *Mona Lisa* was definitely one of them. The trips to Washington and Tokyo had positioned it as the world's best-known picture, and it has remained at the top ever since, thanks largely to the advertising industry. Some of these applications have been witty and clever; others, tiresome and in poor taste.

In the 1950s, shoppers could find the *Mona Lisa* brand on condoms in Spain, on Spanish and Italian oranges, on Italian-made cheese, on Dutch cigars, on US stockings, and on Argentinian matches. In the years since, the *Mona Lisa* has advertised Air-India flights to Paris (1962), rum from Martinique (1986), American wigs, and the 1989 Tapei Trade Show. Mudd, the UK's biggest-selling cosmetic face mask, even represented Mona Lisa's visage caked with mud.

Since 1980, there has been at least one new use of Leonardo's portrait of Lisa Gherardini every week! That's quite a remarkable tribute to an unassuming Florentine housewife. But not all odes to Lisa are creatively equal. Perhaps the most disturbing was an experiment in 1990 by French performance artist Orlan, who underwent plastic surgery to make herself look like the *Mona Lisa*. That same year, the organizers of the World Cup, held in Italy, used Mona Lisa as the tournament's symbol, placing a football in her hands. The portrait has also offered an easy option for cartoonists trying to represent celebrities: Stalin, Tony Blair, Hilary Clinton, and Chairman Mao have all been "Monalized."

Today, the *Mona Lisa* has moved outside her frame, beyond her historical context, and has been used and distorted by an endless succession of painters, writers, advertisers, caricaturists, and musicians. She has saturated popular culture and has become whatever others want her to be.

Now Leonardo's masterpiece has received the supreme accolade. The famous Salle des États in the Louvre has been entirely reconstructed. Its walls are graced by works from the great Venetian painters, including Veronese's gigantic *Marriage at Cana*, five Tintorettos, and ten Titians. In the center of the large room, a new freestanding wall has been erected. There, solitary and smiling, hangs the small portrait of Lisa Gherardini—the only painting in the Louvre to have its own wall.

And it remains the focus of international attention. Will it be cleaned and restored to the vivid colors Leonardo must have used? Will it survive, or will the slight crack detected in 2004 prove to be beyond repair? Any rumor concerning its fate, any new theory concerning its origins, receives worldwide coverage.

One thing is certain: no single factor transformed the *Mona Lisa* into the best-known painting in the world. Its surge to unparalleled fame was due to Leonardo, who painted it; Francesco del Giocondo, who commissioned it; François I, who brought Leonardo to France; the Louvre, which became one of the most visited museums in the world; the romantic writers who made it the femme fatale; Vincenzo Peruggia, who stole it; the artists who played around with the image; the cartoonists who lampooned it; and the advertisers who used it for every conceivable purpose—over and over again.

The Florentine lady immortalized by Leonardo will continue, in her sixth century, to enchant and intrigue.

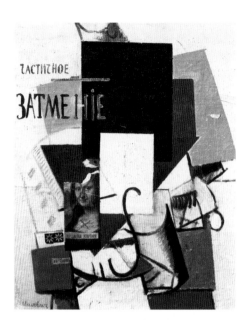

ABOVE
Composition with Mona Lisa
Kasimir Malevich
1914
After the theft, the *Mona Lisa* became a metaphor for
high culture—and, as such, fair game for the avant-garde.
Malevich put crosses through her in his not-so-subtle
rejection of what the painting represented.

RIGHT
L.H.O.O.Q. ("She's got a hot ass")
Marcel Duchamp
1919
Dadaist artist Marcel Duchamp's witty mustache and
rude annotation opened up the floodgates for parodies
of the *Mona Lisa*.

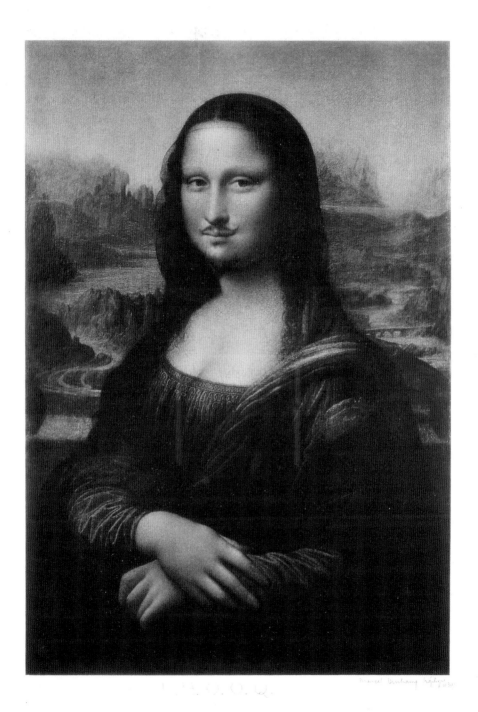

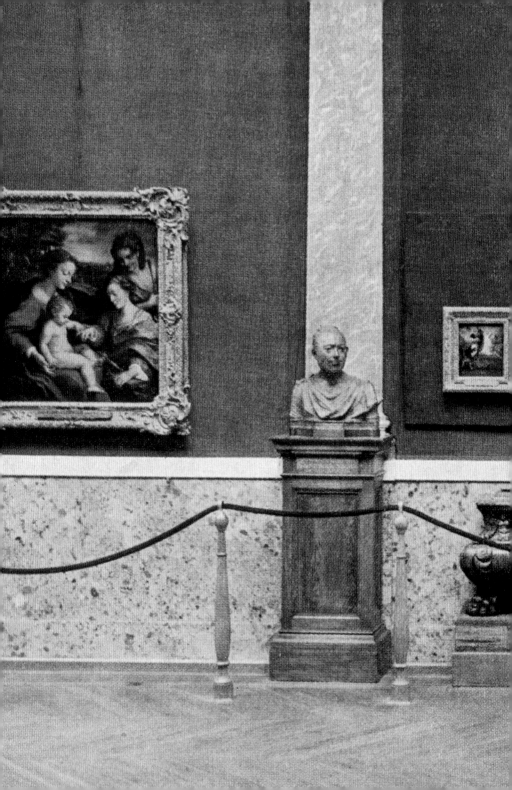

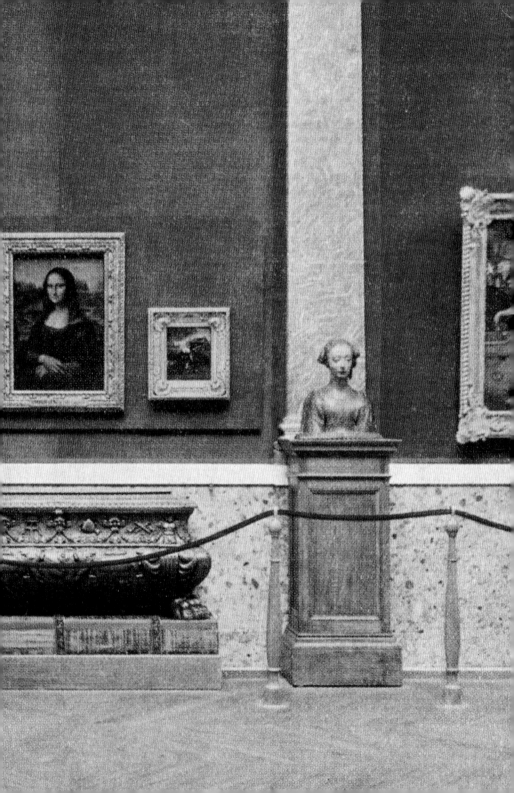

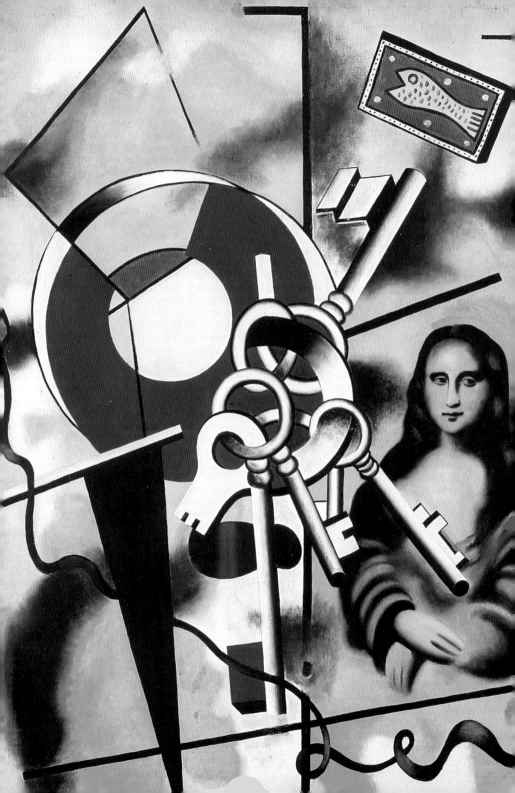

The Salon Carré in the Louvre
1929
Following the *Mona Lisa*'s return in 1913 after the theft, it was given pride of place in the Salon Carré at the Louvre. The portrait was now roped off and flanked by two busts and two small paintings.

LEFT
La Joconde aux Clefs
Fernand Léger
1930
The French cubist painter surrounded Mona Lisa with a bunch of keys—implying that she, like them, was now an unremarkable, everyday item.

HENRI SEGUIN

LE JOCOND

Editions du Siécle

ABOVE
Cover of *Le Jocond*
Henri Seguin
1925
Mona Lisa began making more frequent appearances in literature between the wars, figuring in works by a number of writers, including Aldous Huxley, the Turkish poet Nazim Hikmet and André Gide.

RIGHT
Still from *The Theft of the Mona Lisa*
1931
Many films used the *Mona Lisa* as the center of a heist, but this early German sound film was based quite closely on the true story of the theft by Vincenzo Peruggia.

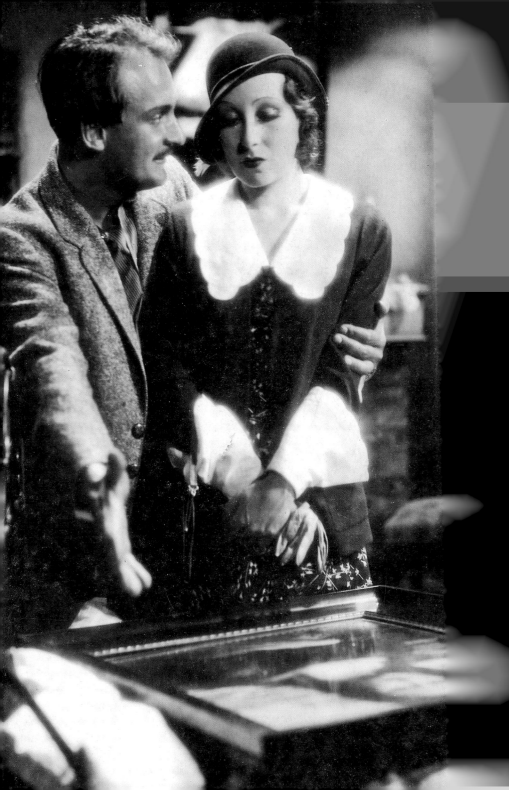

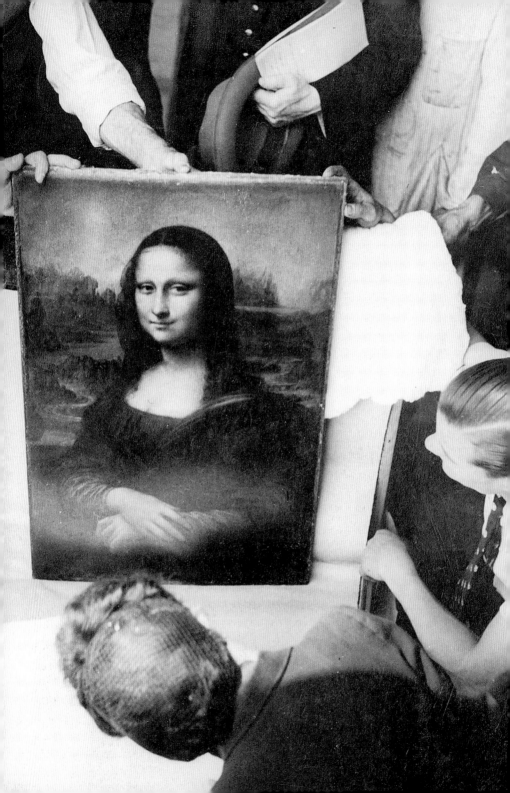

LEFT
Keeping the *Mona Lisa* safe
During the Second World War, the *Mona Lisa* and a number of other valuable works of art were evacuated from the Louvre and moved to a series of "safe houses" in the French countryside. Here museum workers carefully remove protective wrapping from around the painting.

BELOW
**Fire prevention at the abbey of Loc-Dieu
1939**
The *Mona Lisa* was moved first to the Château at Amboise, then to the abbey of Loc-Dieu, and finally to the Ingres museum in Montauban. Here workers spray water on the ancient abbey as a fire prevention measure.

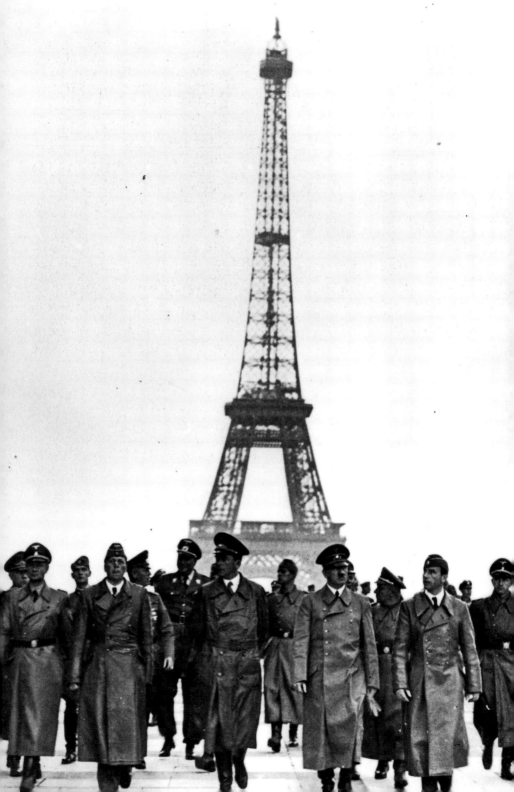

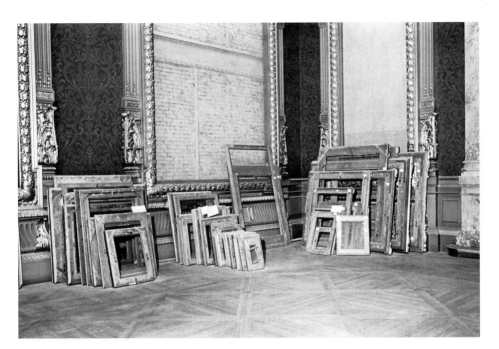

Adolf Hitler enters Paris
1940
When France fell to the German army in June 1940, the Louvre's curators feared Nazi plans for their art treasures. Hitler had detailed Hermann Voss, an art historian, and Hermann Göring to seize objects in occupied countries for a planned museum just outside Hitler's boyhood home of Linz, Austria.

Empty frames at the Louvre
1942
By the time the German army had seized control of France, the Louvre's collection of masterpieces had been safely secured and was left untouched by the occupying forces. Though mostly empty, the Louvre reopened to the public under the Occupation in 1940.

Leonardo da Vinci and Isabella d'Este
André Masson
1942
Despite the war, interpretations of the *Mona Lisa*
continued to appear. This Surrealist painting by Masson
bears little obvious connection to any of Leonardo's
works, but, by this time, the artist and his oeuvre were
so well known that a mention of either was enough to
convey the artist's intentions.

FOLLOWING SPREAD
Paris celebrates its liberation
August 1944
Paris was liberated by Free French forces on August
25, 1944. The *Mona Lisa* could now be safely returned
to the Louvre.

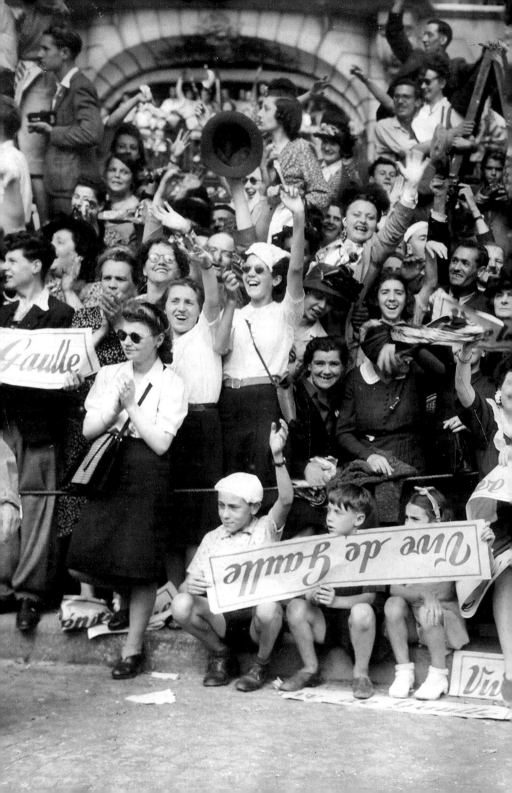

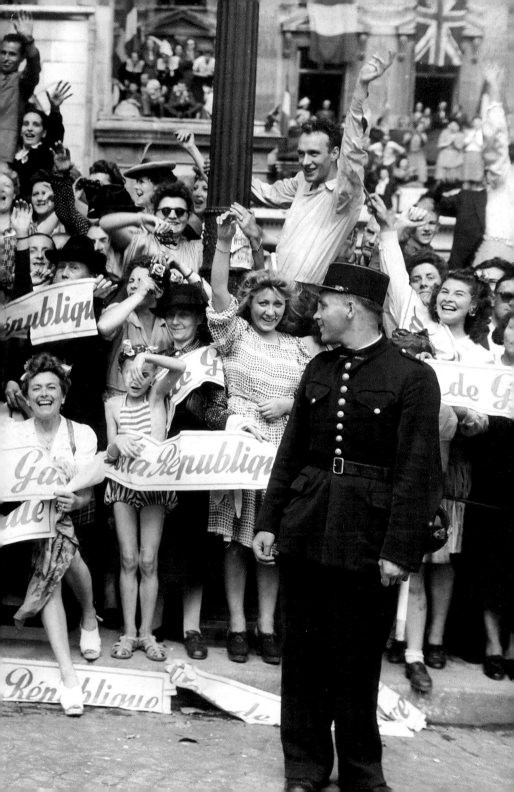

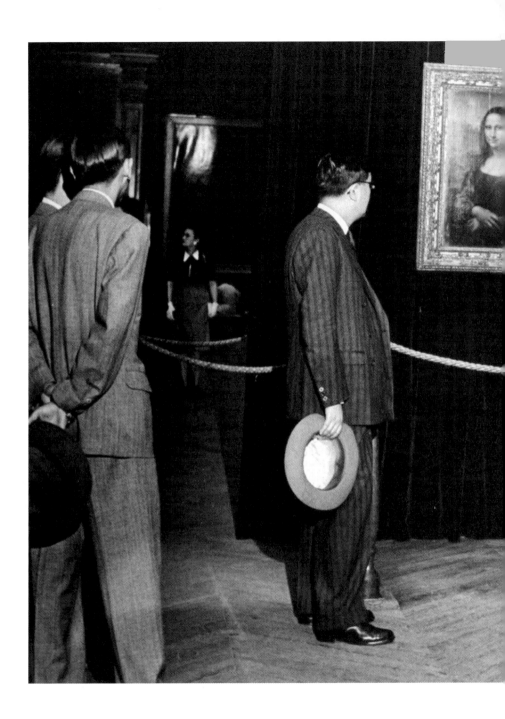

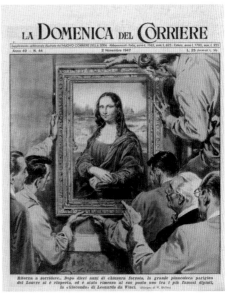

LEFT

Chinese delegates at the Paris Peace Conference
August 1946

Before its return to the Louvre, however, the *Mona Lisa* was put on display for some special visitors. Here, Chinese delegates to the postwar peace conference enjoy a private viewing of the famous portrait. In the decades following the war, a new sense of internationalism opened the *Mona Lisa* to a global audience.

ABOVE

Cover of *La Domenica del Corriere*
November 2, 1947

Given the chaos in France and in Europe generally in the immediate aftermath of the war, it was not until October 1947 that the *Mona Lisa* resumed its place at the Louvre. The event was widely celebrated by the media.

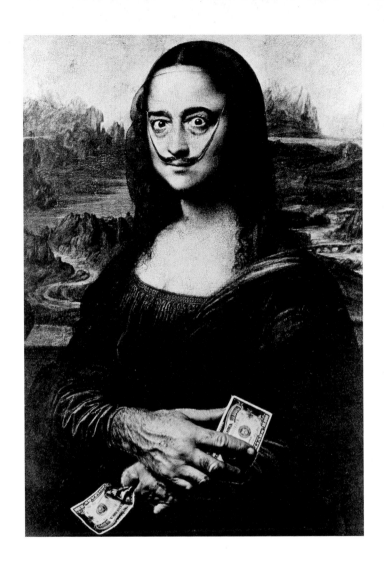

La Joconde
Jean Dubuffet
1948
After the war, artists continued to produce works that
copied, parodied, or borrowed from the *Mona Lisa*.
Avant-garde painter Jean Dubuffet focused in his *art brut*
(raw art) on simple, primitive images, as might be drawn
by children.

Self-Portrait as Mona Lisa
Salvador Dali
1954
Dali parodied both the painting and its most
famous disfigurement.

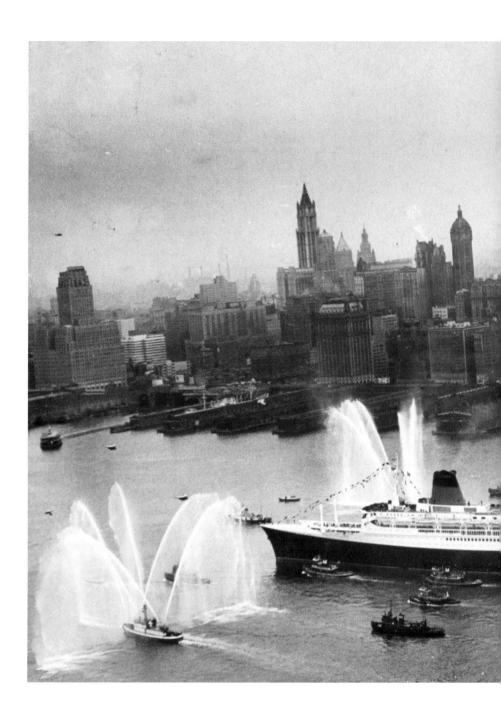

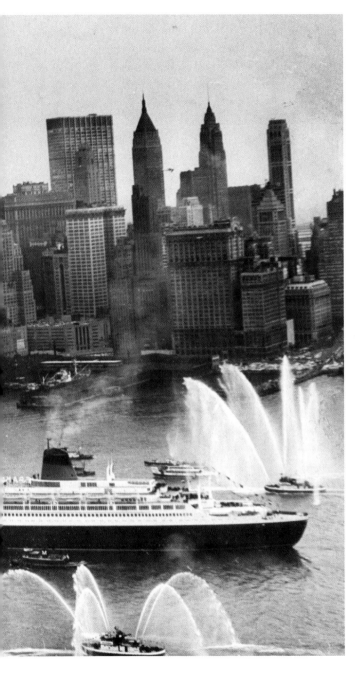

Arrival of the SS *France* in New York City
January 1962
With an American tour for the *Mona Lisa* confirmed, French officials began planning how to transport their treasure. The luxury liner SS *France*, here arriving in New York City after its maiden voyage, was designated to carry the portrait across the ocean in fitting style.

Press conference before departure
1962
The French press has a firsthand look at the specially constructed waterproof box in which the *Mona Lisa* would be housed during its journey to the United States.

The *Mona Lisa* aboard the SS *France*
1962
A French security guard sits watch over the boxed painting as the SS *France* crosses the Atlantic.

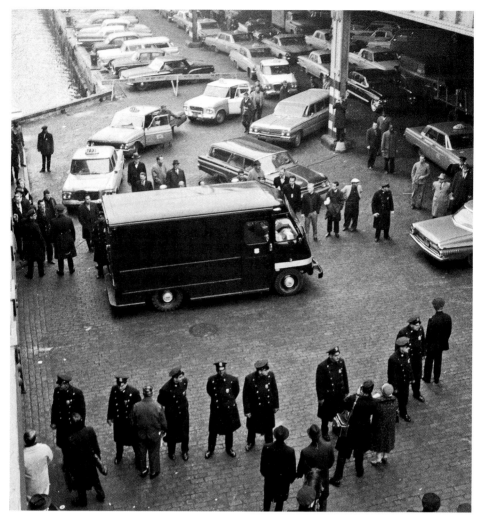

**The *Mona Lisa* arrives in Washington
December 1962**
The *Mona Lisa* landed at the port of New York on
December 19, 1962. The newspapers covered its every
move. The painting departed New York in a modified
ambulance, and is seen here arriving in Washington for
its debut.

RIGHT
**The *Mona Lisa* on display in Washington
1963**
The first public showing was delayed until January so
that numerous important officials, among them the
president, could attend the opening at the National
Gallery. A marine stood guard to prevent any well-heeled
patrons from reaching out to touch the work.

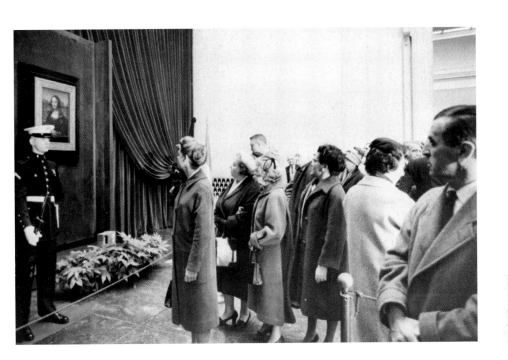

MONA LISA / 297

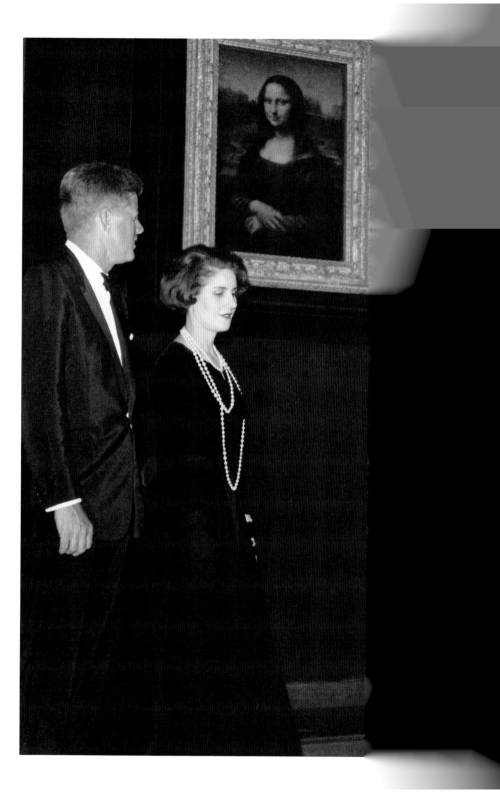

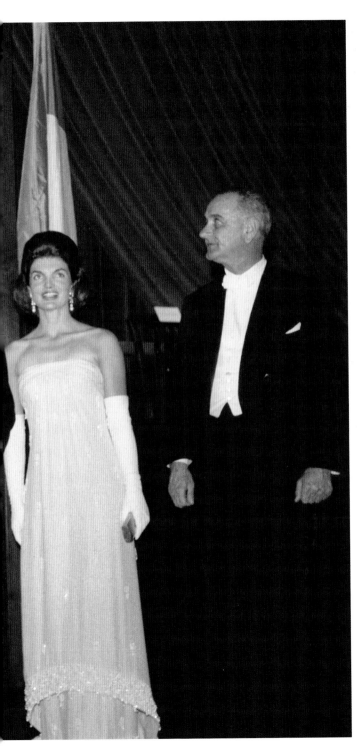

Official reception for the
Mona Lisa
January 8, 1963
Mona Lisa's welcome befitted
a head of state. Here
President Kennedy and his
wife, Jacqueline, stand with
French Minister of Culture
André Malraux (to the left of
Jackie) at the official unveiling
of the painting at the National
Gallery. They are joined by
Madame Malraux and Vice-
President Lyndon Johnson.

Crowds at the National Gallery, Washington
January 1963
The *Mona Lisa* attracted a remarkable cross section of
the public, as this quick glimpse of the crowds reveals.

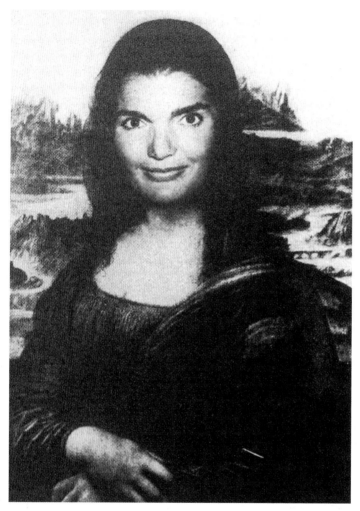

ABOVE
Jacqueline Kennedy as the *Mona Lisa*
1962
As the ultimate living icon of the sixties, Jackie was an obvious candidate for "Monalization."

RIGHT
Mona Lisa Four Times
Andy Warhol
c. 1963
Warhol, the leading pioneer of Pop Art, grasped the painting's modern status. He viewed it neither as a masterpiece nor as an icon but simply as another image endlessly multiplied by technology—just like images of Marilyn or Elvis or soup cans.

FOLLOWING SPREAD
Lining up for the lady with the smile
1962
More than 1.6 million people lined up to see the *Mona Lisa* in both Washington and New York. *The New Yorker* estimated that each one had about four seconds to view the painting. Here, the lineup at the Metropolitan Museum of Art in New York City extends around the block.

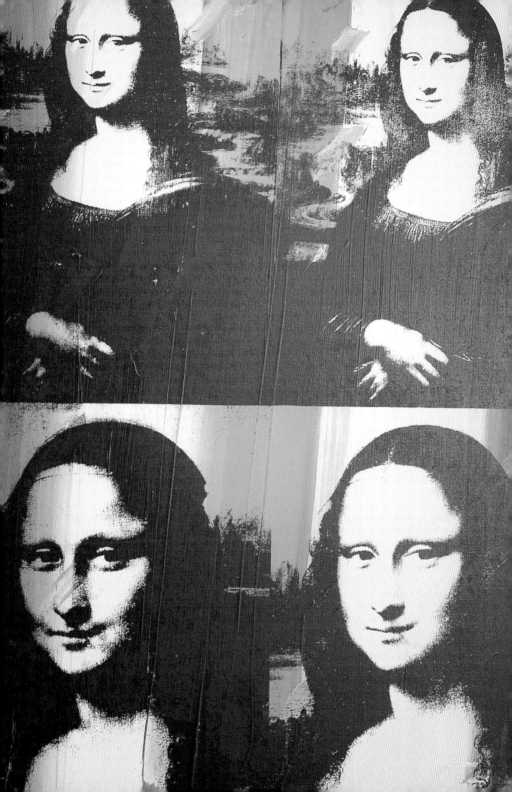

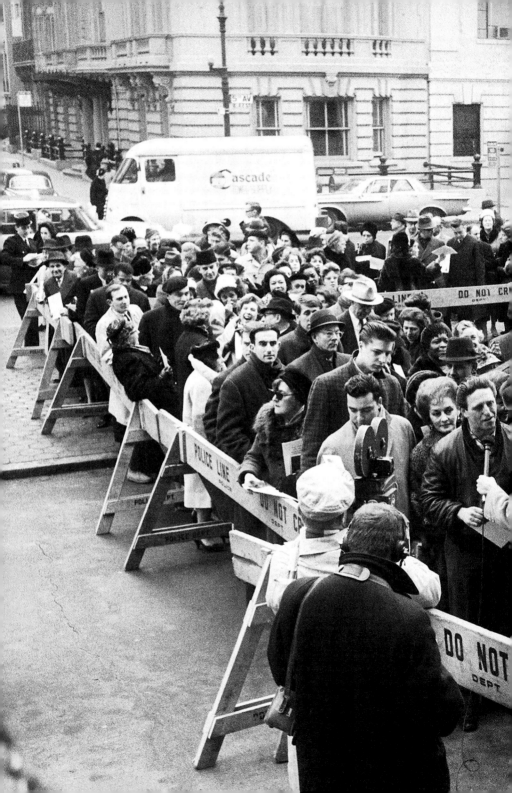

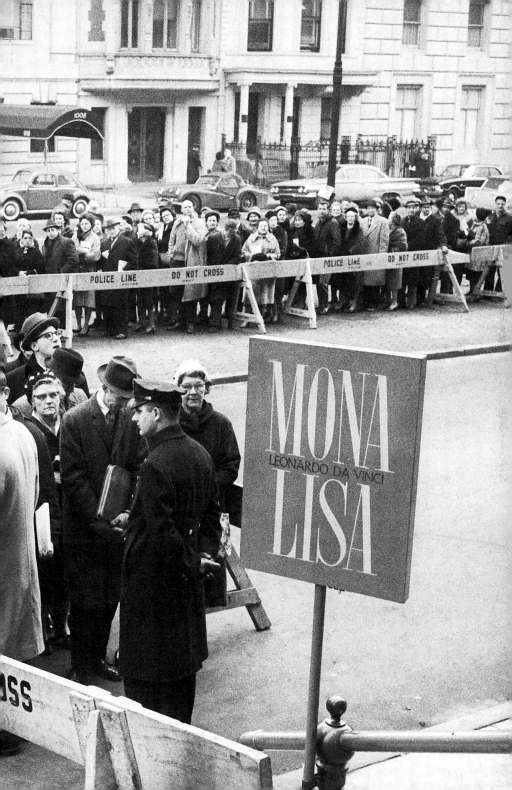

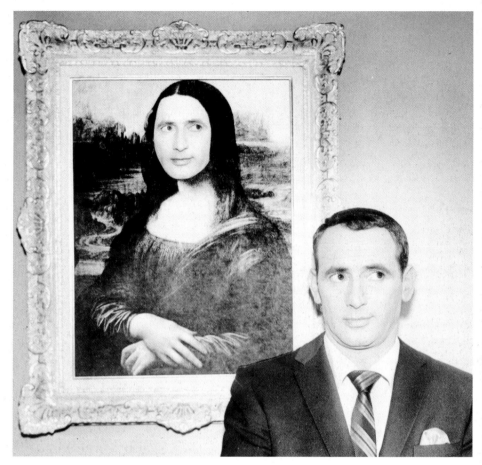

ABOVE
Joey Bishop
1964
Comedian and Rat Packer Joey Bishop was another excellent candidate for "Monalization." He's pictured here beside a gag gift presented to him by his staff on April Fool's Day.

RIGHT
The Vernon Family and the "Vernon *Mona Lisa*"
1964
With the Louvre's *Mona Lisa* established as the world's best-known and most valuable piece of art, challengers were soon coming out of the woodwork. The Vernon family claimed that their version was the real thing. Picked up in late-eighteenth-century Paris by ancestor William Henry Vernon, this painting is assumed by experts to be a sixteenth-century copy. In 1964, however, it was exhibited in Los Angeles with the tag "Attributed to Leonardo da Vinci."

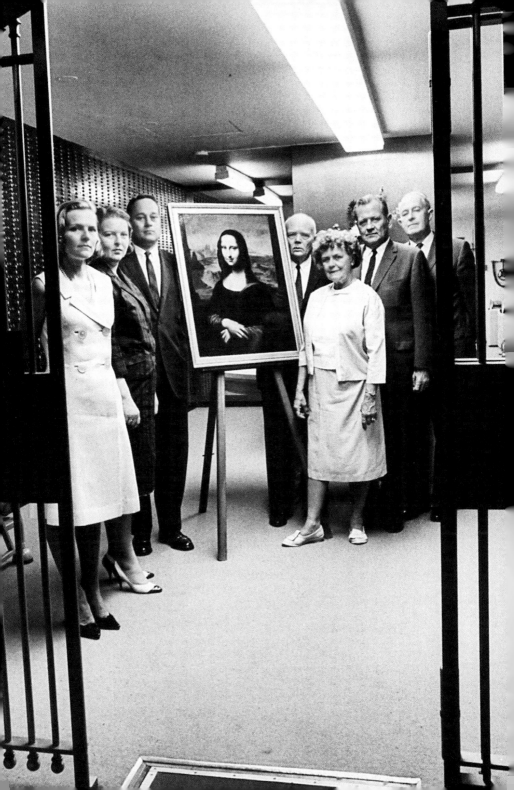

LEFT
The Mona Lisa is in the stairwell
Robert Filliou
1969
In the second half of the twentieth century, the artistic
references continued. No matter how avant-garde the
artists or their work, the *Mona Lisa* remained a visual
and artistic touchstone.

ABOVE
Figure 7, from Color Numeral Series
Jasper Johns
1969

ABOVE
Reverse of the *Mona Lisa*
c. 1970s
In 1970 the *Mona Lisa* underwent some structural repair work. The crosspieces that had been added in 1951 to support the painting and stop it from warping were replaced. Restoration of the *Mona Lisa* has always been a contentious issue. Some art historians continue to argue for the removal of the varnish that covers the painting and gives it the yellow-brown cast familiar to modern viewers. This varnish was probably not original, but may have been applied in the seventeenth century.

RIGHT
X-ray of the *Mona Lisa*
1951

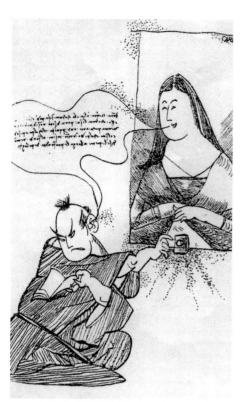

LEFT
Japanese cartoon
1974
In 1974 Leonardo's masterpiece traveled to Japan.
Computer gadgetry, then in its infancy, simulated what
Lisa might have sounded like if she had spoken Japanese.
At the push of a button, the wired Lisa Gherardini said
"Hi, my name is Lisa, and I am known as the Gioconda."

ABOVE
***Mona Lisa* posters cover the floor of a Tokyo bank**
1974
Another great difference between this tour and the
1963 jaunt to the United States was the abundance of
marketing tie-ins. The Japanese trip offered many
opportunities for displaying Mona-related material, such
as this Tokyo bank plastered with posters.

AIR-INDIA

The Second Annual Max Michalski Graphic Arts Competition

For the most original paper on graphic arts technology.

$2,000 award.

A $2,000 award is made to encourage the intellectual curiosity and spirit of discovery that marked the career of the late Max Michalski, Vice President of Engineering, Berkey Technical Co.

In line with Mr. Michalski's achievements, special consideration will be given to topics on the photographic arts. However, any subject concerning Graphic Arts Technology will qualify for this award.

The competition is open to all graphic arts students. Papers of at least 2000 words are to be submitted by December 1, 1978. Awards will be announced January 15, 1979.

In addition, the prize winner may be offered summer employment by Berkey Technical Co. in its Research and Development Labs in the U.S.A. or in Europe. Berkey Technical Co. is the world-wide leader in the design and manufacture of photographic, dark-room and graphic arts products.

Rules.

All entries will be acknowledged and are non-returnable.

All entries must be accompanied by the completed Disclosure Form. Winners will be notified in writing and their names printed in major Graphic Arts Publications.

Berkey Technical Co. will attempt to secure technical publication under the author's name for all outstanding papers.

Berkey Technical Co., at its option, may include the prizewinners in patent applications and commercialization of any qualified novel ideas.

Entries should be submitted to: Max Michalski Award Committee, Berkey Technical Co., 25 ½ 58th St. Woodside, NY 11377, U.S.A.

Sponsored by Berkey Technical Co.

TOP ROW, FROM LEFT
The Mona Gorilla, Rick Meyerowitz, 1971
Advertisement for Air-India
Magritta Lisa, Terry Pastor
The marketing and publicity boom prompted
by the trip to Japan fueled innumerable commercial
manipulations of the *Mona Lisa*. Used in magazines,
on TV, in advertisements, on clothes, her image
was everywhere. In fact, some artists' entire oeuvre
consists of variations on the *Mona Lisa*.

BOTTOM ROW, FROM LEFT
Poster for the Max Michalski Graphic Arts
Competition
Mona Lisa Puzzle
Louvre, Paris, 1990, Vincent Raynal, 1991

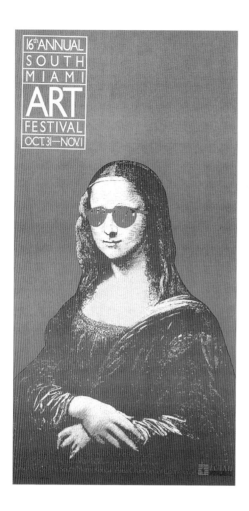

16ᵗʰ ANNUAL
SOUTH
MIAMI
ART
FESTIVAL
OCT.31—NOV.1

ABOVE
Poster for South Miami Art Festival
Although the French consider her theirs, and the Italians certainly have a claim, Mona Lisa has achieved a strange universality. Indeed, so ubiquitous has she become that it's hard to say exactly what she represents any more. Here the lady gets a laid-back treatment for a Miami arts festival.

RIGHT
Chanel advertisement
Despite all the parodies and postmodern deconstruction, the *Mona Lisa* still remains the defining masterpiece in the history of art. The witty Chanel ad capitalizes on this elite status to impress buyers with the ultimate chic of Chanel clothes and the woman who wears them.

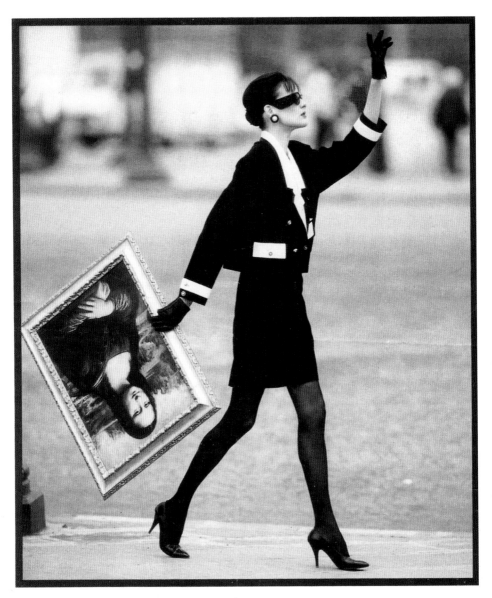

CHANEL
BOUTIQUE

31, RUE CAMBON – PARIS 1er 42, AVENUE MONTAIGNE – PARIS 8

Le Jocondasaure
1997
Recent technological advances have opened up new ways for artists to manipulate the *Mona Lisa*.

**Leonardo — The Artist Becomes
the Model for His Mona Lisa**
Lillian F. Schwartz
1995
Other variations on the *Mona Lisa* theme served to extend
ideas about the painting's true nature. The idea that
Leonardo himself was the model for the painting goes
back to Maurice Vieuille in 1913. Modern technology
lets us explore this idea more closely.

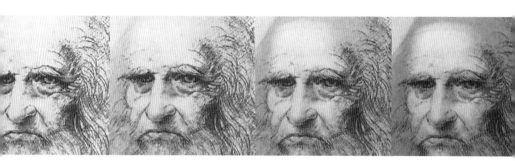

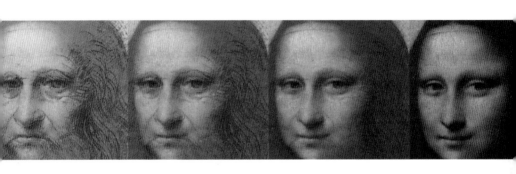

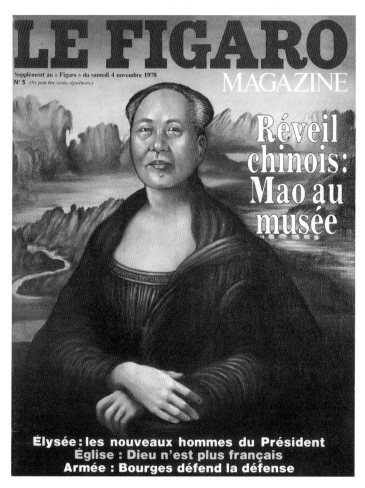

LE FIGARO

Supplément au « Figaro » du samedi 4 novembre 1978
N° 5 *(Ne peut être vendu séparément.)*

MAGAZINE

Réveil
chinois:
Mao au
musée

Élysée : les nouveaux hommes du Président
Église : Dieu n'est plus français
Armée : Bourges défend la défense

ABOVE
Cover of *Le Figaro* magazine
November 4, 1978

RIGHT
Cover of *The New Yorker*
June 3, 1991
Mona Lisa has received considerable mileage as a
cover girl. She can instantly convey several possible
messages—from fame to mystery to inscrutability.

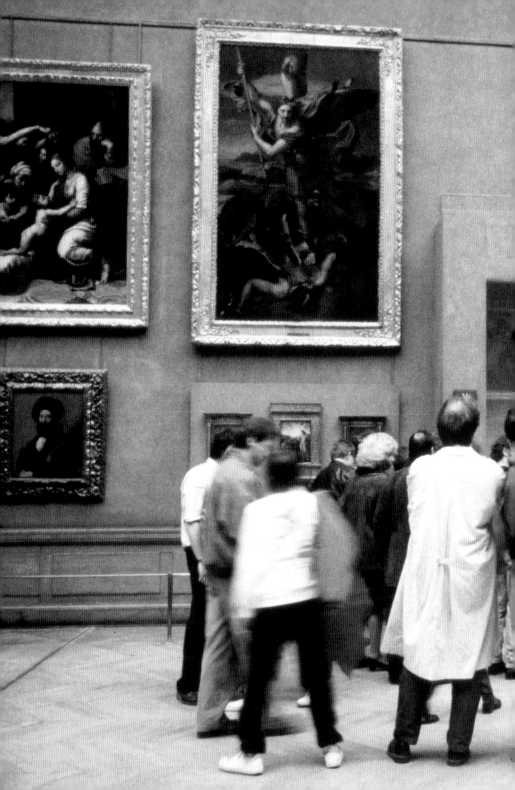

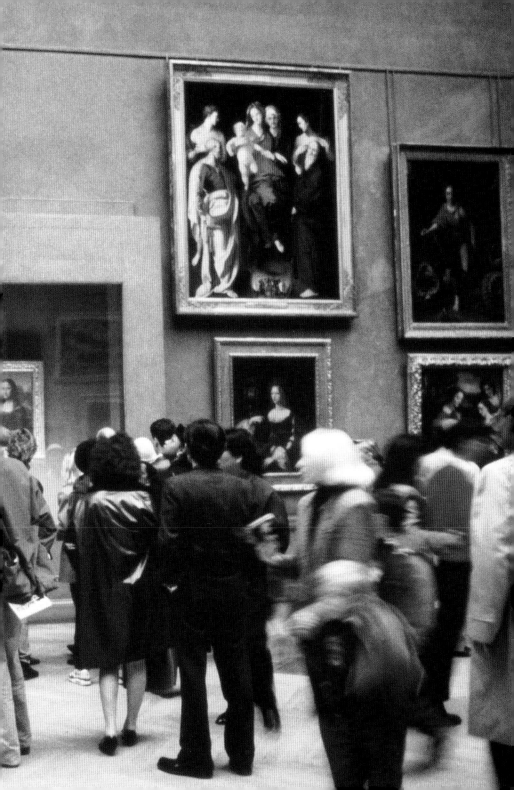

PREVIOUS SPREAD
The *Mona Lisa* on display at the Louvre
c. 1995
Still in the reinforced concrete chamber fronted with bulletproof glass that had been designed for her stay in Tokyo, the *Mona Lisa* received an ever-increasing number of visitors throughout the last decades of the twentieth century.

ABOVE
***Mona Lisa* mural on a barn in Wisconsin**
c.1999
Mona Lisa is everywhere. One Wisconsin farmer found that the best way to celebrate his favorite local sports teams was to show the lady wearing their shirts.

ABOVE
Dan Brown's *Da Vinci Code* in a Uruguay bookstore
2003
First published in 2003, and with over 25 million copies currently in print, the runaway bestseller *The Da Vinci Code* by Dan Brown capitalizes on the fame and the aura of mystery that surround Leonardo.

RIGHT
***Mona Lisa* clock**
Since the 1950s, Mona Lisa has appeared on a vast range of products. Technological advances of the late twentieth century and beyond have made it simple to scan, reproduce, and alter her image. Now she appears on ties, clocks, teapots, condoms, and just about every other product imaginable.

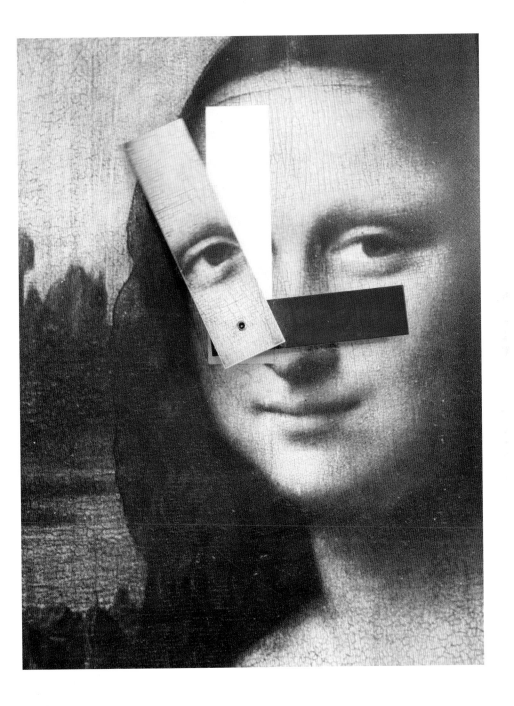

The *Mona Lisa* on display in the Salle des États
After a $6.2 million renovation designed by Peruvian architect Lorenzo Piqueras, the *Mona Lisa*'s new home on a specially constructed viewing wall in the Salle des États was unveiled to the public on April 6, 2005. From there, the lady continues to court controversy, inspire all manner of artists, and draw crowds in their millions. Five hundred years of history, influence, and intrigue have only added to the allure of Leonardo's masterpiece.

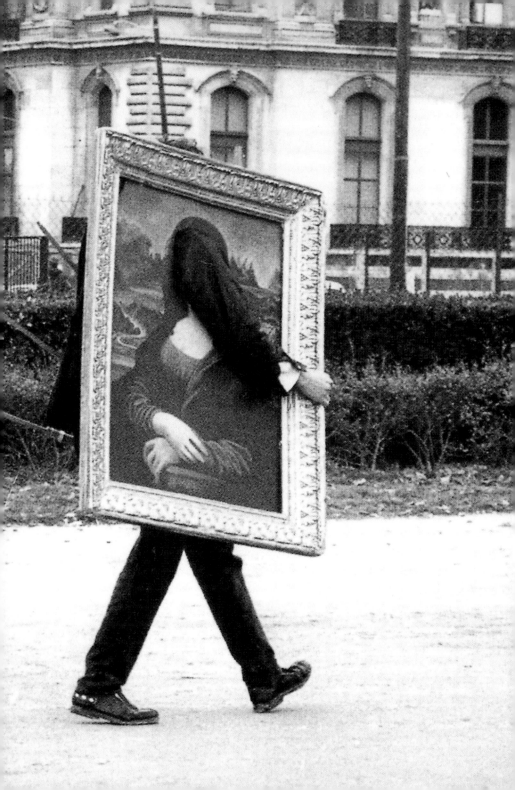

CREDITS
AND
INDEX

PICTURE CREDITS

Front cover:
Mona Lisa
Leonardo da Vinci, 1503–c.1507
Oil on wood
Louvre, Paris, France
© RÉUNION DES MUSÉES NATIONAUX /
ART RESOURCE, NY.

Back cover:
© PHOTOGRAPH VINCENT RAYNAL.

Front flap:
© ROGER VIOLLET / GETTY IMAGES.

Back flap:
PHOTO © STEVE MUREZ 2006.

P. 2
© ANNEBICQUE BERNARD /
CORBIS SYGMA.

PP. 5–6
© BETTMANN / CORBIS.

P. 8
[For full details, see entry for
front cover.]
© RÉUNION DES MUSÉES NATIONAUX /
ART RESOURCE, NY.

P. 10–11
© COSMO CONDINA / GETTY IMAGES.

P. 12
© CLARENCE SEET / ISTOCKPHOTO INC.

P. 13
© DOUG ARMAND / GETTY IMAGES.

P. 14
Nike (also known as **Winged**
Victory) of Samothrace
c. 190 BC
© SYLVIE FOURGEOT / ISTOCKPHOTO INC.

PP. 14–15
The Birth of Venus
Sandro Botticelli, c. 1483
Uffizi Gallery, Florence, Italy
© SCALA / ART RESOURCE, NY.

PP. 16–17
The Creation of Adam, from the
Sistine Chapel
Michelangelo, 1509–12
Sistine Chapel, Vatican Palace,
Vatican State
© ERICH LESSING / ART RESOURCE, NY.

P. 17
Sunflowers
Vincent van Gogh, 1888
Oil on canvas
Neue Pinakothek, Munich, Germany
© SCALA / ART RESOURCE, NY.

PP. 18–19
PHOTO © STEVE MUREZ 2006.

PP. 20–21
© B.S.P.I. / CORBIS.

P. 175
Vetruvian Man
Leonardo da Vinci, 1490
Accademia, Venice, Italy
© ALINARI / ART RESOURCE, NY.

PP. 176–177
[For full details, see entry for
PP. 156–158.]
© ERICH LESSING / ART RESOURCE, NY.

P. 178
Napoleon I Visits the Louvre,
Accompanied by Architects
Percier-Bessant and Fontaine
Louis-Charles-Auguste
Couder, 1833
Louvre, Paris, France
© ERICH LESSING / ART RESOURCE, NY.

PP. 180–181
The Gallery of the Louvre
Samuel Finley Breese Morse,
1831–33
Oil on canvas
Terra Foundation for American Art,
Chicago, U.S.A.
© TERRA FOUNDATION FOR AMERICAN ART,
CHICAGO / ART RESOURCE, NY.

PP. 182–183
Four o'clock at the Salon
François Biard, 1847
Louvre, Paris, France
© ERICH LESSING / ART RESOURCE, NY.

PP. 184–187
Courtesy of the Library of Congress,
Prints and Photographs Division
[LC-USZ62-120707].

P. 188
Tourists on Vesuvius
c. 1840
© MARY EVANS PICTURE LIBRARY.

P. 189
View of a park
Louis-François Cassas,
19th century
Watercolor
Musée des Beaux-Arts,
Orleans, France
© RÉUNION DES MUSÉES NATIONAUX /
ART RESOURCE, NY.

PP. 190–191
© RÉUNION DES MUSÉES NATIONAUX /
ART RESOURCE, NY.

P. 193
Engraving of the Mona Lisa
Antoine-François Dezarrois,
19th century
Louvre, Paris, France
© RÉUNION DES MUSÉES NATIONAUX /
ART RESOURCE, NY.

P. 194
Poster for the opera La
Gioconda, from L'Illustrazione
Italiana
Prina, 1876
© MARY EVANS PICTURE LIBRARY.

P. 195
Mona Lisa with a Pipe
Eugène Bataille (Sapeck), 1887
© JANE VOORHEES ZIMMERLI ART
MUSEUM, RUTGERS, THE STATE
UNIVERSITY OF NEW JERSEY. ACQUIRED
WITH THE HERBERT D. RUTH SCHIMMEL
MUSEUM LIBRARY FUND.

P. 196
"The Climax," from Oscar
Wilde's Salome
Aubrey Beardsley, 19th century
Line-block print
Victoria and Albert Museum,
London, Great Britain
© VICTORIA & ALBERT MUSEUM, LONDON /
ART RESOURCE, NY.

P. 197
Helen on the Walls of Troy, with
Two Figures at Her Feet
Gustave Moreau, 19th century
Watercolor
Louvre, Paris, France
© RÉUNION DES MUSÉES NATIONAUX /
ART RESOURCE, NY.

P. 198
© RÉUNION DES MUSÉES NATIONAUX /
ART RESOURCE, NY.

P. 199
Nude with a Fan
Théophile Gautier, 19th century
Bibliothèque de l'Institut de France,
Paris, France
© RÉUNION DES MUSÉES NATIONAUX /
ART RESOURCE, NY.

P. 200
Game of Madness
Pierre-Louis Pierson, c. 1863–66
© COURTESY OF THE FRAENKEL GALLERY,
SAN FRANCISCO.

P. 201
La Ghirlandata
Dante Gabriel Rossetti, 1873
Guildhall Art Gallery, London,
Great Britain
© ERICH LESSING / ART RESOURCE, NY.

PP. 202–203
[For full details, see entry for P. 201.]
© ERICH LESSING / ART RESOURCE, NY.

P. 204
© HIP / ART RESOURCE, NY.

P. 205
Sarah Bernhardt
Georges Clairin, 1876
Oil on canvas
Musée du Petit Palais, Paris, France
© GIRAUDON / ART RESOURCE, NY.

PP. 206–207
Sphinx (of the Caresses)
Fernand Khnopff, 1896
Oil on canvas
Musée d'Art Moderne,
Brussels, Belgium
© ERICH LESSING / ART RESOURCE, NY.

P. 208
Cartoon
Lucien Métivet, 1898
Reproduced with permission from
Jean Margat from *Le Mythe de la
Joconde* (Lausanne, Switzerland:
Éditions Favre, 1997), p. 118.

P. 209
© GETTY IMAGES.

CHAPTER 4

PP. 210–212
© ROGER VIOLLET / GETTY IMAGES.

PP. 219–221
© MARY EVANS PICTURE LIBRARY.

PP. 222–223
Based on an image taken from
http: // www.pbs.org /
treasuresoftheworld / a_nav /
mona_nav / mnav_level_1 /
1crime_monafrm.html.

P. 224
Cartoon
Georges Léonnec, 1911
© ROGER VIOLLET / GETTY IMAGES.

P. 225
Mona Lisa Cartoon
c. 1911
© MARY EVANS PICTURE LIBRARY.

P. 226
**Cover of *La Domenica
del Corriere***
September 10, 1911
© FOTO ARCHIVIO LEONARDISMI — MUSEO
IDEALE LEONARDO DA VINCI.

P. 227
Cover of *Excelsior*
August 23, 1911
© FOTO ARCHIVIO LEONARDISMI — MUSEO
IDEALE LEONARDO DA VINCI.

P. 228
Taken from *Apollinaire: Chronique
d'une Vie* (Paris: N.O.E.,1965), p. 96.

P. 229
© RÉUNION DES MUSÉES NATIONAUX /
ART RESOURCE, NY.

P. 231
Cartoon
Adrien Barrère, 1911
© MARY EVANS PICTURE LIBRARY.

P. 232–233
Taken from *Stealing the Mona Lisa:
What Art Stops Us From Seeing*
(London, U.K.: Faber and Faber,
2002), p. 3.

P. 234
© ROGER VIOLLET / GETTY IMAGES.

P. 235
Taken from *The Day They Stole the
Mona Lisa* (New York: Summit
Books, 1981), photo section.

PP. 236–237
© ROGER VIOLLET / GETTY IMAGES.

P. 238
[For full details, see entry for P. 144.]
© ERICH LESSING / ART RESOURCE, NY.

P. 239
Woman with a Pearl
**Jean-Baptiste-Camille Corot,
c. 1869**
Louvre, Paris, France
© ERICH LESSING / ART RESOURCE, NY.

P. 240
© BART PARREN / ISTOCKPHOTO INC.

P. 241
Taken from http: // www.pbs.org /
treasuresoftheworld / a_nav /
mona_nav / mnav_level_1 /
5return_monafrm.html.

PP. 242–243
[For full details, see entry for
front cover.]
© RÉUNION DES MUSÉES NATIONAUX /
ART RESOURCE, NY.

PP. 244–249
© ROGER VIOLLET / GETTY IMAGES.

PP. 250–251
Taken from *Mona Lisa: The Picture
and the Myth* (Boston: Houghton
Mifflin Company, 1975), p. 212.

P. 252
© ROGER VIOLLET / GETTY IMAGES.

P. 253
© TIME LIFE PICTURES / GETTY IMAGES.

P. 254
© BART PARREN / ISTOCKPHOTO INC.

P. 255
**Postcard commemorating
the return of the Mona Lisa
1913**
© ROGER VIOLLET / GETTY IMAGES.

P. 256–257
© GETTY IMAGES.

P. 258
**New Year's postcard featuring
the *Mona Lisa*
1913**
© ROGER VIOLLET / GETTY IMAGES.

P. 259
**Postcard from the return of
La Joconde
c. 1913**
© MARY EVANS PICTURE LIBRARY.

CHAPTER 5

PP. 260–262
© PAUL SLADE / PARIS MATCH / SCOOP.

P. 272
***Composition with Mona Lisa*
Kasimir Severinovich Malevich,
c. 1914**
Collage of paper and oil on canvas
State Russian Museum,
St. Petersburg, Russia
© STATE RUSSIAN MUSEUM, ST.
PETERSBURG, RUSSIA / BRIDGEMAN
ART LIBRARY.

P. 273
***L.H.O.O.Q. ("She's got
a hot ass")*
Marcel Duchamp, 1919**
Private Collection
© ESTATE OF MARCEL DUCHAMP /
SODRAC (2006)
DIGITAL IMAGE © CAMERAPHOTO /
ART RESOURCE, NY.

PP. 274–275
© MARY EVANS PICTURE LIBRARY.

PP. 276–277
***La Joconde aux Clefs*
Fernand Léger, 1930**
Oil on canvas
Musée National Fernand Léger,
Biot, France
© ESTATE OF FERNAND LÉGER /
SODRAC (2006)
DIGITAL IMAGE © RÉUNION DES MUSÉES
NATIONAUX / ART RESOURCE, NY.

P. 312
Taken from *Chronique des Arts* (1974).

PP. 312–313
Taken from *Mona Lisa im 20 Jarhundert* (Wilhelm-Lembruck-Museum der Stadt Duisberg,1978).

P. 314 (top left)
© RICK MEYEROWITZ.

P. 314 (top right and bottom left)
Courtesy of Museum für Gestaltung Zürich.

P. 314 (bottom right)
Reproduced with permission from Jean Margat from *Le Mythe de la Joconde* (Lausanne, Switzerland: Éditions Favre, 1997), p. 52.

P. 315 (top)
Courtesy of Terry Pastor.

P. 315 (bottom)
© PHOTOGRAPH VINCENT RAYNAL.

P. 316
Courtesy of Museum für Gestaltung Zürich.

P. 317
Reproduced with permission from Jean Margat from *Le Mythe de la Joconde* (Lausanne, Switzerland: Éditions Favre, 1997), p. 63.

P. 318
Le Jocondausaure
1997
© GETTY IMAGES.

PP. 320–321
Leonardo — The Artist Becomes the Model for His Mona Lisa
Lillian F. Schwartz, 1995
© 1995 LILLIAN F. SCHWARTZ. COURTESY OF THE LILLIAN F. SCHWARTZ COLLECTION, OHIO STATE UNIVERSITY. ALL RIGHTS RESERVED. MORPHING SOFTWARE BY GERARD HOLZMANN.

P. 322
Cover of *Le Figaro*
November 4, 1978
Artwork © Marcel Laverdet.
© LE FIGARO MAGAZINE / NOVEMBER 1978.

P. 323
Cover of *The New Yorker*
June 3, 1991
Original artwork by
J. B. Handelsman / *The New Yorker*
© CONDÉ NAST PUBLICATIONS INC.

PP. 324–325
© GRAEME HARRIS / GETTY IMAGES.

P. 326 (left)
© ZANE WILLIAMS / GETTY IMAGES.

P. 326 (right)
© AFP / GETTY IMAGES.

P. 327
Courtesy of Terroni Restaurant, Toronto, Canada.
© PHOTOGRAPH BY EDWARD POND.

PP. 328–329
© AFP / GETTY IMAGES.

CREDITS AND INDEX

P. 330
© PHOTOGRAPH VINCENT RAYNAL.

PP. 351–352
© SUPER-FILM (ALL RIGHTS RESERVED).

FOR ANGEL EDITIONS
EDITORIAL AND ART DIRECTOR
SARA ANGEL

———

MADISON PRESS BOOKS

EDITORIAL DIRECTOR
WANDA NOWAKOWSKA

BOOK AND JACKET DESIGN
UNDERLINE STUDIO

PROJECT EDITOR
AMY HICK

MANUSCRIPT EDITOR
ROSEMARY SHIPTON

EDITORIAL ASSISTANCE
PATRICIA HOLTZ

PHOTO ACQUISITION
SHIMA AOKI

PHOTO RESEARCH
BAO-NGHI NHAN

PRODUCTION MANAGER
SANDRA L. HALL

PUBLISHER
OLIVER SALZMANN

VICE-PRESIDENT, BUSINESS AFFAIRS AND PRODUCTION
SUSAN BARRABLE

PRINTED BY
IMAGO PRODUCTIONS (F.E.) LTD., SINGAPORE

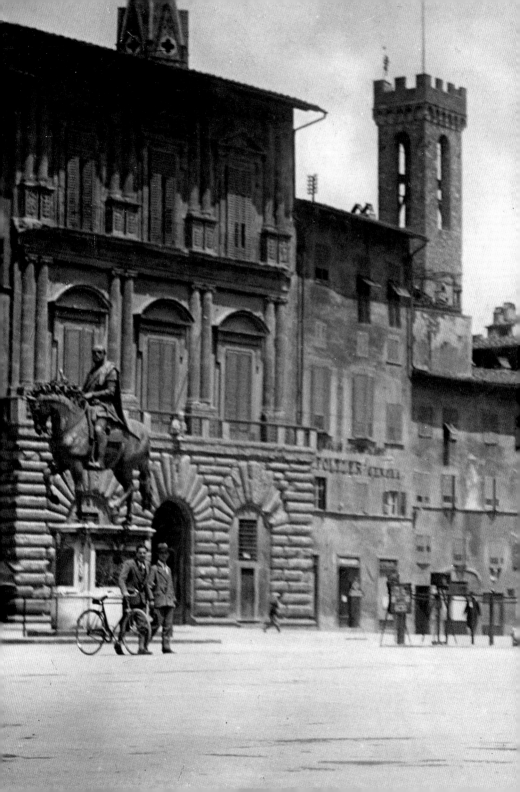

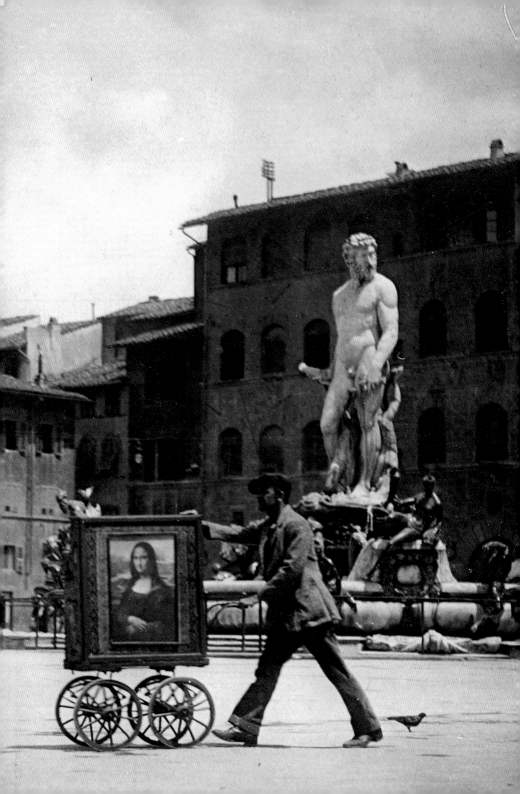